good deed rain

In the Valley
of Mystic Light

An Oral History
of the Skagit Valley Arts Scene

Claire Swedberg & Rita Hupy

In the Valley of Mystic Light:
An Oral History of the Skagit Valley Arts Scene
©2017 Good Deed Rain
Bellingham, Washington
ISBN 978-1-64008-161-1
Cover by Richard Gilkey, courtesy of Guy Hupy
Editing Assistance by Helen Frost
Production by Allen Frost and Fred Sodt

INTRODUCTION

This book was conceived by Rita Hupy with her friend Mary Evitt more than a decade ago, as an opportunity to explore a unique time in La Conner and the Skagit Valley's history. There are hundreds of art colonies and communities across the U.S. and world, but an explanation of just what makes them germinate and then grow, seems elusive. The most compelling questions for Rita were: Why did those early Northwest mystics—Morris Graves and Guy Anderson—settle here, and why did several waves of artists continue to follow? And what has that meant for the community and for the artists themselves?

When Graves and Anderson arrived in the 1930s they found a quiet, inexpensive oasis with intriguing skies and light to paint, and an abundance of quiet for inner contemplation. But those basics alone couldn't drive the transition that took place over the next 50 years, transforming La Conner from a farming and fishing village, as remote as it was small, to the expanded art community that host museums, an international poetry festival and draws thousands of tourists not just to see flowers growing in the fields, but to peruse the art galleries. Yet, throughout the approximate half-century transition chronicled in this book, the area continued to sustain its origins in farming and fishing.

Rita Hupy came to me to author the book, and we took the project from its concept to the story that's included here, guided by the individual accounts from hundreds of interviews. We didn't limit our interviews to artists, for this is the story of a community and how it was altered by the arts. We also didn't limit our interviews to locals because this is also a story of the artistic process—not only do artists impact a place, the place just as completely affects the artists and the work they do here.

This book has been an unending conversation on art and community. Imagine two barstools in a small town drinkery—Guy Anderson may be sitting on one, and a farmer or fisherman might be perched on the other—and those two individuals are locked in lively conversation about everything from baseball, to the artistic experience, from politics to Proust. That was the Skagit Valley that the artists and locals knew.

Together, Rita and I learned that the exploration for art, beauty and understanding is timeless, and those who live in or who migrated to this corner of the U.S., have found an enduring environment in which they can share that exploration.

Sadly Rita Hupy died before the interviews for this project could be completed, and it is in her memory that I have written the following and am publishing it today. Rita loved the Skagit Valley and dedicated most of her life to arts and artists, as did her husband Art Hupy. These stories, I think, reflect many of the aspects of the place she loved the most.

As a writer, I am neither artist nor historian. I entered this project with Rita's questions as well as my own and let the answers from those we interviewed fill these pages. With that said, this is only one part of the story of art, or the Northwest arts, and of this community. There are hundreds of individuals with their own stories, and artists with unique talents who were not included here simply to keep a focus on the local history.

This narrative is an oral history, based on personal recollections of those interviewed, in most cases reinforced by at least two witnesses. But time can modify memories, and just like the shifting flow of the Skagit River and Puget Sound, memories and stories sometimes shift through time.

Claire Swedberg

CONTENTS

ACKNOWLEDGEMENTS

An oral history by nature depends on the support, time, work and patience from a community of people.

In fact, so many individuals have contributed to this book that it's impossible to name them all. The list of contributors included at the end of this book offers some but not all names of those who have helped make this book a reality. The artists, farmers, fishermen and other residents of the Skagit Valley have been generous with their time and their memories over this decade-long project.

Early on, several dozen financial contributors provided support to help fund the research and interviewing process. Without their help, we would never have gotten beyond that first step, and Rita and I were immensely grateful to each and every one of them.

Others have gone far beyond any reasonable expectations when it comes to helping me understand the community and its history: patiently answering questions, no matter how repetitive or obscure, and taking me on personal tours of the important sites where the arts scene developed. Among those valuable sources are the Museum of Northwest Art and especially Museum Curator Kathleen Moles, as well as Janna Gage, Lisa Harris and Harris Harvey Gallery, Charles Stavig, and Deryl Walls. In some cases, individuals tolerated a dozen or more conversations to help me fully understand the area and the arts here.

Thanks go to the numerous readers who provided their valuable insights and edits especially Terri Cunningham and Susan McKeehan.

Mary Evitt helped launch this project with Rita Hupy and conducted the first three interviews. I am immeasurably grateful to her for that early start and those important contacts.

And most importantly I owe immeasurable gratitude to Allen Frost who shared my vision, and worked tirelessly to make this book a reality. His support, editing and craftmanship are central to this story and its publication.

There is a light in the Valley that holds a wealth of graces, and sets them down before us, unhindered and full. Everyone can feel it, everyone can see it; but to make art of it requires a long, tireless, ongoing attention – and a fascination that endures through all vicissitudes and difficulties of time.

—Robert Sund
(Skagit Valley Artists 1992)

Mystic:
inducing a feeling of awe or wonder,
having magical properties.
Mysterious, obscure, enigmatic.

Part I

1930s — The Early Years

Chapter 1

Seattle Artists

Seattle in the 1930s was a remote, gritty town built for the timber and fishing industry and, like most cities of that decade, it had fallen on hard times. British conductor Thomas Beecham famously dismissed the city as a "cultural dustbin."

So when it came to art, Seattle was a world removed from the vibrant art scenes in Europe and the East Coast of the U.S. However, the Northwest city, with its 350,000 residents, fostered a community of artists of its own that was little influenced by the abstract expressionism of painters like Jackson Pollack 3,000 miles east in New York. Many of Seattle's artists, living among the hardscrabble city of loggers and shipyard workers, were looking in an entirely different direction: Asia.

Northwest painters and sculptors during the Great Depression tended toward social realism and often experimented with religious and artistic influences from the other side of the Pacific. Around these movements, several groups of artists formed in the city—one at the University of Washington and another known casually as the "downtown group" that was known for aesthetic art that was pleasing to the eye. Yet another group of artists attended Seattle's school of Cornish—a private art academy that had developed a reputation for graduating quality artists. Faculty member Mark Tobey was part of the reason for the excellence graduating from the art program. The New York ex-pat had high expectations for his students. He taught with a Far-Eastern aesthetic and approached art as a form of spiritual quest.

Morris Graves was one of Tobey's students; a lanky man who came to class barefoot or in slippers, a torn jacket, and frayed pants that stopped half way down his calves. Nearly always he carried a worn sketchbook with him, recalled artist George Tsutakawa.

Graves, raised in a Methodist family in Edmonds, had the eye of an artist early on. Even as a teenager he was affected by Seattle's shadowy light and made a study of it. He was drawn to paint scenes

depicting the crepuscular light after the sun sets, as the sky slowly faded to night. His travel influenced him on an artistic and spiritual level early in his life. He dropped out of his sophomore year of high school and sailed on American Mail Line ships, with his brother, to Japan. After he returned he settled in Edmonds, attended a Buddhist temple and practiced the Zen-like pursuit of raised consciousness through stilling the mind.

Morris Graves, untitled

At the age of 19, Graves sought out another young artist from Edmonds: Guy Anderson. Anderson grew up in the same community Graves did, born there in 1906 in a middle class home; his father was a carpenter and musician. Anderson described his parents as kind people although his older sister once commented that his father did not approve of painting as a career choice. Anderson paid little heed to discouraging advice. "I'm terribly self-possessed," he said. "I didn't listen to anyone."[1]

Anderson had worked a year on the Edmonds Ferry as a teenager.

That was where he began an artistic study of water, examining the way waves churned up behind the ferry, the way droplets appeared in each isolated instant as they twisted in the air.

Guy Anderson, like Graves, showed a talent for the arts while still in school. At the recommendation of illustrator Ernest Norling, he applied for a Tiffany Foundation scholarship that would pay for a summer program: his first formalized training outside of the Northwest.[2] He won the scholarship and went to work selling magazines in the Edmonds neighborhoods to raise enough money for the trip to Cold Spring Harbor, Long Island, New York.

When he returned, there were few jobs for artists, so Anderson embarked on one of his father's trades—furniture making. He was doing just that one day when Graves visited his home. Anderson had built a chair out of cedar and Graves admired his handiwork. They soon found they shared a general love of art and their conversations evolved from furniture to painting, Asian philosophy, literature and art history. Both intended to pursue a life dedicated to artistic expression. "There wasn't all of the money concern at that time," Anderson said in an interview years later. "Prices were not all that great, and if you got—for a very good little painting—50 to 75 dollars, we thought that was really pretty good."[3]

By this time Anderson, Graves' elder by four years, had exhibited his oil paintings at the Seattle Fine Arts Society. And Graves was intrigued with Anderson's early successes. "He talked like a painter and he knew a great deal about design," Anderson recalled. At the time, Graves' father was managing Evergreen Cemetery while Morris and his brothers were building a small studio on his parents' property in north Edmonds. "We used to kid Morris," Anderson said, about his father's work, "because of the name Graves."

Graves had every intention of being taken seriously as an artist, however. Several years after meeting Anderson, he gained early recognition when he won the Seattle Art Museum (SAM)'s Northwest Annual Exhibition in 1933, at the age of 23. The museum had opened that same year.

One patron for Graves, Anderson and other burgeoning artists, was Richard Fuller, the SAM cofounder and president. Fuller offered them odd jobs hanging paintings and provided opportunities to not only show their own work but to study the art of others.

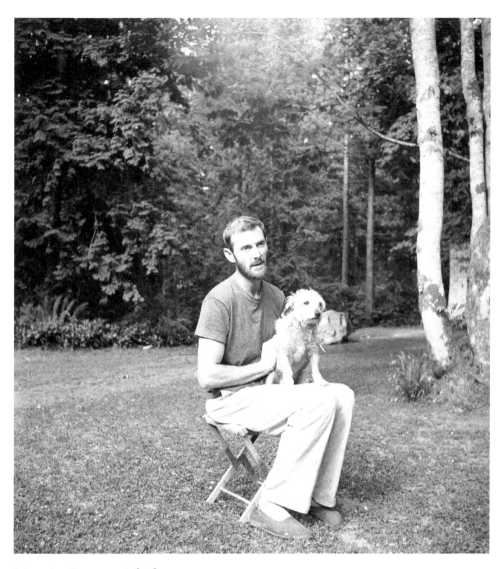

Morris Graves with dog

The experience of working in a museum, surrounded with the work of inspiring artists, was pivotal for Graves and Anderson. "If you had a little time you could always go in the stacks and look at the great collection of prints, or you could look in the various files," Anderson said, "like the Mustard Seed Garden prints, Japanese and Chinese prints, and things that don't get out too often. Or you could go back and look at your favorite icon… all of that was interesting."(4)

For those few in Seattle who were pursuing art, there was a camaraderie, centered around their aesthetic interests. "They didn't have in mind any great shows going on," Anderson said, "and they weren't, as

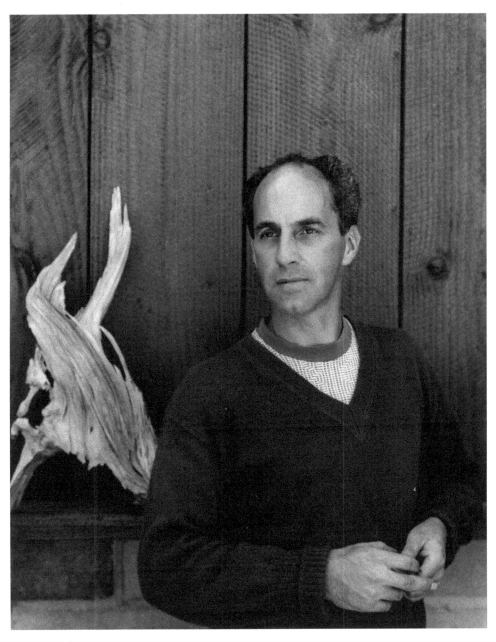

Guy Anderson

far as I knew, interested in being any big names." They simply wanted to do their own best work. "And if you were influenced by the impressionist school, or you were influenced by this or that, why that's what took place," he said.

If an artist was productive and had talent, he might show his work a few times a year, the greatest prize being the Northwest Annual

show. "You always hoped to save your best paintings, and hoped that you would get in the show," Anderson said, "and that was the only thing that happened for years in the Northwest."[5]

Anderson and Graves both made Cornish instructor Mark Tobey a mentor. Tobey was born in 1890 and seemed sophisticated in a way that was incongruous for the Puget Sound logging town. At Cornish and in the nascent art scene, he drew followers and admirers to his side. Originally a Wisconsinite, Tobey had earned acclaim in New York as a portrait painter and caricaturist before he moved to Seattle in 1923. But he was unlike any of the modern artists coming out of New York or Europe. For one thing, around 1919 he had converted to the Baha'i faith, a religion originating in the Middle East that espouses a oneness among all people of the world. And the Asian influence went beyond his spirituality.

In 1924 Tobey met Teng Kuei, a Chinese painter and student at the University of Washington, and Kuei taught him the art of Chinese calligraphy. From that point, Tobey began his famous style of "white writing," featuring white calligraphic designs that streaked and swirled across his paintings. That style inspired imitation from numerous Northwest artists. Morris Graves, often described as a mystic artist himself, was especially taken with Tobey and his Far Eastern-inspired spirituality and artistic vision.

Another key member of the Seattle art scene was Kenneth Callahan who was also commonly referred to as a mystic artist. Born in Spokane, Washington, and raised in Montana, Callahan started painting early under the encouragement of his mother. He made his way to California and held a one-man show exhibiting his paintings, then took a job as a ship steward. He married Margaret Bundy, an editor and Seattle native, and made that his home in the 1930s. At that time he was painting landscapes, especially mountains. He had a great interest in Van Gogh and he and Anderson, Graves and Tobey were all attracted to what was called "mood painting," something some critics would call "mud painting." It was rich with earth tones and shadows.

"My inner eye deals with the flux and flow of the ocean and its waves, the winds, the mountains, insects—they're all interrelated," Callahan said in a statement to Foster/White Gallery that showed his work on Occidental Avenue in Seattle. Callahan, the only married

Guy Anderson, Scene of Edmonds

artists among the group of Graves, Anderson, Toby and himself, offered a domestic environment the others didn't experience. Callahan and wife Margaret hosted dinners for artists who could gather and discuss universal and philosophical questions such as, "Why are we here?" "Where are we trying to go?" They sought and found answers to these questions in the brooding environment around them—in the sea, mountains, the clouds—and in the art they created based on

what they saw.

George Tsutakawa challenged European art concepts as well. He rejected the idea that art must draw a distinction between live animate objects versus non-animate objects or "still life." His more Zen-like perspective embraced the concept that everything is alive and he painted it as such—trees, cows, mountains. Like Callahan and Anderson, he found inspiration in the natural course of water flow and was attracted to the Northwest by the convergence of capillary sized streams with arterial rivers, like the Skagit River to the north, and the cold, deep waters of the Puget Sound itself. For all the artists, the wet, brooding grays of the Northwest tapped into a more Asian sensibility, full of spiritual influences.

Guy Anderson, untitled charcoal sketch

It wasn't only Asia though, that influenced Seattle's artists. Native American styles were evident in the work of artists like Helmi Juvonen; Scandinavian folk art was the centerpiece of painter Pehr Hallsten, while Bill Cumming named his own favorite artist as

Alaskan landscape painter Eustice Zeigler.

Although Seattle offered a small and therefore close community for artists, it also had its limits. Anderson's and Graves' new friendship took them beyond the city they grew up around. They were both explorers, and eventually they bought an old truck—by some accounts it was a bread truck, others insist it was a milk truck. In fact, Graves and Anderson were known for having a series of aging jalopies that they maintained as long as they could, until they found another good deal. With the flatbed to stretch out in for the night, they drove their truck south to California, found a place to park at night and set up camp. Then they painted what they saw in spontaneous responses to nature, creating their own largely self-taught landscape style. They used transient materials they found around them, with little thought to permanence of their work. One night they propped up a piece of plywood and each painted on one side of it. Inspiration came from not only landscapes but cities, zoos and books.

In 1936 the two decided to explore the farm country of Skagit County. By this time they had a Model T Ford that ran adequately, although it would be a breezy ride, since the car was missing its top. They packed up their materials, something to eat, and headed north.

Chapter 2

A Farming and Fishing Village

At the end of a two hour drive north from Seattle, Morris Graves and Guy Anderson arrived in La Conner in their 20-year-old Model T Ford. They pulled to a stop at the local Bettner's gas station on the outskirts of town and fueled up.

From the filling station Graves and Anderson could see fields stretching north and east, snowcapped Mount Baker to the Northeast, and the foot hills rising toward the Cascades Mountain Range directly east. A single unpaved and unmarked road, Morris Street, led west into town.

This place, 66 miles north of Seattle, was familiar to Anderson; he had passed through it as a boy on family trips to camp at Deception Pass, where Fidalgo Island meets Whidbey Island. While Deception Pass could later be accessed by Interstate 5 and Highway 20, at that time there were no such thoroughfares, and travelers had to pass right through the center of La Conner. Looking at the familiar town as an adult, Anderson was attracted to what he called the "long vista; the long stretch of pasture and sky." It seemed to want to be painted.

Not far past the service station the painters also could see the majority of homes that made up La Conner. About 600 residents, mostly Dutch and Scandinavian immigrants, lived on one side of the Swinomish Channel, and 260 Swinomish and Samish tribal members resided on the other side, on Fidalgo Island. A bridge tender managed the swing bridge on First Street that was the only road connection to the island.

In 1936, life in La Conner had been little impacted by the Great Depression that was ravaging the economies of larger cities. Eking a living here was often a simple matter of hard work and local resources.

On the day the artists came to town, several La Conner residents paused to notice Anderson and Graves and their Model T. The town drew a steady stream of transients and travelers, but most were migrant laborers, or tourists on their way to vacations on the islands. Few came through the area on painting expeditions. Austin Swanson,

a young man who would go on to farm in the community his entire life, was struck not only by their appearance, but the car which he recalled having no top whatsoever. "It was missing its lid."

Roberta Nelson

High school student Roberta Moore didn't see the two young artists' first visit, but she would become a lifelong friend to Guy Anderson once he moved in. Like most La Conner residents, young Roberta had never lived outside of the Skagit Valley. Her family inhabited one of the oldest homes in La Conner, on Second and Calhoun. Her father, John (Jack) W. Moore, was a lather, and his two sons, Milo and Vernon, operated one of the town's three fish-buying operations, selling salmon to Seattle's fish markets.

Outside of school hours Roberta, the baby of her family, accompanied her brother Milo by boat to buy fish. At sunrise they started the outboard motor and chugged up Telegraph Slough to purchase the catches of local gillnetters, some white, some Swinomish natives. The water was glassy at that time of day, and their boat would startle herons wading in the shallows. Those morning runs were a time of tranquil reflection for her, as the boat made its solitary way through the still water.

The fishermen treated Milo, the young fish buyer, and his sister, like family, and many invited them in for breakfast. After Milo and Roberta returned from their run, she and her other brother Vernon would then haul the fish to markets in Seattle, trailing water and their catch's blood as they traveled south, the smell of fish and gasoline wafting through the truck's cab. Decades later, she said, "For me that's a very nostalgic smell."

It's hard to imagine the plentitude of fish at the time: boats loaded with sockeye, pink and Chinook salmon churned their way up and down the channel surrounded by chattering swarms of sea gulls. That sound regularly punctuated an otherwise quiet landscape.

From the Reservation, at times, long-house drumming pounded across the channel to La Conner. For the most part, though, man-made sounds were so unusual, especially on the early morning fish runs, that in old-age Roberta still remembered the first time a radio broke the valley's silence, emanating voices over the water from another, more crowded place.

On the south side of town, at the McMillan Pea Cannery, business was quiet until late June when cannery workers descended from neighboring communities in Washington and British Columbia as well as the Swinomish Reservation. For about six busy weeks, boats hauled empty cans in during each high tide, while trucks delivered loads of freshly picked peas from area farms.

A small army of workers—mostly men—unloaded the peas, women picked out the dirt by hand, and the cleaned peas were then packed in brine. The girls who got the pea cleaning done included Lea McMillan, daughter of one of the cannery's two brother owners. Lunch breaks were the highlight of each day. The young workers wore bathing suits under their clothes and between shifts would go swimming in the Swinomish Channel (known at the time as the Slough). When McMillan blew a whistle signaling the end of lunch, workers swam to shore. A few years older than Roberta, Lea too was growing up in the town where she would eventually live out her adult life. As a teenager in the 1930s, her existence was simple—school, her friends and summer work at the cannery.

Fellow teen, Bill Bailey, who eventually would become a federal marshal, lived with his grandparents in La Conner. His grandfather, William McCluskey, had retired from his job as Swinomish tribal

agent under the Tulalip Agency that encompassed Tulalip, Lummi and Swinomish reservations. Bill spent most of his time visiting friends around town and taking up odd jobs. He and Roberta were like brother and sister; at night she climbed out her bedroom window onto the porch roof where Bill had shimmied up to meet her and they sat gazing out over the moonlit channel, talking for hours, undetected by her parents. And if there was one thing Bill loved to do, Roberta recalled, it was to talk.

Austin Swanson

On First Street the town's only inn—The Planter Hotel—was operated by Ephraim Fahlen, a soft-hearted, but moody Swede known as "E." He kept his restaurant filled with locals, as well as itinerant workers who came in for field or cannery jobs. E was known to provide a free meal when his diners were down on their luck. La Conner businessmen were accustomed to the transience of itinerant workers and were generally accepting of strangers. Diners flowed through the Planter Hotel's restaurant, but a large group of farmers—known as the "Cabbage Swedes"—typically kept one large round table reserved for themselves as they bandied about crops, their neighbors and the growing troubles in Europe. One of them was Anton Swanson, who also operated Palace Meats, the local butcher shop just down the block. In his own meat store, like Fahlen, Swanson often ran long tabs for customers who came up short on cash to pay for their meat.

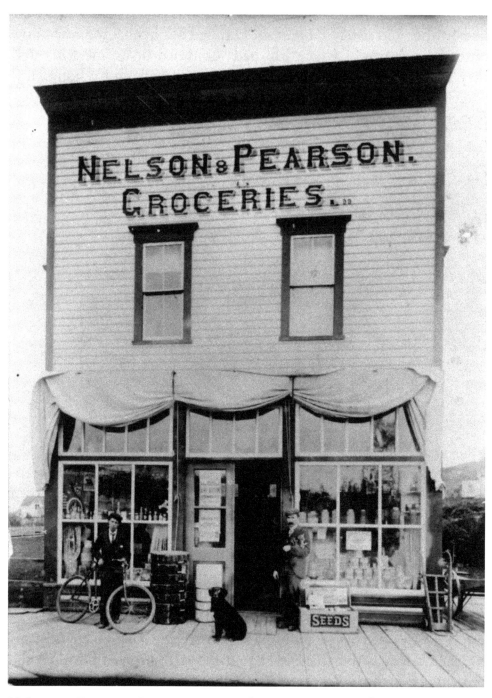

Nelson & Pearson Groceries, typical La Conner storefront

There were so many Swedes farming the Skagit Valley that many not only retained their Swedish accents but passed them on to their children who had never set foot in the "old country."

Anton's youngest son, Kermit, was 16 in 1936 and had been driving a delivery truck for meat orders for the past two years. Often kids followed him on his delivery route in hopes of securing a free "weenie." That, he later recalled, was an expensive give-away considering the high volume of kids, but something that found its way into the meat market budget.

Swinomish tribal member Adeline Daniels, in her late teens, lived a life balanced between two cultures—the tribe on the Swinomish Reservation and the whites across the channel. Many of her peers had been sent away to boarding school on the Tulalip Reservation, 40 miles to the south, where natives from a variety of tribes were directed to learn a trade from white American instructors and were forbidden to speak their native tongue. Adeline's mother was adamantly opposed to organized education either at Tulalip or locally, Adeline recalled. Not only was the boarding school systematically separating children from their culture, the children were getting sick as well. Her older sister Margaret had contracted tuberculosis there. As a result Adeline was several years older than her classmates by the time her mother was persuaded to send the girl to the La Conner public schools in the 1930s. To get there she caught a ride from her neighbors, crossing the swing bridge in their Model T Ford (not unlike the one driven by Graves and Anderson). On the way home she recalled extra passengers had to step out of the car as the driver tried to coax the vehicle to the top of the hill.

Adeline grew up surrounded by Swinomish tradition, and she watched as her elders carved and painted totem poles, made drums, and carved canoes. Each carving told stories passed down through the tribe. She visited the Swinomish long-house for ceremonies, to which whites, including Roberta and her family, were often invited. The tribal members who impressed Adeline most were the seers. During bone games, when participants had to guess in which hand a bone was hidden, the seers seemed to see right through closed fists. They had a vision others didn't have that made an impression on her as a young girl and perhaps on many visiting non-tribal attendees; "The seers were people who hadn't had their brains messed up at school,

17

people who were trained in the ways of the Indian," she said.

At one ceremony, she recalled a white man dressed in a suit tapping his foot by the fire. "As a little tyke I recognized him: 'there's that man that works at the shoe department of JC Penney (in neighboring Mount Vernon).' He was just having a ball dancing away there... The whites were trying to teach the Indians the white man's ways," she said, but at the same time, many of the whites were learning from the Indians.

Seattleites also came to participate in some of those events, taking the long road north to experience a culture of which they were unfamiliar.

In some cases they came by water, or just came to visit friends in La Conner. Planter Hotel's Fahlen had a fellow-Swedish friend in Seattle who often visited; folk singer Ivar Haglund would boat up the channel to visit, often accompanied by a large group of young women, sunning themselves on the deck, while music drifted from the cabin. Haglund was famed as both a folk singer on local radio and the "flounder" of Ivar's Fish and Chips, on Pier 51. He was also known for another restaurant; "Ivar's Acres of Clams" with its motto "Keep Clam." When Pete Seeger and Woodie Guthrie came to Seattle in the 1940s they stayed with Haglund and his wife Margaret, and Haglund claimed he taught Seeger a song he called "Old Settler's Song," although Seeger and Guthrie both claimed it was Seeger who taught Haglund the song, the opening stanza of which began:

"No longer the slave of ambition
I laugh at the world and its shams
As I think of my happy condition
Surrounded by Acres of Clams."[1]

This was the song La Connerites sometimes heard as Haglund's large boat powered up the Swinomish Channel, Roberta recalled. Once docked, Haglund headed for the Planter Hotel to visit his friend E.

Despite the personalities populating the area, La Conner and the valley were mostly defined by nature. When Anderson and Graves first arrived in the valley, the quiet there was profound. The ebb and flow of tides in the channel and the Puget Sound, the flow of glacial

water into the Sound's bays, the formidable presence of the towering cedars, firs and Spanish madrones, that were seasonally fiery red, offered a sharp contrast from city life.

And then there was the sky—a reliable palette of cloud cover that filtered light over the valley from the Puget Sound and Olympic Mountains to the Cascades. While occasional bright sunlight could both intensify and saturate color—as well as cast shadow to describe dimension and perspective—more often every tree, plant, weathered barn or even each wave in the churning waters was awash in subdued, cloud-filtered light.

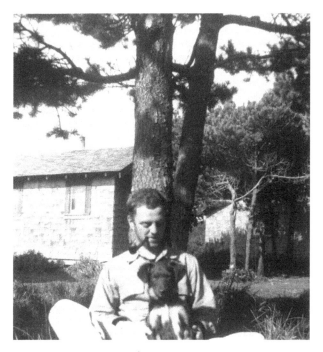

Morris Graves with Dog

In the land where the Swinomish had been carving and weaving for centuries, the challenges to visiting painters with an interest in natural form, artists like Anderson and Graves, were unending. "It was a great place to paint," Skagit County historian Tom Robinson said.

After that first 1936 visit from the two young painters, Seattle's new art movement would make a permanent impression on La Conner and the valley it inhabited. A new art scene was born.

Chapter 3

Morris Graves and Guy Anderson Move In

Late in life, Anderson describes himself and Morris Graves as the country's earliest hippies. Three decades before the 1960s, they were traveling around the countryside on a nearly nonexistent budget and devoting their time and energies to painting what they saw.

On the day in 1936 when they arrived in Skagit Valley in their Model T, Graves had a problem. He and his brothers had built a studio and home on his parents' property in Edmonds where they could live at no cost and where Morris could paint uninterrupted. But it had recently burned to the ground, and he'd lost not only all the art work that he'd completed and was storing there, he'd also lost his home. So when he and Anderson entered the small town of La Conner, they wondered if there might be some cheap housing that would solve Graves' problem as well as offering a retreat for Anderson.

In the Skagit Valley they'd have unending quiet without the pressures of high rent and the related costs of city life. It helped, too, that a gentle, mystical kind of light that washed over the fields and sparkled in the channel seemed to entice them to paint.

They made several visits before Graves found a house poised on a rocky hill that overlooked miles of plowed farm fields. The structure had a notable feature that kept the rent down to nothing—part of the roof was entirely burned out so that half of the upper floor was exposed to the elements. Anderson said in an interview, "The owners agreed that if we fixed the roof we'd get it rent free."[1] Inside they found the previous inhabitants had fashioned tables and chairs from chunks of driftwood that they'd abandoned with the home. It was exactly what Graves wanted and Anderson agreed to join him there.

The house that Graves and Anderson moved into had been owned by Margaret Parsons, a widow who for many years had made her living selling ornate handmade hats. Parsons had the help of the Tillinghast family who supplied flowers for hat-brim garnishments. She would seat herself at a table in front of the town's Planter Hotel or other public places where she displayed floral headwear, made to order for

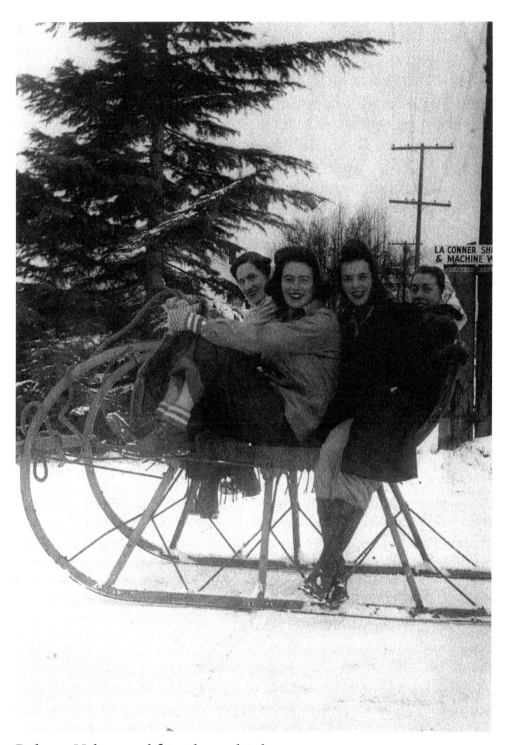

Roberta Nelson and friends on sleigh

fashion-conscious ladies. Her customers came to her from across the channel on the Swinomish Reservation as well as La Conner and neighboring Mount Vernon.

Mrs. Parsons' hilltop home included a carriage shed, with shelves crisscrossing the walls to serve as cubicles for her hats. Her house was grand by La Conner's standards, built well before 1880, when it was first photographed. After Mrs. Parsons died, her family rented the house to tenants. There is no record as to how the house caught fire, but neighbors speculated it was one of these tenants who inadvertently set the blaze, possibly while smoking in the upstairs bedroom.

Although that bedroom was destroyed, the rest of the house was still reasonably tenable, and a great opportunity for artists like Graves and Anderson. They moved in. Graves brought his dog, Edith, and they got to work decorating as well as, reportedly, repairing the roof.

It didn't take long for word to spread around La Conner that there were two unique new residents in town. The townspeople had never seen anyone quite like this. They were artists, and they acted and looked the part. Morris Graves drew most of the attention. With his uncut hair and long beard, "he looked like Jesus," recalled Roberta Nelson.

"The artists seemed strange. They were nice enough, but there was the question of 'what are they doing here? In an old fashioned pioneer town?'" commented Phyllis Dunlap, sister-in-law to the owner of the town's tugboat business.

At well over six feet tall, Graves could attract attention without trying. He ambled down sidewalks on bare feet or wearing ragged shoes, a rope holding up his pants, a pencil and sketchpad in his hand. Some La Connerites recalled Graves pushing a baby buggy that may have transported his artistic tool—sketches, brushes, paints, pencils. He was no stranger to performance art.

"We were all curious; I was dying of curiosity about these artists. People made fun of them," Roberta recalled, "Maybe not 'made fun' per se," she added, "but certainly spoke about them and laughed."

Gary Campbell, who lived next door to Graves' new home, was not old enough for school yet, but he recalled the Model T Ford bouncing up the hill on the unpaved road from downtown La Conner. "That really made an impression on me, watching Morris bounce up the hill in that Model T. He looked like he was going to bounce right

out the top," Campbell said.

Walking home from school at lunch time, Roberta Nelson found Graves seated on the side of the road, with his legs crossed under him, intently sketching on a loose scrap of paper. She'd never seen an adult do such a thing. Roberta worked up the nerve to approach him.

"What are you drawing?" she asked. Morris Graves had both charisma and charm, but he employed it selectively. He was in no mood for conversation that day. He looked at her, then stood, pocketed his drawing and walked away. From what she managed to see of his work before he put it away, she wasn't impressed. It didn't look like the La Conner she knew.

Graves and Anderson were ultimately beneficiaries of the town's people's curiosity. Graves would trade his paintings and sketches for food at the general store, although no one knows of anyone actually keeping one of his pictures. More than likely, most agree, they were thrown away as soon as he left the store. Whether he knew that or not, he didn't look back.

It wasn't just food Graves was acquiring either. After "E" Fahlen sold individual cigars, the inn keeper donated the empty boxes to locals. "We all got cigar boxes from Fahlen," Roberta said. The ladies loved them for stashing their sewing tools. Graves seemed to like the wooden boxes the best. He fashioned them into shoes with a strap across the top. Sometimes, Roberta said, he may have walked barefoot and carried them with him. They were too short for his feet, so he cut holes out of the front through which his toes poked. They couldn't have been either comfortable or supportive, but they were eye catching. When he was in Seattle he drew some stares for wearing them on the city streets as well. At least once he took the boxes off his feet at the bottom of a store escalator. He placed them side by side on the ascending stair and then watched them rise before stepping on a lower step to follow them up, according to local lore.

In the meantime, in La Conner, Anderson and Graves were decorating Mrs. Parsons' old house. Graves had several artistic pursuits at the time—building and painting holy grails and renditions of the Inner Eye. He managed to work them into the home in several ways.

Teenager Bill Bailey struck up a friendship with the artists, and he soon became one of the few La Conner locals who was a frequent visitor to their home. They seemed to like the boy as well. They gave

him odd jobs, talked to him about their painting and, when they left town, put him in charge of cats they had adopted. (The cats slept in the cubicles previously designated for hats by Mrs. Parsons.) Bailey had never seen a home decorated like theirs and he soon set out to share what he saw there.

Morris Graves, Dalmatians

Roberta convinced him to bring her to the house when the artists were out of town. "I got to talking to Bill that I was dying to see that place. He said they would be gone next week and he would be there feeding the cats. He agreed to bring me along."

Roberta remembers walking into the overgrown yard and being greeted by the sight of women's dress shoes stuffed with straw, nailed to a tree in what Roberta called an "interesting fashion," as if they were stepping skyward up the trunk. Lea McMillan made a similar visit with Bill Bailey and recalled the straw as dried plants stuck in

24

many of the shoes.

In either case, "It really looked good," Roberta said. She believed that was Anderson's influence. "He had a knack for that kind of artistry. He found junk and would do something beautiful with it," she said.

Around the yard they found more women's shoes, arranged in abstract designs. And both girls recalled that when Bill brought them inside there was a distinct piece of art hanging from the ceiling, watching them. "The ceiling had an eyeball looking down. It looked just like an eye," Roberta said. The eyeball on the ceiling regarded the room's occupants as the "inner eye" that fascinated not only Graves, but many of his colleagues in Seattle.

Lea also recalled that where there were holes in the wall, perhaps knotholes, Graves or Anderson had painted a vase. Dried flowers were stuck in the holes as if arranged in the vase. Some have said the house also featured sand on the floor, carefully raked to keep it smooth.

Bill Bailey wasn't opposed to making a little extra money while caretaking the house. According to Jan Thompson, a close friend of Morris Graves, a young man from La Conner was offering visitors a tour of the place in Graves' and Anderson's absence. Teenage Betty Bowen, a Mount Vernonite who would go on to become one of the most important art patrons for Northwest artists, reportedly was given a tour of the house and was fascinated by what she saw.

"She was walking through [town] one day," Thompson said, "she was like 16 or 17—and some young kid, some fellow, came along and said, 'Hey! You want to see the house of a crazy man for a quarter?' And she said 'Sure!' Well he had found a way into Morris' house and he was doing tours through it. So that's how Betty first saw Morris' place and she was fascinated with this surreal house that had all black charred walls and sand on the floor—deep sand you walked through."[2]

Graves and Anderson didn't eat much in their home since there were no kitchen facilities. When they could afford it, they bought a meal at the Planter hotel. Fahlen occasionally gave them free food, as he did with the itinerant workers. Some of the locals had developed some fondness for Graves and his companion, Anderson. If nothing else, the artists were an oddity and an entertainment. "It was like a monkey showed up in town," Roberta said.

Years later, Graves liked to tell friends of an anecdote from his time in La Conner in which Jehovah's Witnesses came to his door in an effort to save his soul. As he opened the door to receive them, they looked behind him, into the house, and saw its decor, including the painted eyeball hanging from the ceiling. They made a hasty exit from the neighborhood, he said.

Anderson didn't make the house in La Conner a permanent home at the time. He was often absent, spending weekdays or other extended periods of time at his parents' home in Edmonds. Eventually Graves who stayed in the house full-time had to find work.

McMillan's family owned the pea cannery, and when canning season began, Graves was given a job there alongside Lea and her close friend, Barbara Johnson. "He called Barb and me the Pea Witches," Lea said. "He was always going to paint our picture. He liked us and thought that we would make a good picture. At that time we didn't even think about it. He was just one of the crew."

As the operation started each day, "Morris Graves was the first person the peas met when they arrived," McMillan said. He hoisted peas off the truck and carried them inside the facility where he poured them into a chute that transported them into the cleaning section of the operation.

Across the channel on the Swinomish Indian reservation, a Works Progress Administration (WPA) project was underway that most likely caught the attention of Graves and Anderson. Tribal leaders had been meeting throughout the 30s under the umbrella of the Northwest Federation of American Indians for the tribes to regain rights promised in treaties they had signed in the previous century.

In 1937, one year after the Swinomish Tribe was formally incorporated through the Indian Reorganization Act, the members applied for, and received, funds from the WPA to build a totem pole that would tower above the athletic center there. Totem poles weren't part of the tribe's tradition; rather, the tribe's carvers displayed their skills on canoes. But in this case, their senior carver, Charlie Edwards, would sculpt a 61-foot totem depiction of the tribe's traditional teachings and guiding spirits. Franklin Roosevelt was commemorated on the top, and a picture of the totem pole was displayed in the 1938 edition of *Life* magazine.

Graves and Anderson were visitors to ceremonies in the 130-foot

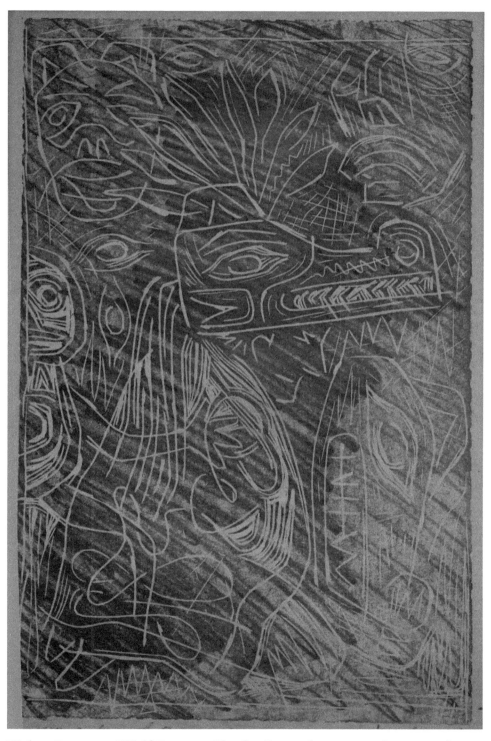

Helmi Juvonen, Wolf Dance: Charlie Swan dancing at Swinomish

Mark Tobey, photo by Art Hupy

long house with dirt floor and three large holes in the roof through which smoke and sparks shot out. They were accompanied at times by Seattle friends and artists such as Helmi Juvonen and William Cumming.[3]

In 1938, Cumming said, he and a group of artists and anthropologists came to La Conner at Graves' invitation and, apparently, at the invitation of the Swinomish Tribe, to experience summer dance ceremonies. Cumming was impressed with the ceremonies, but not as much with the town of La Conner. "Not much there," he commented.

In October 1938, all four of what would later be dubbed the "Big Four Artists" by *Life* magazine, were included in one exhibit for the first time, in the annual art exhibit at the Seattle Art Museum. Mark Tobey, who had been living and teaching in England, came to Seattle in the late summer of 1938 and visited friends including Kenneth and Margaret Callahan.

But life in the house in La Conner didn't last long for Graves and Anderson. The world stage was changing, and artists were finding new ways to make a living. With the war escalating in Europe, Tobey chose to settle permanently in Seattle in late 1938 or early 1939. Graves became a frequent visitor to him there. Graves had begun a series of gouache paintings that featured the moon and animals, particularly birds, which he painted both in La Conner and Seattle.

Within the course of a few years La Conner had been changed by Graves and Anderson. The residents may have already been tolerant of eccentricity, but now they had a new respect, or interest, in art. "When I started coming here it was amazingly sophisticated for a small rural community. You could be yourself here (in the early 1960s). Normally you would have to go to a big city for that." All that sophistication and open-mindedness comes courtesy of one individual, Tom Robbins said, "due to the singular personality of Morris Graves."

In 1938 Anderson gained work with the WPA Federal Art Project and, with artist Vanessa Helder, went to teach at the Spokane Art Center. Directed by Carl Morris and with a faculty from across the nation, it was considered one of the best art centers in the country at that time. In 1940 Anderson returned to Seattle and remained there working with Tobey, Graves, and Callahan as well as George Tsutakawa and Margaret Tomkins.

Graves moved out of La Conner around the same time to a new location across the Swinomish channel on Fidalgo Island. He built his own home on "The Rock," a place yet more remote, perched on the top of a steep crag. Although Anderson returned to Seattle, he missed the quiet nature of La Conner and its residents, and eventually he would find his way back to La Conner, moving into a cabin in a pea patch belonging to a farming family named Jenson, for minimal rent. William Cumming later described Guy's connection to La Conner: "Guy's soul is stuck so deep in the La Conner mudflats that if he were to leave on a spaceship to settle on Mars, he would still have one foot rooted at least knee deep in La Conner mud."[4]

Local stories have it that in 1938 when Graves and Anderson departed the burned out home in La Conner, they left paintings and sketches scattered around the house and local children came inside and used the art work to make paper airplanes.[5]

The Campbell family next door bought the Parsons house and young Gary and his brother got to work cleaning it out. They rolled a large boulder out of the house that Graves had planted next to his bed. They scraped away the art work on the walls. Gary Campbell wasn't impressed with what he saw there. "I have no idea what that was supposed to represent," he laughed. For year after, as the place was renovated and housed the Campbell family, Graves' reputation grew. Curiosity seekers would often drive by the house and stop to stare, taking a picture of the single remaining piece of art created by Graves—a mural of a chalice.

Part II – 1940s

Remembering the Painter Richard Gilkey 1925-1997

There's war in a tube of Grumbacher
Ivory Black
lying under all that light,
blushing up as if it was natural,
some kind of poppy,
from under barn roofs,
the shadow side of every silent
blade of grass.
No mallards, no geese, no
trumpeters,
maybe a heron, stony or terrified,
as if a howitzer blast hit the ditch
a moment before and there's
a white deafening over it all.

—Georgia Johnson[1]

Chapter 4

WPA and World War II

The Works Progress Administration, part of the New Deal aimed at putting Americans to work, offered an opportunity to Northwest artists. It launched in 1935, and Graves began spending more time back in Seattle for a WPA project in 1936. For the project, he collected beeswax from a La Conner beehive and then laid a layer of the wax over his tempera paintings.

Under another Depression era arts program, Seattle's Kenneth Callahan found his way to Anacortes, 12 miles west of La Conner, where he painted a mural as part of the U.S. Treasury Department's Section of Painting and Sculpture, later called the Section of Fine Arts. The post office based project was one more nationwide effort to boost the morale of American citizens. Callahan's "Halibut Fisherman," in the Anacortes post office was one of three New Deal post office murals in Skagit County. (Years later another Skagit artist, Max Benjamin, was employed to repair and restore the mural. Eighty years after it was first created, the restored mural remained at the Anacortes post office on Commercial Street.)

In 1939 Graves was ready to explore the world further and headed for Puerto Rico, but not before buying a 20-acre piece of land overlooking Lake Campbell on Fidalgo Island for $40. The wooded lot near Anacortes, with soaring, panoramic views, would eventually become his retreat. He dubbed it "The Rock." Graves rented an apartment in San Juan that gazed across the street at the city's Catholic cathedral. From that location he studied the cathedral and painted a ritualistic series of paintings known as the purification series that reflected the state of mind he was adopting as the world was becoming more chaotic. The series suggested that peace could only be found from within.[2]

A year later Graves returned from Puerto Rico to his wooded property, a short drive from the home he had shared with Anderson in La Conner. He was ready to begin building a house there that

The Rock, photos by Thomas Skinner

would resemble an eagle's aerie, looking directly level at the Three Sisters Cascade peaks to the northeast.

Graves had been spending some of his Seattle free-time with Japanese artist and architect George Nakashima,[3] from whom he developed his belief that form evolved from the natural elements of the earth, such as stone or wood. He followed this philosophy as he designed his new home on the precipice of what he himself called "a discouragingly steep slope" on the top of the rocky hill. In fact, his home overlooked a breathtaking drop into a deep valley, hundreds of feet below. From his new home he could look down upon soaring birds, or gaze directly east at the Cascade peaks known as the Three Sisters.

He landscaped the mossy plateau behind his new home into a Japanese style garden that included sand and boulders. He lined the windows with rice paper that provided just enough light to outline the silhouette of the pines outside, a specter he painted as well.

Even at The Rock, Graves' retreat from Seattle was only partial, however. He was also working at the Seattle Art Museum for two-week intervals, doing tasks such as moving paintings, then spent two weeks painting at The Rock. The Fidalgo Island property was his muse for both painting and meditation, and here he undertook a new exploration—painting sounds, such as the surf and birds, following a Vedic concept that sound and form were one and the same. He often walked in the woods around his cabin late into the night and then set up his materials and painted until sunrise.

Fittingly, Graves was also still working on bird portraits, possibly inspired here in his panoramic aerie. This was where many of his bird paintings were completed, including his Maddened Bird Series and Inner Eye. Seattle artist Bill Cumming recalled visiting Morris at this time, climbing to the top of his peak on a rocky, narrow trail, to find Graves seated like a Maypole surrounded by his friends; Mark Tobey, Guy Anderson, Lubin Petric (a live-in partner of Graves's sister, Celia,) and Kenneth and Margaret Callahan.

While he was drawing attention for his work in Seattle, Graves often shunned art buyers and rejected large gallery shows, instead focusing on small art displays in the city. He showed intimate paintings, of birds and night fog, across the United States, interpreted as a symbolic statement about the expanding war in Europe and Asia

and the harm it was doing to humanity. His work often featured the Northwest light that served as such a mystical influence for him and many of his fellow artists. Graves studied the effects of the post sunset light that can linger as much as an hour in the Northwest summer, casting a moody golden glow on trees and walls, while the sky deepens from blue to a dusky gray.

Morris Graves, circa 1944

Even as Graves rejected public scrutiny, the Museum of Modern Art in New York City showed 30 of his paintings in 1942, which catapulted him into the national public eye. Unlike so much of the art in New York at the time, Graves' paintings possessed an eerie, dreamlike

quality evoked not only by the light but by a delicate paint stroke that suggested the fragility of birds or other small animals who returned the gaze of the New York art viewer with haunting expressions.

Graves' work and that of other artists evoked the tumult in Europe and Asia where vulnerable people were thrown into chaos and violence. Eventually they too would be summoned to be part of that action. Guy Anderson, in Spokane at the time, was drafted, and filed for conscientious objector status, which spared him from serving. Graves was not as fortunate. He was called to military service in 1942. He too had registered as a conscientious objector, but because he hadn't requested a written review of his application, the government disregarded his request. When he reported for duty with the U.S. Army, he was less than cooperative. First he refused to take the oath of allegiance to the U.S. military, then he walked away from the group of inductees as they waited to be transported to camp. Military police took him to the stockade but when he was released, instead of returning to active duty as required, he went to his mother's home in Edmonds.

At the time his friend and mentor, George Nakashima and wife Marian, were staying at Graves' mother's house, preparing for their own removal to a Japanese detention camp in Minidoka, Idaho. But Graves was collected before they were. The U.S. Army sent MPs to the house, who watched in shock as Graves embraced George and kissed Marian before they took him to Fort Lewis. He was subsequently questioned by the Army about his possible collaboration with the Japanese.

Graves was next shipped to Camp Roberts in California. While there he wrote letters home, including letters to his dog Edith, saying he missed the heavy rain on the roof and the blue luminosity over the Puget Sound at dusk.[4]

Graves' mother hired a lawyer to appeal Morris's case. In December 1942, he was delivered to a camp psychiatrist who determined that Graves would never adapt to military service and recommended that he be discharged. The Army sent him back to the stockade instead, and he expressed his protest by refusing to work and refusing to shave. Finally, he won in the battle of wills against the U.S. military. He earned a diagnosis that read "Individual philosophy and asocial religious convictions make M. Graves of no use to the Army."[5] In March

1943, he received an honorable discharge which he announced he rejected.

Not every artist admired his form of protest. Reportedly, Kenneth Callahan, too old to serve in the military himself, objected to Graves' behavior in the Army and was furious with his friend.

Once released from the military, Graves returned to the sanctuary of The Rock. The people of La Conner saw Graves less often than they had when he and Guy Anderson inhabited Mrs. Parsons' burned house on the hill. But he still came into town periodically sporting an unfashionably long beard, raising speculation about his motives. One rumor made its way through town that Graves was a German collaborator.

Sometimes Seattle artist William Cumming visited with Graves and Anderson, often accompanied by their friend Lubin Petric. At the time, he says, Graves "was in pursuit of God and making a full-time job out of it." Unlike Graves and many others of the "Northwest School" Cumming was working on figurative painting rather than the more abstract work of some of the others. "I do everything my own damn way," Cumming said. "People like it fine."

Another member of the artistic circle was a young war veteran from Skagit County—Richard Gilkey. Having just completed service in the military in Europe, Gilkey was attracted to the mystical style of the artists such as Anderson, Graves and Tobey who actively opposed the war.

Gilkey was born December 20, 1925, and spent the early part of his childhood in a logging camp in British Columbia until moving to March Point, near Anacortes. His paternal great-grandfather was among the first settlers in the Skagit Valley, building dikes in the town of Edison. Gilkey's maternal lineage was also rooted in Skagit—his grandfather had once served as bridge tender at the Swinomish Channel crossing. His parents were tug boat operators who moved him to Seattle as a teenager where he attended Ballard High School.

Gilkey didn't consider himself an artist as an early teenager, but when he moved to Ballard High School he studied art with a teacher who influenced him heavily—Orre Nobles. In 1941, the day the United States declared war on Japan, Richard Gilkey's elder brother Tom had enlisted in the Marine Corps. Richard decided his passion was with the war effort. As a 17-year-old high school junior,

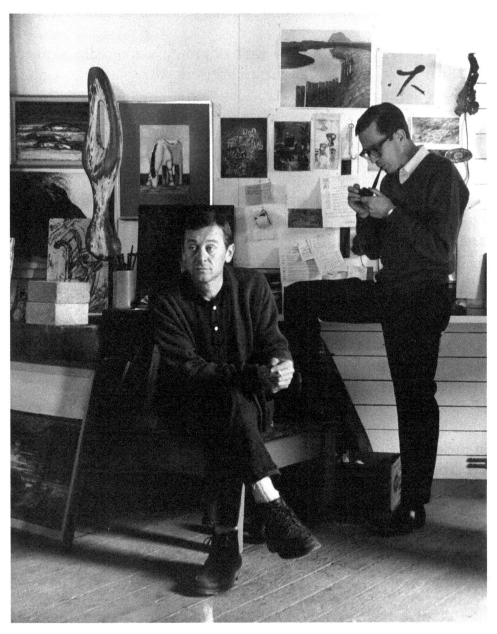

Richard Gilkey and musician Ray Tufts

he dropped out of school and joined up with his brother as a private first class in the 3rd Marine Raider Battalion. Soon Gilkey was thrown into heavy fighting in the Solomon Islands in the invasion of Bougainville. It was a bloody fight. Gilkey was one of the few members of his battalion to survive. He'd been knocked out twice by artillery fire, spent 10 months in the hospital, and earned a medical

discharge in August 1944.

Gilkey returned to Seattle a different person than the 17-year old high school student who'd been enthusiastic about the war effort. Many of his friends agreed that he was suffering from what today would be diagnosed as Post Traumatic Stress Disorder. As one form of distraction, he frequented Seattle's counterculture gathering place—the Blue Moon Tavern—in a University of Washington neighborhood, filled each evening with students, artists, and poets. He was a regular there, a hard drinker, with a reputation as a rabble rouser; quick to lose his temper and just as quick to throw a punch. He was also ready to question the concept of war, and he was newly interested in painting.

Richard Gilkey painted that which triggered an emotional response, he said. He studied the work of Braque, Picasso, and later Cezanne. He admired their work for being structural, rather than illustrative.[6]

Gilkey painted fearlessly—he enjoyed working with a palette knife the way others would wield a brush, slicing thick layers of paint on giant canvases.

During World War II another artist on another coast was expressing his own opposition to the war. Clayton James, a Midwesterner transplanted in New England, registered as a conscientious objector. James' mother, Neva Ann Sturgeon, was a poet; his father was a dyer for a silk thread mill. They moved to Connecticut when Clayton was a teenager and Clayton then attended the Rhode Island School of Design on a tuition scholarship where he worked in the cafeteria to pay living expenses. Stocky and strong willed, with startling blue eyes, Clayton James had begun painting landscapes in Provincetown, Massachusetts, when he met fellow artist Barbara Straker and soon they were romantically involved.

He had no religious reason to avoid the war; his opposition was more one of morality. "I just decided I wasn't going to war and the more they pushed the more stubborn I got," James said. He didn't consider himself a pacifist—he felt they presented a purer form of anti-war protest than his own—but in his case, "I felt 'Thou shalt not kill' and that's all there was to it." When James declared himself a conscientious objector, he was permitted to avoid military service, assigned instead to the Civilian Public Service (CPS) program. In

Seattle, as well as on the East Coast, refusing to go to war was a decidedly unpopular, even incomprehensible stance to many at the time. James was criticized and shunned in some cases by the community around him. "It was very difficult. I had the support of Barbara, alone."

Through the CPS, conscientious objectors could serve their country as civilians in a scattering of camps across the U.S. First James was assigned to a Quaker camp in Petersham, Massachusetts, where he cleared brush and dead trees scattered by a 1938 hurricane and dug water holes to fight forest fires.

His next assignment was in upstate New York, then another camp like it across the country in coastal Waldport, Oregon. He hitchhiked to the wooded camp known as Camp #56, and Barbara soon followed. Here his task was to reforest the coastal mountain range. The camp was populated by poets, artists and actors, and James found himself truly in his element. He and fellow residents founded an arts program that included staging poetry-readings, plays and painting exhibits.

It was Clayton and Barbara's first time to the West Coast, but they took naturally to the wet environment of the Northwest. They were married in Toledo, Oregon, in June 1944. Clayton was assigned to the kitchen, which provided him with free time to paint.

Clayton James was familiar with the work of Morris Graves—he had seen the Seattle mystic's paintings in the 1942 New York exhibit and the work had struck a chord with James. At that time he had visited Marian Willard's East River Gallery, which represented Graves, to investigate more about this artist and learned of his pacifist leanings and troubles in the military.

Knowing Graves lived in neighboring Washington State, Clayton James persuaded the camp's fine arts director, poet William Everson, to invite Graves to the camp as a guest artist. According to a friend of Graves, Dorothy Schumaker, when Graves received the letter inviting him to the camp, he was so excited he almost left immediately.

When Graves did arrive in camp, he did so with some shyness. He set himself up in a lean-to he built in the Oregon woods, days before the Jameses knew he was there. He sent Clayton a letter indicating he'd arrived. "Would like a few days to feel further toward the informing-essence of this coast country," he wrote. "I realize this (via

letter) is a very indirect way to communicate with you—I hope you will forgive me."[7] In fact, he had been in camp a week, painting in his new home, before Clayton and Barbara ran into him on the road. Clayton recalled he was walking on the side of a county road one day when a Model T Ford passed, then pulled to a stop just ahead of him. The tall, lanky Graves stepped out, and walked back to introduce himself, accompanied by two dogs. "That was the beginning of our relationship," Clayton James said.

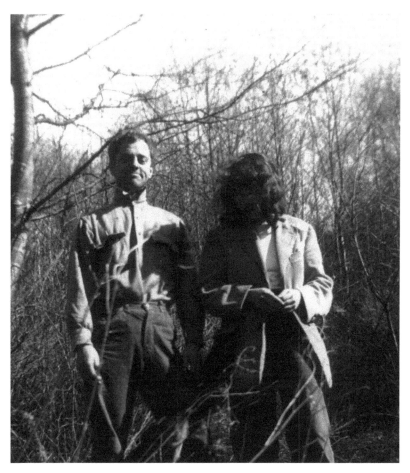

Clayton and Barbara at Waldport, Oregon

The artists shared a mutual admiration. "Morris had an air of glamour about him," James said. "He was my nature guru." James felt he had much to learn from Graves and recalls that Graves willingly shared both his artistic and spiritual knowledge. "He was very generous; he liked to have novices around him."

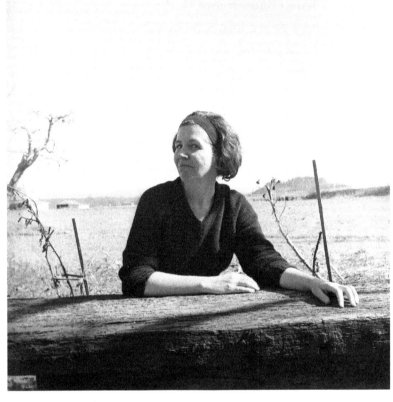

Barbara Straker James

Graves remained at the camp, to paint, for two months and participated in a small exhibition. One evening at a beach campfire, drinking tea from oriental cups, Graves, William Everson and Clayton James caught the attention of members of the Coast Guard who were patrolling the beach. They asked Graves, who claimed to be in charge, to produce his papers. He handed over his "psychiatric release documents" while offering them a cup of tea. The Coast Guard officer spent some time with the paperwork before opting to leave the men to their campfire and tea. The episode was tense enough that many speculated it was the reason Graves left the camp shortly thereafter.

In the spring of 1945, Graves invited the Jameses to join him in his home at The Rock on Fidalgo Island. It was Clayton's furlough, so the young couple headed north, hitchhiking up the coast, and catching rides on logging trucks.

Once there, James built himself and Barbara a lean-to similar to the one Graves had constructed in Oregon, and Clayton decided not to return to the camp. Instead he went to work for Graves, clearing brush for $7 a week. Clayton and Barbara stayed for several months in the summer with Graves at the Rock. "We had a good summer there," he said. They planted a garden and each got to work with their painting. Eventually Graves encouraged them to move on, so that he could return to his solitude. With few options, Clayton and Barbara made their way to the Oregon camp at the end of July. By this time, James was months late from his furlough and was arrested by the FBI, but released with a suspended sentence since the war was nearly over.

In the meantime, safely exempted from military service, Guy Anderson spent part of the war in Eastern Washington, employed by the WPA Federal Art Project teaching at the Spokane Art Center. In this position Anderson earned $100 a month. He stayed on for two years. He experimented with abstraction and cubism as well as metal collage, using rusted, flattened tin cans to represent disintegration. At the time his work was dominated with rusts, charcoal and umber, colors that would be central to his work most of his life.

Anderson then worked for some time at the Seattle Art Museum for Richard Fuller where he earned a subsistence pay. However, on one single day an art buyer purchased all of Anderson's paintings and, exalted, he subsequently quit his job, built a studio in Granite Falls where Ken and Margaret Callahan lived, and settled into his painting full time.

Anderson was developing his work with the human form, a subject that would be central for him throughout his life. He began using broad dark outlines for his figures as he explored human forms and landscapes—displaying the relationship between man and nature. He commonly painted reclining figures, sometimes in fragments, usually male, often floating above a landscape that resembled the expanse of field and water around the Skagit Valley. These figures are often interpreted as symbols of man's compression within society's restricted expectations, while hanging in midair as if awaiting their release from gravity.

He continued his study of the Northwest Indian carvers and admired the earth tones, the geometric forms and patterns of circles and squares that often defined Pacific Northwest Native American art.

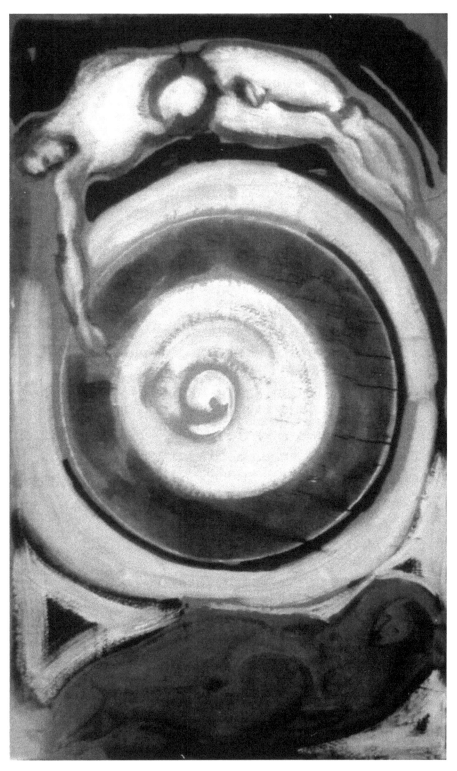

Guy Anderson, Reach

Anderson also began examining other icons and religious figures depicting Christian and Buddhist themes; both ancient civilization and mythical figures appeared in his work in a variety of abstractions. For Anderson, perhaps the most core universal symbol was the circle—representing at once womb and egg, the void and cosmos.[8]

Guy Anderson at work

And in the meantime, as the artists in their midst were posing philosophical and spiritual questions on canvas, most inhabitants of La Conner and the Skagit Valley were focused on adjusting to the changing economy that World War II was bringing. The young teenagers who had explored Graves' and Anderson's burnt home on the hill were growing up. Roberta, at the age of 18, married her high school boyfriend, Louie Nelson, the descendent of Swedish farmers tending fields in the valley. Like many other La Conner high school graduates, he made a living fishing and then later joined Roberta's brother Vernon in business, delivering fish to be sold in Seattle. Louie Nelson was known by everyone in town—and he could enjoy the company of fishermen and artists alike.

Sullivan Slough

A single butterfly bush
dancing in the wind
Old broken windshield truck

Rusted stovepipe pokes from boom shack roof
swimming willow trees, scuttling clouds
cedar stump hosts alder shoots

All the old river shacks
slowly settling
into Skagit silt

Shifting channels
moving clouds
A break from the rain.
Tide dropping, grass roots
Revealed

—Bob Rose[1]

Chapter 5

Objectors Find Community

With the war ended, Clayton and Barbara James were free to head north, setting up camp on the Hood Canal, before joining fellow artists in Seattle. They lived a transient life at first. Clayton took a job as a gardener at the Seattle Arboretum and grew a bushy beard. Their only major purchase was a Model A Ford that they drove up and down the coast or into the Olympic Mountains during free time, typically to paint.

They also reunited with their friend Morris Graves. At Graves' advice, they built themselves a more permanent home in Woodway Park, Edmonds, adjacent to Graves' home "Careladen" where he spent his time when he was not on The Rock. James collected scrap wood Graves had salvaged from an abandoned chicken coop on the property and constructed their new home, secure enough to keep the rain and cold out, but without the comforts of plumbing or power.

By this time the Jameses were accustomed to living off the land, eating a diet similar to that of the Pacific coastal Indian tribes. They picked mushrooms and berries in the forests, caught salmon and collected oysters in the Puget Sound. By all accounts, Barbara found ways to create gourmet meals out of what they scavenged and what they could afford, without the convenience of an electric stove, and they often entertained other artists in their small, hand-built home. To earn extra money, in addition to gardening, Clayton illustrated books of poetry for friends, wove rugs out of burlap bags, and made leather sandals. He sold his first pair to Richard Gilkey, but Gilkey reportedly complained that they were uncomfortable.

In the meantime, James was painting. Russian/French painter Wassily Kandinsky was leading the abstract expressionism movement, which was being adopted widely by American artists such as Arshile Gorky, Jackson Pollock and Willem de Kooning using non-geometric abstraction in painting and sculpture. James, however, was uninspired and frustrated by this movement. Instead, he experimented with other styles in which to express himself through Northwest landscapes.

Barbara, a minority as a woman artist, was drawn to abstracts and expressionist drawings, paintings and collages; however, she often yielded the artistic accolades to her husband, telling friends "one artist in the family is enough."

Early into the James's tenure in their Edmonds cabin, Graves introduced the couple to Guy Anderson who had returned to his mother's home, also in Edmonds. Anderson and the Jameses took to each other immediately, although the Jameses would soon be moving on. Graves had other ideas for the young conscientious objector and his wife. He urged Clayton to apply for an apprenticeship with woodworker George Nakashima in New Hope, Pennsylvania, where he could experiment with Asian art. And when Nakashima accepted him, Clayton and Barbara left the small cabin in Edmonds and spent a year and a half with Nakashima, before returning to the Northwest.

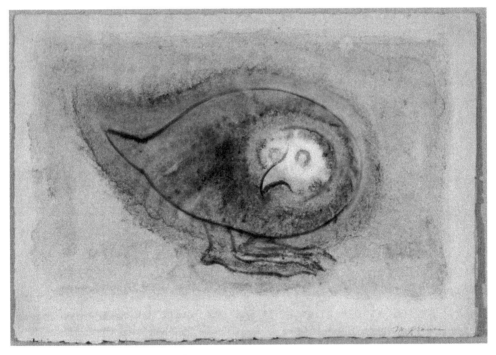

Morris Graves, Spirit Bird

By this time, Morris Graves had made a name for himself in the national art world, and he was looking beyond the Northwest for greater challenges. "Morris [Graves] was like a butterfly, flitting from place to place, always looking for the perfect environment," Barbara James later described. In 1949 Graves traveled to England, then

France, as a guest of British art collector Edward James, who had an affinity for surrealistic art. Graves settled down in Paris then and took up a study of architecture. He spent months painting and repainting the image of the gothic Chartres Cathedral in central France.

A year later, however, Graves returned to the Northwest in a dark mood. He told friends he was frustrated and dissatisfied with his work. In fact, he destroyed much of the art he had done in France. According to a letter that had been left behind in his La Conner home, he also asked friends to destroy the work he had done in that Skagit Valley retreat. He seemed to be a different person, transformed from his sensitive and philosophical former self to a brooding and short tempered character. And the man, who had not long ago shunned the public art world and commercialism, was now anxious to sell some art.

Although he was receiving recognition for his work in Seattle, and the prices he could fetch for each painting were rising, it wasn't as much as he felt he deserved. And he was impatient with Seattle art patrons and SAM's Richard Fuller for not buying as many paintings as he believed they should. To express his dissatisfaction, he made a likeness of Fuller in mud, and stomped on the image. He was later convinced and even gleeful that a stroke of bad luck that followed in Fuller's life resulted from Graves' act.[2]

One of Graves' odder stunts, however, took place in June 1954 and included a handful of artists who were connected to the Skagit Valley.

The prank was conceived when Richard Gilkey, Graves and a handful of other artists were finishing a roast turkey meal at Graves' Edmonds house, Careladen. The group included Ward Corley, an artist who lived for a time in a studio with Richard Gilkey in La Conner. He was known for abstract botanical paintings. The two not only had art in common, Corley, like Gilkey, had served in the Marines in World War II. (Corley's early death in 1962 would put an end to what was expected to be an impressive career in oil painting.) The group gathered around the turkey dinner commented on the artistic appeal of the finished meal—including the turkey carcass and spilled wine. They had been discussing the lack of respect they felt they were receiving for their work from the media, from art patrons and the Seattle Art Museum. They then spawned an idea. Graves sent

invitations to art patrons, journalists and other artists proclaiming "You are not invited" for a date ten days following. Graves and his friends then left the table as it was, complete with turkey bones, meat and side dishes, to await their arrival.

Recipients of the invitations took the statement, "You are not invited," to be typical Morris Graves' irony and arrived on time in appropriate art show attire. In the meantime, to add drama to the table's decaying effect, Gilkey installed a sprinkler above the unfinished meal to drip water on the half eaten food and spilled wine, and by the time the invitation recipients arrived, the table was a soggy, putrefied mess. To add a layer of insult, Graves had dug a trench in the driveway entrance, forcing the guests to walk a long distance in their fancy attire to reach the affair.

Graves told his brother Wallace Graves in a July letter that 50 to 60 people attended, although he added that most "had sufficient humor to stop at the gatehouse barrier."

Helmi Juvonen, who was among those "not invited," took one look at the table's sad condition and declared "How wonderful!" and sat down to sketch the spoiled meal.[3] She was alone in her delight, however; other guests left in outrage. A *Life* magazine photographer began snapping pictures but was sent away by Graves who had been watching the spectacle from behind a cinder-block wall.

Barbara and Clayton James were incensed. They had been listed among the other event hosts on the invitation, unbeknownst to them. Barbara, perhaps even more than Clayton, felt this prank was inexcusable. He'd created a farce for the entire Northwest art community, and the Jameses, who lived on the same property, wanted no part of it. Their relationship to Graves was never the same.

"Happy day—awful lot of work and a total and final rejection by C and B James,"[4] Graves told his brother.

Graves was increasingly baffling to others in the local art scene and was developing a reputation for his pranks. According to the recollections of Wesley Wehr, Graves once told Anderson that he was "51 percent put-on." It was up to Graves' companions to determine when they were faced with the real thing or the put-on version of their friend.[5] "Morris, obviously, is one of the great pioneers in shaking up the status quo," Wehr said.

Years later, when contractors got to work tearing out an interior

section in Graves' Edmonds home—after it had been sold—they were surprised to find a stuffed gorilla boarded inside a wall, waiting for them there, presumably entombed by Graves.

Whether or not his pranks were appreciated, the art world loved him. Graves had surprised many of his friends, including Guy Anderson, by the ease at which he abruptly shed the simple life of living off the land, including The Rock, for the glamorous jet-setting of the international social elite. It was a far cry from the burned out home he had inhabited less than 20 years before in an effort to seek solitude. Unlike the skeptical La Conner fishermen and farmers, the art world now seemed to fall at Graves' feet. For a time during the 1950s, Graves and his companion, Seattle singer and actor Richard Svare, lived in Ireland and were entertained by celebrities of the western world, such as the Rothschilds, the Duke and Duchess of Windsor, and movie director John Huston.

Guy Anderson's shack

Around the same time, the Jameses decided to move north to the Skagit Valley, where they already spent much of their free time. In 1953, in a Jeep station wagon, they brought their prized possession—a mattress—to La Conner. They found a home on Fourth Street, owned by local farmer Axel Jenson. The house and unheated outbuilding already had a history for housing artists—it had been previously rented by Richard Gilkey and Ward Corley. It was painted a ghastly yellow color at the time, small and unglamorous, but functional, recalled Jenson's daughter Sybil. Clayton and Barbara paid $50 a year for it, and James provided some major restoration to the place.

For Gilkey, the post World War II era was a time to freely explore art styles, and he drew inspiration from the environment and older artists around him. Since the end of the war, Anderson, Tobey and Graves had continued to encourage and inspire Gilkey. "They wanted to see my paintings," he told an *Anacortes American* reporter in 1991.[6] "But they didn't tell me what to paint." Instead of discussing technique, or the content of the art they were producing, "There was a lot of philosophy in our discussions."

Gilkey, who had never completed high school, now read voraciously about art, literature and music. He studied the cubists and tried a variety of styles until he found one that felt comfortable—at first with few sales but making slow inroads with local art buyers. When he needed money he found laboring work, whatever he needed to do to paint. Of all the artists, Gilkey may have been the most visible in quiet Skagit Valley. He often slogged into the fields with paints, easel and massive canvas to paint what he found there.

Still early in his career, Gilkey had several paintings included in the 1948 Northwest Annual Exhibition in Seattle, pushing his name into the limelight in the Northwest. Like Graves, Gilkey by this time was focused on wildlife and generated a series of paintings created with a palette knife including "Young Bird" depicting a baby robin; the painting is now part of SAM's permanent collection.[7]

In the meantime, the Jameses were not the only ones relocating to La Conner. In 1953 Guy Anderson, who had left the Skagit Valley village 15 years earlier as an obscure and impoverished artist, had become one of Seattle's recognized painters, and was now ready to return. While Anderson had gained some acclaim in Seattle, it was not to the degree of Graves, and unlike his old friend, he wanted to

retreat from the city and the distraction of the art patrons and even other artists. Anderson was well into his 30s, and fed up with Seattle life. "I felt like I've got to go away or I'm going to go to pieces," he recalled.[8]

One conversation with Mark Tobey at the time made an indelible impression on him. Once you find fame and success, Tobey warned, your time and your art are never quite your own again. Anderson feared such a fate could be in his future and he longed for solitude.

The Jensons, Jameses and Anderson

Anderson found his new home in a vacant structure on a field–side piece of property owned by Axel Jenson, landlord of the Jameses', who was related to the Dunlap Towing family that still today runs tug boats up and down the Swinomish Channel past the center of La Conner. The small cabin had been a storage shack, then was used for temporary housing for farm hands.

Once Anderson settled in, he didn't restrict himself to the Jenson property cabin. For one thing, he had earned a painting commission for several large pieces for the Seattle Opera. Because the cabin wasn't big enough to accommodate the large works he was creating,

he rented space above the brick-sided Planter Hotel on First Street.

Anderson was continuing to depict his floating figures, and he employed the brushwork of Asian calligraphy and the colors and hues of Northwest Coastal Indian art. He often painted in oils—on paper, wood, plywood and any other material he could find. He befriended Roberta's young husband, Louie Nelson—who now ran a lumber yard—and shared scraps of wood with him, which Anderson took back to his cabin to create pieces of art. So as Graves had moved away from the earthier part of his artistic youth, Anderson made a career out of it. In general, Anderson's favorite material was the plain brown paper used by builders with a reinforced webbing. He commonly laid the paper on the floor and painted there where he had the space to create his largest works.[9]

During World War II, Anderson had also experimented with sculptures out of driftwood which he scavenged off beaches. One buyer of much of his work at that time was Francis Wright, sister of architect Frank Lloyd Wright, as she passed through Seattle.[10] Anderson also used smooth stones he found on the beach to make patios for Anne Gould Hauberg (art collector and architect of Seattle) and gallery owner Zoë Dusanne. Sybil Jenson recalled spotting strange vehicles in the driveway, such as a Rolls Royce that had ushered Hauberg to Anderson's shack for a visit.

By living across the channel from the Swinomish Reservation, Anderson also drew from the Indian culture for artistic inspiration. The Swinomish—who participated in ceremonies, danced and carved—were gaining their own inspiration directly from the tradition and spirituality, through meditation or prayer, receiving their vision and putting that inspiration into their work, a practice that appealed to Anderson and Tobey as well as Seattle's Helmi Juvonen. Juvonen was known for her exploration of Native American traditions in various parts of the state. She was periodically incarcerated at a mental ward at Harborview Hospital. Based on anecdotal descriptions of her mental state at the time, she had episodes in which she seemed exalted, talking rapidly, until she was redirected with questions.[11] When she was able to quiet her mind, she gained some respite visiting friends at the Yakima Indian reservation. She camped with them in teepees and painted the dance ceremonies. Despite her mental conditions, her art work had striking clarity.

Guy Anderson at home

Tobey came to visit Anderson in La Conner, although he felt out of place in the small town and never liked being so far from the city. He left La Conner once late in the night in a panic after discovering that his room at the Hotel Planter had no lock on the door. He was not to be appeased by Anderson who suggested that if he was fearful at night he could push some furniture against the door to keep intruders out.

Ultimately, Anderson had to drive him to Coupeville—the closest hotel he could find with a locking door.

La Conner native Roberta Nelson recalled occasionally seeing Tobey with Anderson, carrying a trumpet which he was known to play. Despite Tobey's general dislike and mistrust of rural life, he had an interest in the town and its ability to inspire artists. "I remember Tobey many years ago standing down at the north end of First Street and saying he felt strongly that La Conner, with its mix of cultures should be an art center, a place for a good art school, we all used to talk about that," Guy Anderson told a reporter at the *Skagit Valley Herald* in 1988.[12]

The fact that both Anderson and the Jameses arrived in La Conner about the same time was largely a coincidence, according to Clayton James. "I didn't even know Guy had moved to La Conner," he said. "I was walking down the dike one day and I heard him singing and recognized his voice."

To the townspeople, artists living subsistent existences among them were no longer much of a shock, and Anderson got along well with his neighbors and landlords, the Jensons.

The cabin itself soon smelled of turpentine and paint. Sprays of dried flowers stood in rusted coffee cans, or were tacked to the wall in delicate arrangements. Anderson's Mexican chair, with its rounded leather back was often pulled close to the fire, but facing his artwork where Anderson could sit and ponder his latest efforts, one paint brush never leaving his hand. The homemade wood stove provided enough heat to make the shack comfortable on cool wet days, but typically Anderson dressed in layers—a shirt, sweater and jacket—when the temperature dropped. He also constructed a front porch area with an outdoor wood stove so that he and his visitors could sit outside under a shingle roof on a rainy day and stay warm. An artist who would later move to La Conner in the 1970s, Ralph Aeschliman, visited Anderson with friends such as painter Wesley Wehr and he recalled that Anderson designed a smooth transition from the outdoor world to his enclosed abode. As visitors neared his home, pots with ornaments such a dried flowers or plants led the way to his front door. "It left an ambiguous transition zone from outdoor to indoor. It was as if the house extended itself out," he recalled.

The Jensons watched with some admiration as Anderson built a

rock garden with a fireplace with stones and other natural constructing material. They became frequent members of the parties the artist threw there. These functions typically included not only local farmers and fishermen but other artists and Anderson's admirers from Seattle.

There seemed to be no one Anderson wouldn't converse with, and he spoke as enthusiastically about the condition of the fields or the weather as he did the art world, philosophy or music. He may have been reading Proust in his cabin (he once expressed exhaustion to the Jensons after spending an afternoon pondering one of Proust's sentences), but he enjoyed the farmers and fishermen just as much, and could just as easily slip into talk of their trades. As a result, the locals welcomed him as one of their own, inviting him for meals at their homes or driving him to the nearest art supply store.

"My parents were just thrilled to go down to Guy's," Sybil Jenson said, although inside the shack there was little room for a large group. Guy also did some of his work, especially sculptural work, in Jenson's neighboring old woodshed, and many of those sculptures ended up decorating the Jensons' home.

Fellow artist and friend Wesley Wehr recalled a time when he was visiting Anderson in La Conner. "We were having dinner and nice fishermen would come by and pleasant neighbors. Guy looked at me and he said, 'Well, you may be a little surprised at some of the friendships I have up here and might kind of be thinking to yourself, well, 'how come?' but Wes, let me tell you I like these people. I have nice times with them, nice friendships. It's the people in Seattle that invade my center. These people up here, they don't invade the part of me that paints, the part of me that needs to be left alone. It's those people in the art world in Seattle. I had to get out of Seattle because they go for your center'."[13]

Sybil recalls not only a friendship that developed between her farming parents and the charming painter, but also the relationship her parents developed with Barbara and Clayton James, their tenants, who were both by that time in their mid 30s.

Axel Jenson gave Clayton James a job driving the pea truck on the farm delivering peas to the viners. Another truck then took the shelled peas to the cannery where 15 years before Graves had been employed with processing. La Conner was a booming town, filled with temporary labor, during canning season.

"Between the fish cannery and pea cannery, half the people of La Conner in the summer worked there," Jenson said.

And despite their cultural differences, Barbara James was very close to Axel's wife, Susan. They spent holidays together, visited each other's homes, and talked late into the evenings. This new friendship brought out a whole new side to the otherwise conservative Jensons.

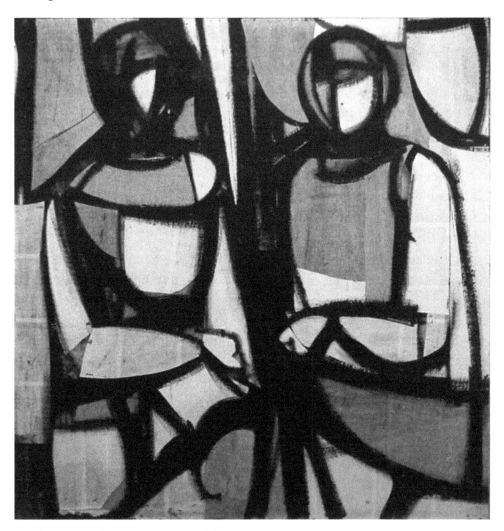

Barbara Straker James, Double Image

They bought some of Anderson's work as well as that of the Jameses' and hung it in their living rooms. "It was good for my father, he'd never been around people like that," Sybil recalled. It may have been inconsistent with his conservative hard-working upbringing, but he liked them and they liked him. "The artists considered [Axel] an artist

himself because he was a very good farmer. He respected the land and understood it. I think they appreciated that; there was a certain mutual appreciation between all of them." Not only did the artists take their inspiration from the fields, water and mountains around them, they appreciated the farming architecture and the way they blended into the landscape. Sybil Jenson recalled when Axel Jenson hand-split the shingles for the barns, they were delighted; when he painted the barns red, they were not. James and Anderson were outraged, "That was a no-no because they wanted them unpainted."

Anderson spent considerable time on the low tide beaches of the Swinomish Channel combing through driftwood and gathering enough material for sculptures that for a time he gave up painting. This became part of what he would call the "found object" assemblage which he would exhibit several times including his 1947 show in Seattle that drew the attention of Francis Wright.

Anderson was thoroughly enjoying his life of selective obscurity among the farmers and seemed quite capable of living quite comfortably without electricity or plumbing. That was all about to change however, thanks to an article published in the popular *Life* magazine. The 1953 edition printed a story on painting in the Pacific Northwest, titled "Mystic Painters of the Northwest: they translate reality into symbolic and distinctive art." The piece, by Dorothy Seiderling, began, "a remarkable art of simmering lines and symbolic forms has been coming out of the northwest corner of the U.S. stirring up storms of irritation and enthusiasm in the galleries of New York, London and the Continent. Produced by a variety of artists living around Seattle, the paintings range in style from realistic to nonobjective. Yet they have one characteristic in common, they embody a mystical feeling toward life and the universe. This mystical approach stems partly from the artists' awareness of the overwhelming forces of nature which surround them, partly from the influence of the Orient whose cultures have seeped into the communities that line the U.S. Pacific Coast. The painters of Seattle have merged these influences creating an art that without being a limited 'regional art' is distinctive of the Northwest."

The story singled out four artists who would, for decades, be referred to as the "Big Four": Kenneth Callahan, Mark Tobey, Morris Graves and Guy Anderson. Morris Graves was pictured in the story

"Contemplating Light" according to the picture's subtitle.

Following that publication, the four would become, at some level, the darlings of the Northwest arts for years. All four gained from the national attention. Graves, who said he didn't like the publicity, or having his picture taken, was more amused than impressed by the attention. Following the story he was known to sign letters to his friends "Northwest Mistic."[14] Graves went to Japan in the fall of 1954 to collect rice paper and paste for future part work. In the meantime, he was preparing for the move to Ireland. His close friends Dorothy Schumacher and Richard Svare moved with him to County Cork, Ireland, where they bought and restored Woodtown Manor, a stone house built in 1750 on a 35-acre country estate near Dublin. He would not return to La Conner aside from brief visits until 1964. Graves was now, at least in the art world, a celebrity.

The magazine article would have a far reaching effect not only on the artists but on La Conner. An 18-year old college student at Richmond Professional Institute, in Virginia, Tom Robbins, who would go on to become acclaimed in his own right as a best-selling novelist, remembers reading that issue of the magazine. He found the mystic, Zen-like image of these Northwest artists intriguing. "At that time there were rumors about Morris Graves, that he lived in a hollow tree," Robbins said. Almost a decade later, when he finally moved to the Northwest, attracted to that mystic image, "I found out Morris absolutely adored luxury. There were all kinds of rumors about Morris Graves that turned out to be false." But in 1954, Robbins said, Seattle seemed as far away as Alaska or the Fiji islands.

Part III – 1950s and 1960s

The Hole and the Cosmos
For Philip McCracken

 I have taken down
A piece
Of the night sky,
Just for the night.

At Mole's suggestion
I've put it by the window
Where it looks glorious
Against the mountains.

Some say moles are blind,
But it's just that they love
To look at things far away,
 Like stars.

Sometimes when I step out
To look at the night sky
I have to ask mole
What's what, where's where?

And mole, as if he were
A poor country fellow
Naming wildflowers,
Lists off the constellations:

Southern Cross, Flying Fox,
Bernice's Hair, Winged Horse,
Great Dog, Water Bearer,
Painter's Easel, Chained Maiden.

Mole's deep voice,
Sunk like the roots of a tree,
Steady, reassuring –
You just know he's right.

—Tony Curtis[1]

Philip McCracken, Mole Greeting the Sun

Chapter 6

Arts Meet Crafts at Quaker Cove

One of the most striking figures to visit the Skagit Valley artists came regularly from Seattle in a Mercedes. Betty Bowen, of Mount Vernon—who had been introduced to the arts by teenage Bill Bailey when he escorted her through Morris Graves' home in La Conner in the 1930s—grew up to be assistant director of the Seattle Art Museum. Bowen was a civic activist on behalf of the arts and historic preservation and an indefatigable promoter of Northwest artists. Bowen grew up as Betty Cornelius, then married Captain John Bowen, who captained an AT&T vessel that lay underwater cables.

She graduated from Mount Vernon High School in 1936 and studied journalism at the University of Washington. She had a knack for writing, as well as a charismatic personality, and she used these skills as a publicist for Trader Vic's and a Seattle hotel, and then broadcasted on a short segment on KING TV in the early 1950s. But she was best known for the knowledgeable way she wrote about the Northwest arts. Richard Fuller, of the Seattle Art Museum, hired Bowen to publicize the museum, then promoted her to assistant director. Bowen served in that role until Fuller retired in 1973.

The beautiful and magnetic Bowen made regular visits to the artists in her childhood home, the Skagit Valley. Many of them depended on her marketing skills and wealthy friends to bolster their livelihood. So when she drove north from Seattle in an expensive car, breezed into a gathering or artist's home glamorously dressed, with a cigarette dangling from a long cigarette holder, there was likely a sale in the works.

"Betty Bowen was, at times, a force of nature," wrote Emmett Watson for the *Seattle Post Intelligencer*. "She would cajole, berate, encourage and on those occasions when she confronted blatant hypocrisy and self-serving deviousness, her formidable wit could slash like a straight edge razor."[2]

Christopher Barnes, Bowen's niece, remembered Bowen more intimately than most. Bowen's sister Harriet Tjernagel, Christopher's

mother and owner of the Wide World Shop in Mount Vernon, raised Christopher in the Skagit Valley and their family gave Bowen a reason to make visits. Harriet summered in a cottage not far from Quaker Cove, a beach on Fidalgo Island that would soon become another attraction for artists. Aunt Betty visited the young family there, always bringing brilliant flare, Barnes recalled. "She would come into a room and everything stopped." Betty had little patience for children, but she had an ample supply of charisma and "really I thought she was quite beautiful," Barnes said.

Betty Bowen portrait with Gilkey painting

Bowen was a fairy godmother to starving artists. With her innate love of the arts and a passion for connecting poor painters or sculptors with her wealthy friends, she helped launch many artists and writers. The lengthy list of recipients of her efforts included Anderson, Graves and Gilkey.

Betty's sister Harriet had a more direct interest in the arts. Two years younger than her flamboyant sister, Harriet loved to paint. Growing up with health problems, she had been protected as a child and spent much quiet time with pencil or brush in hand. Betty Bowen's friendships did, however, help Harriet as well. Bowen introduced her sister to Mark Tobey who would be an instructor and mentor to Harriet.

"At a time when it was fashionable to buy Monet reproductions, Betty got people with money to buy living artists," Barnes said. (Two days before Bowen's death at age 58 of a brain tumor, Mayor Wes Uhlman named her First Citizen of Seattle and proclaimed Valentine's Day in her honor.)

Bowen, as well as Anderson, James and Gilkey, gave many creative spirits reasons to travel north to the quiet Skagit Valley's open skies and diffusely lit fields. More artists, who had graduated the University of Washington, Cornish College of Arts, or elsewhere around the country, were in search of a reclusive place to work or low priced inspiration. In 1955, sculptor Philip McCracken, a native of Anacortes, returned to the Skagit Valley area from New York.

McCracken was a good friend of Morris Graves whom he had met in Seattle. McCracken attended U.W. as a pre-law student before serving in the army during the Korean War. He then completed his BA with a degree in sculpture. Renowned British abstract sculptor Henry Moore accepted McCracken as a student and was a strong influence on the young artist. On his way to the elder British sculptor, McCracken met his future wife, Anne McFetridge.

Until this time, McCracken had been exposed to the more isolated and introspective artists of the Northwest, like Graves, and was pleased to discover that Moore was able to be both artist and family man, filling his days with artistic pursuit, and his evenings with friends, family and leisure. That example strongly influenced McCracken at a time when he was considering combining a life of art and family. In fact, Moore served as best man at Anne and Philip's wedding. They settled in New York, but McCracken missed the

dramatic skies, forests and sea of the Northwest. The young couple came to Guemes Island and have remained there since.

Guemes Island is accessible only by boat or a public ferry that crosses from Anacortes. The McCracken's raised three sons on this somewhat isolated island about 16 miles northwest of La Conner and 10 miles north of The Rock. The family was sustained largely on fresh caught fish and vegetables from a plentiful garden on the property. Anne taught English at the Anacortes Public Schools.

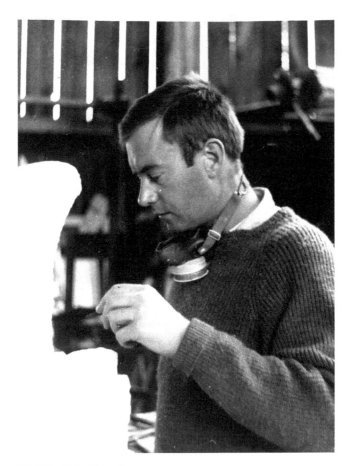

Philip McCracken

In the meantime, McCracken created a studio for his sculptural work in an unheated barn. He developed an interest in the birds of the region, including those that made their prey the chickens he raised on his property. It led to pieces such as "War Bird," featuring a hawk carved out of cedar, and "Armored Bird," which also served as a comment on the destructive nature of war.[3]

McCracken won the Washington Governor's Art Award in 1964 for his sculpture work, and many of his pieces have been exhibited at the Smithsonian Institution and the Chicago Art Institute. McCracken moved among the early "Northwest School" artists of Seattle and the Skagit Valley. A decade younger than Graves and Anderson, he maintained a friendship with both, as well as Mark Tobey. Graves influenced McCracken's own sensitivity toward nature and wildlife. When it came to Anderson, McCracken says, "He was very likeable—I was interested in Guy Anderson's ideas and admired the strength of his work."

However, one of McCracken's greatest influences was University of Washington ceramist Paul Bonifas. From Bonifas, he said, he came to understand his own integrity—something both McCracken and Bonifas exhibited in their art and in their lifestyle.

McCracken walked in two worlds. He came to Guemes to do his work by retreating into the nature he had grown up in, but he sold his work around the world and was a common presence in the New York art scene. His creative influences spanned the U.S. coasts—he was as familiar with the likes of Andy Warhol as the Northwest mystics.

Another painter Max Benjamin moved to Guemes Island from Seattle in 1959 to devote his full energy to art. Benjamin, born in San Diego, California, in 1928, also attended the University of Washington, and studied with Walter F. Isaacs. He spent four military service years in Europe, and while there acquired a life-long respect for European culture, food and wine as well as art. Upon return to the Seattle area, he married his wife Thresa and took a job as an illustrator for Boeing. The couple began raising three children together in what could have been a fairly typical middle-class life. But by this time Benjamin was making a name for himself as a painter in the Seattle area.

While at the U.W. he had developed friendships with Northwest artists and he furthered those relationships as a professional painter. He worked with the Artists Equity Association—an artists' union where he acquainted himself with many fellow painters and sculptors. Those included Guy Anderson, Richard Gilkey, Morris Graves and Mark Tobey. However, the artist who made the greatest impression was Tobey, whom he would meet in the University District; the two painters often took the bus together from school. "Tobey had a

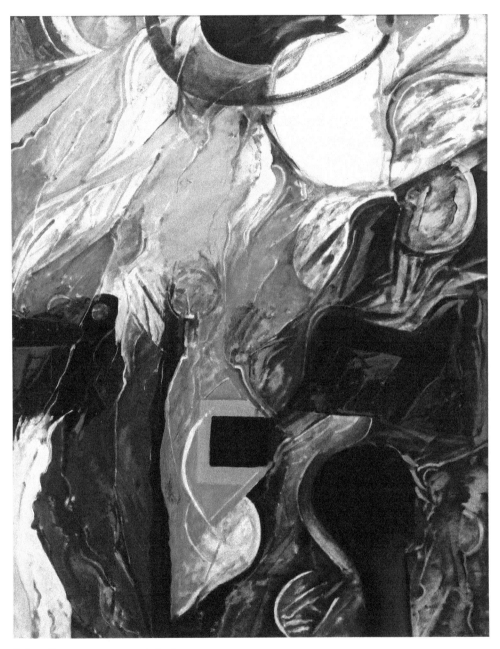

Max Benjamin, untitled

big vision of things artistically, personally and spatially," he recalled.

Benjamin's move to Guemes Island coincided with his decision to devote his full energy to art. "I reached a point where I had to decide what I was going to do." He wanted to paint, so he and Thresa bought a cabin on this remote island which he knew of in part because of a friendship with Philip McCracken who was also living there at the time (he and McCracken had shared a basement studio in the U.W. art building while in school). The old cabin Benjamin bought was built in 1870 at the end of a half mile road.

The cabin later included beef livestock. Once living in the Skagit Valley, Benjamin recalled stopping in on Guy Anderson in the shack on Jenson's property to talk about art and art history. Their friendship spanned several of Anderson's households. At one time Benjamin recalled helping the elder Anderson move a piano from his winter apartment above what had been the Planter Hotel. (As Benjamin struggled under the weight of the piano, Anderson stood at the top of the stairs and admonished, "Be careful, don't let that piano get away.")

Both Benjamin's early and later work suggests the European style of early 20th century painters more than the mystic Northwest School. He has painted landscapes and abstract paintings featuring a unique balance between foreground and background using powerful imagery. His earliest landscape work on Guemes evolved over time. "My work became more and more abstract and I've reached a point now where I believe all paintings are fundamentally abstract." He has been influenced, he said, by his own inner reactions to the water, weather and nature of the Northwest environment. He always worked with oil, with which, he said, he could build layers and washes of color to create translucence and a depth and intensity artists couldn't get from acrylic.

At the same time there was another set of artists altogether who were relocating to the Skagit Valley to attend a summer school that would bring artists as well as craftsmen from all over the country. What would become the Fidalgo Summer School of Allied Art began simply at Quaker Cove, a rustic Quaker community of cabins near Anacortes. The retreat offered meeting rooms and lodging surrounded by the drama of forested hills overlooking the Skagit Bay on southern Fidalgo Island. Watt Fallis, a purchasing agent for Kenmore Trucks, and a Quaker, had purchased the property years before. He

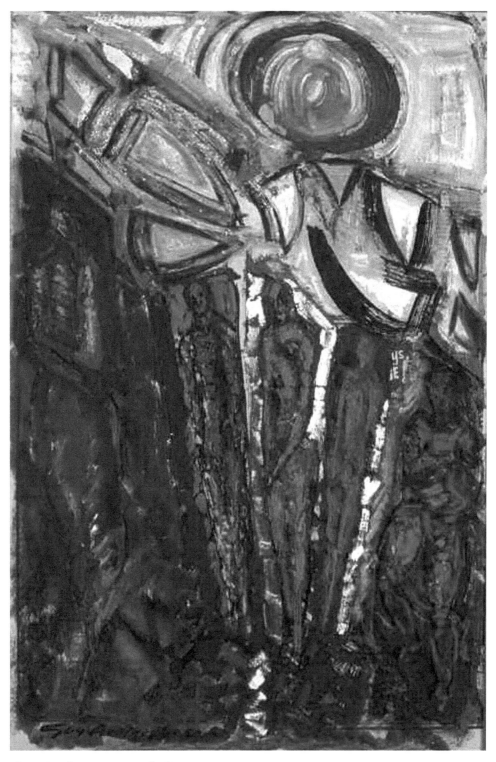

Guy Anderson, untitled

had noticed, said Watt's son Richard (Dick) Fallis, that the Quakers, spread throughout Western Washington, lacked a common meeting area and Quaker Cove could prove to be that. However, the camp was rarely used and eventually Watt Fallis put a 'for rent' sign in front of the camp.

Ruth Penington was a University of Washington art instructor, a woman who challenged the definition of fine arts; she had a gift for delicate silversmithing and metal jewelry craftwork, but was passionate about art in all its forms. Born in 1905, Penington (who died in 1998), was an instructor at the college's School of Art from 1927 to 1970, and head of the Metals Department toward the end of her career.

Ruth Penington

She also was a founding member of Northwest Designer Craftsmen and Friends of Crafts in Seattle. She believed in teaching through experience. "You learn art from art," she said in a Smithsonian Art Archives interview in 1983. "You've got to see it, you've got to be with it, you've got to be a part of it. This is the advantage of a school, or you can go to a museum and study or be in a community where art is going on all the time."

She drove by the "for rent" sign on Fidalgo Island one day, down the road from Morris Graves' home, The Rock, and called Watt Fallis. The resulting rental contract established the first art school in Skagit County, run by Penington. The school would operate in the summer with painters, potters and metal craftsmen, culminating in a large art show at the end of the session.

Dick Fallis got wind of the coming school from his father and wasn't happy about it. A recent veteran of the Navy, he was enjoying the solitude the old Quaker retreat provided; he had built himself a cabin there and had the run of the place. Now he would be homeless. Considering his options, he decided if artists were descending on the camp for the summer, he would get out ahead of them.

However the day Fallis intended to leave, potters and ceramists Jim and Nan McKinnell, with their toddler daughter Katie in tow and a potter's wheel in the back of a truck, arrived just ahead of his departure. As Fallis made his way out of the woods with his clothing and scant household equipment in hand, he came upon McKinnell hefting the assemblage for a loose brick gas-fire kiln, potters wheel, clay, glaze and sundry pottery equipment out of a red Chevrolet truck.[4]

"You want to lend me a hand?" McKinnell asked. Fallis agreed and they started a conversation as he helped the potter unload. Jim and Nan McKinnell were renowned for their pottery skills and had established their own pottery school in Montana. Penington had invited them to spend the summer teaching at her new school. The pottery material was intriguing enough, Fallis said that, "I was hooked."

Initially Fallis decided to help by gathering and chopping wood for the school to heat the lodge and meeting area. In exchange, Penington provided him free pottery courses from the McKinnells. The classes went well. "Jim liked me, he wanted me to come back to his home in Helena, Montana," Fallis said. Fallis, who would later take the reins of the La Conner newspaper, the *Puget Sound Mail*, however, considered himself more of a writer than an artist or a craftsman.

During that six week period the McKinnells were joined by Clayton James, Nan McKinnell recalled, "and he was quite fascinated with everything," she said.[5] James readily agreed that the pottery work being done by the McKinnells was a source of fascination as well as inspiration. He gave the McKinnells, especially Nan, the credit for helping germinate what would become a decades-long interest in pottery.

Nan McKinnell later recalled the camp as beautiful, as well as dangerous and just plain damp. Often the potters used heat lamps to dry the pots—frustratingly damp from the humid environment—enough that they could fire them. In the meantime their small daughter had

Dick Fallis

an interest in the colorful jellyfish washed onto the rocks below the camp. "Katie was fascinated—so I had to tie her with a rope to keep her from going down there and investigating," Nan said.

Vera Helte Strong, a Swedish-born weaver from Seattle, brought her family to La Conner for her summer teaching stints at the

Penington School in the late 50s and early 60s. Her eldest son, Peter Strong, recalled taking children's classes from the local artists during those summer programs. Free time was spent playing jacks or other games on First Street, La Conner, only rarely being interrupted by the occasional motorist.

Christopher Barnes, daughter of Harriet Tjernagel, was also taking children's classes. In the meantime, Tjernagel studied painting under Guy Anderson.

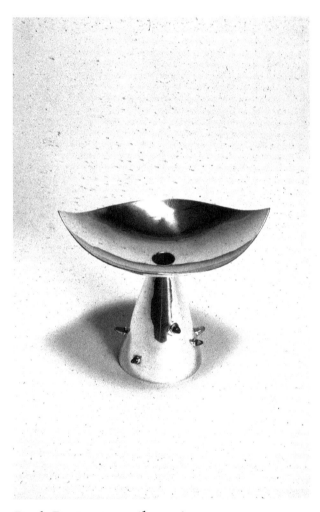

Ruth Penington, silver piece

When Peter was old enough, Guy Anderson, another Penington instructor, hired the boy to haul wood to his pea shack. At times Anderson traded his work for other arts or crafts, and at least once he traded a painting for a blanket woven by Helte Strong.

The school included a handful of cabins for students and faculty, a few bathrooms and a dining area for three meals cooked on the camp grounds. At the end of the summer term the artists put on a public show of their work, whether paintings, sculpture, pottery or jewelry. *Sunset* magazine, covering the news and features of the Western U.S., learned of the event and sent a photographer, Art Hupy of Seattle.

Clayton James in Studio

Hupy, with artistic leanings of his own, had probably never seen anything quite like this wooded artists' camp before. He got to work at what he did, photographing what he found, and at one point Dick Fallis was his subject.

"I was trying to make this little pot," Fallis recalled. "This photographer from *Sunset* magazine came over and started photographing me as I cut out the heel of the pot using a kick wheel." It was difficult, delicate work, he recalled, "I sure didn't want to make any mistakes. I was very proud of it. I wished this guy with the camera would go away." Eventually under the pressure of the camera, he sliced through the bottom of the pot.

Although it was a successful summer from the standpoint of productivity, Ruth Penington had not been happy with the accommodations. Fallis did all he could to keep her comfortable in the school, he said, but the rustic condition of the cabins, the cold damp evenings and minimal sanitation facilities had taken their toll on Penington, faculty and students. She began looking in the neighboring towns for a new home for her school.

She settled on a ramshackle building downtown on La Conner's First Street, with two stories—it provided space for class work on the lower level and accommodations for some of the visitors above. For the coming years, artists migrated each summer to the La Conner area, renting houses, cabins and rooms around the valley, with many selling their work at the end of the session at Woodside Gallery in Seattle.

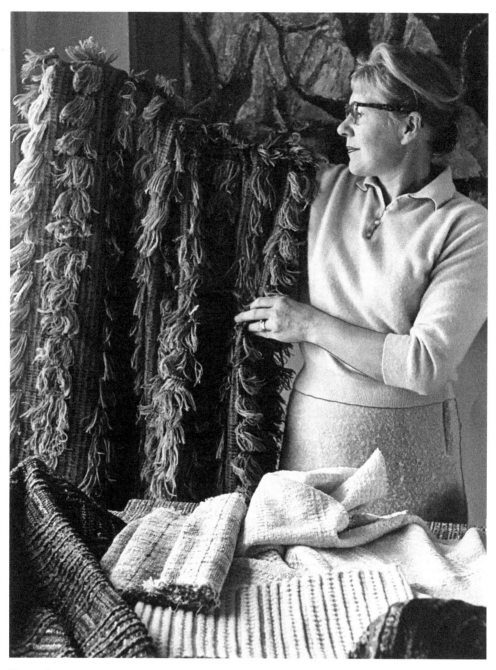

Vera Strong

Coming home from the Club
That place of red stools
and round tables.
Of darting words,
mean and sweet scrutinies.
I stopped under
The great iron bridge
And saw these spring flowers –
Not fleurs de mal
Though painted black,
But deep garnet
With flashing whites
As the eyes
Of a wild bull at moonrise.

—Guy Anderson in description of flowers at the Rainbow
Bridge after leaving the La Conner Tavern

Chapter 7

Blend of Arts and Farming

In the 1950s, Skagit Valley farmers started branching into new agricultural territory. While oats, peas, cabbage and potatoes dominated in the 40s, a non-edible crop brought by the valley's Dutch immigrants was making inroads—flowers. Tulips, along with their delicate yellow cousins the daffodils, liked the wet rich soil and cool conditions. A side benefit for farmers was the tourism. A field of tulips transformed the overcast springs on the flatlands of La Conner and Mount Vernon into a breathtaking shock of color. People couldn't help but stop to take a look.

That was just plain good business for the valley's towns. A handful of farming families, such as DeGoede and Roozengaarde, made tulips part agriculture, part tourist attraction and very big business.

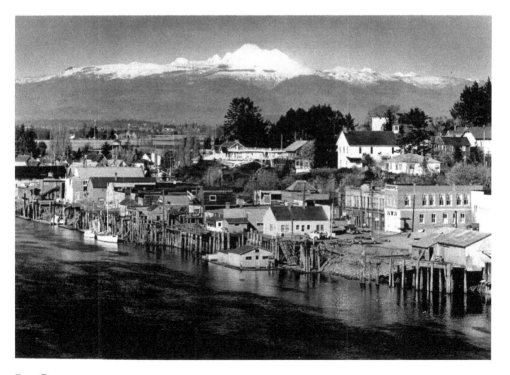

La Conner

Amongst the fishermen and farmers, the Skagit Valley also had a home grown artist who got little acclaim from the mystic Seattle painters and sculptors. Laurie Wells, born in 1898 (he lived to the age of 96), created hundreds of paintings depicting the Skagit Valley, but enjoyed little of the celebrity status of Graves, Anderson, Gilkey or James. He pursued art that was pleasing to the eye and highlighted the best of the landscapes around him. He never studied art formally, and was a stranger to the Northwest art scene. But Wells was a true Skagit Valley man, descended from one of the first homesteading families on McLean Road, the connecting thoroughfare between Mount Vernon and La Conner.

Wells painted ducks, wildlife, whatever he found at his own backdoor, using historic photos as his subject. And he had little preference for a single medium—he painted in oils, water colors and acrylics. He was not only a prolific painter but was as practical as the Skagit families he had grown up around. He once boasted that during the Depression he was able to eat for a year on $50.

One of Wells' greatest loves was flowers. As a self-made horticulturist, he met with the La Conner garden club in the early 1950s. The group held a flower show each fall and he proposed designing artwork for a tulip festival. As a result, springs in La Conner were punctuated with an extravagant weekend of flowers aimed at gardeners first, then tourists. For the festivals, Wells splashed colorful images of Mount Baker, forests and flowers on 40 foot murals that would hang in the high school gym. Not to be outdone, the garden club planted flowers amidst a carpet of moss they brought to La Conner by the truckload from neighboring Rockport. The garden club constructed archways and water falls, creating a setting like a mini Holland inside the La Conner High School gym. The entire grandiose affair dazzled the locals and visitors for two days before it was taken down. This ritual, which soon became known locally as "the tulip festival," went on into the late 1950s before the garden club began to lose steam. Years later the festival would be revisited by organizers in Mount Vernon and eventually transformed into the festival that draws thousands of tourists to the valley every year today.

At one time Wells' work could be found all over the valley, with murals decorating the interior of Seven Cedars ballroom, which later burned down, as well as the brick façade of La Conner's local

paper—*The Puget Sound Mail.*

Farming in the Skagit Valley had always brought a degree of transience to the community and field workers flowed in and out of the region as strawberries ripened or daffodils budded. The arts comingled in that space, as well, among the people who harvested the fruits of the valley's soil. One prolific artist of the Skagit Valley focused on the beauty of the fields and especially the workers laboring there. Jesus Guillén was a Mexican-American artist who came to this Northwest community from Texas in 1960 and stayed the rest of his life.

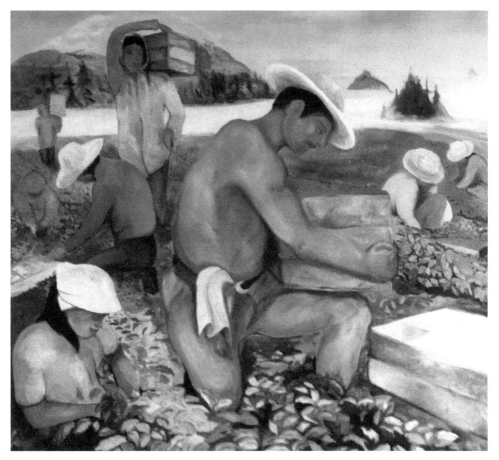

Jesus Guillen, untitled

Guillén was born in Coleman, Texas, in 1926 and exhibited an early gift for the arts. He was entirely self-educated: he taught himself to read and write in both Spanish and English, and learned to paint and draw in his free time when not working in farm fields. His artistic talent may have passed down from his paternal grandparents,

both Tarascan indigenous people known for pottery skills. He began playing with clay early in life, as well as drawing and painting on paper sacks, while employing the natural dyes he made from the earth and plants.

Jesus Guillen

Guillén married Maria "Anita" in 1950 and began a family in rural Texas where both made their living as migrant workers. In 1960, Guillén travelled to the Skagit Valley to pick strawberries on a farm owned by Jim Hulbert Jr. Guillén saw the lush green fields, towering foothills and mountains, the Skagit River spilling into the churning Puget Sound and decided he was home. He brought Anita and five children from Mexico to live in the Hulbert migrant labor camp and served as field supervisor during the busy farming seasons, then

bought a home in La Conner. And he painted.

His work was inspired most by several of Mexico's most prominent painters—José Clemente Orozco and Diego Rivera. The subjects of his work included the fruits that he picked in the fields or grew in the garden he and Anita tended together. His still lifes found beauty in the seemingly ordinary—on multiple pieces he captured both grace and magnificence in the humble squash. His eye for beauty found elegance even in a migrant labor camp. His children remember a graceful Japanese style rock and bamboo garden he created in the back of the farm labor cabin they lived in, to serve as a quiet reflection space for the family.

But his most iconic paintings focused on the workers. They shone a light on those who were often otherwise overlooked as they brought local fruits and vegetables to harvest. His colors and figures showed a richness, peace, and sensitivity, said Anita, "to be admired by those who have eyes to see and a mind to understand the will and perseverance of the farm worker. His legacy is one of dedication to one's culture, work ethic, family and art."

Almost as soon as he arrived, he caught the attention of the local artists. Clayton James and Guy Anderson visited him at the migrant camp and at his new La Conner home which he renovated and expanded over several years. He transformed an old shed into an artist's studio which his family left untouched after he last walked out of it in 1995.

Guillén's children recalled the visits of La Conner's elder artists, especially those visits when James who would join Guillén in his art studio, where the two were not to be disturbed as they listened to music, smoked and talked about political movements and their impact on art, music, poetry, as well as carrying on unending debates about what is and isn't art.

Anita (and her three eldest daughters), didn't initially love the valley the way Jesus did. The scarcity of Spanish speakers (she didn't speak or read English at the time) made communication and friendships impossible, the rain seemed incessant and the days, gray.

She soon conquered both problems—she taught herself English, befriended people like Barbara Straker James, and learned to love the rain. Like her husband, she saw beauty in the work being done on the strawberry field.

Guillén faced some prejudice and discriminatory treatment in La Conner. He challenged the community with art from an entirely different culture. However, Clayton James and Guy Anderson proved to be lifelong friends, as much influenced by him as he was by them. Both Anita and Jesus spent time with the Swinomish people as well. Jesus Guillén saw beauty in the tribe's totem pole and canoe carvings. The carvers, as well as Guillén, Anderson and James, found they shared an artistic pursuit of expression based on the mysteries presented by the environment around them. "We humans must communicate our spiritual feelings, a commitment to beauty, our previous heritage and the honorable values we hold," Guillén said in an Artist's Statement in 1993. Guillén's art was most fully recognized by the art community at large in the latter years of his life.

While agriculture was thriving in La Conner, the business area was nearly silent. The city center along the channel had more boarded up buildings than open ones.

Guy Anderson, Between Night and Morning

Guy Anderson was fully enjoying the undisturbed life he lived on the Swinomish Channel, while his reputation in Seattle continued to grow. Glen Turner, a young poet teaching writing courses at Skagit Valley College was introduced to Anderson in the early 1960s shortly after moving to Mount Vernon, and the two became fast friends. Anderson soon introduced Turner to Clayton and Barbara James.

Turner and his wife Ellie spent so much time with their new friends in La Conner they moved there, to a small house near what is today known as "the Hole in the Wall." The house sat at the Delta of the Skagit River with access to a sandbar the Turners could explore and share with their new friends. Soon they were entertaining, inviting Anderson, the Jameses and other artists to barbecue on the beach. It was at one of these barbecues where Turner recalled Guy found a large piece of driftwood along the craggy shore. Anderson was planning submission of a piece of art for the 1962 Seattle World's Fair, and he proclaimed the driftwood would be his contribution. Turner doesn't recall if Anderson made any modifications to the driftwood before he submitted it. The power of his name alone had become enough to sell the piece for a good amount of money. Guy may have lived an austere life in the Skagit Valley, but his name carried considerable weight in Seattle.

Anderson could count on the locals for both privacy and social events free from the pressures of art patrons and dealers. They also provided him with rides. Although Anderson had driven across country with Morris Graves in his 20s, he had long since given up driving and preferred to have someone else behind the wheel. Roberta and Louie Nelson as well as Glen Turner shuttled Anderson to the paint store in Mount Vernon—Carl's. They also took him to art openings in Seattle.

The Turners delivered Anderson to a Mark Tobey show there once. "I bought a small Tobey, and Guy had to convince Otto [Selig] I was good for the credit," Turner said. "It was fun to go to an art show with him," Turner recalled. "Once you got to know him you could tell by the tone of his voice what he thought of a piece of art." For example, at times, "He would look at it and say 'Very interesting' which meant it was a piece of crap."

Skagit Valley residents were developing an eye for art. Anderson had, by this time, sold much of his work to the locals—the farmers and the fishermen as well as the growing number of new artists migrating to the area from Seattle or other cities. Turner remembers one incident that may have illustrated Anderson's view of the Seattle art scene. On that day, when Turner was visiting Anderson at his pea patch shack, an art patron from Seattle came to visit. When she asked pointed questions about his work, he grew uncharacteristically gruff

and pointed out to the woman that she had yet to buy any of his paintings. Turner recalled she eyed the largest one on his wall, and asked for the price. "It isn't for sale," Anderson retorted. He pointed to Turner who had already bought several of Anderson's paintings, on installment plans. Turner, on a teacher's salary, couldn't afford more than $50 payments and that was what Anderson accepted. These locals, Anderson said, were his patrons.

Louie Nelson

Anderson's work, in the meantime, was evolving with a lifelong theme—the roiling man floating through the universe. Often that floating figure was painted on building or roofing paper he obtained from the Nelson lumber company or from roofers. Roberta Nelson was now a middle-aged mother of two, and along with her husband Louie, had become a close friend to Anderson. Like Turner, they too sat in Anderson's yard or shack sipping drinks and talking about any

number of subjects. Anderson often celebrated Christmas or other holidays at the Nelson family house.

A small group that included Guy Anderson, Barbara and Clayton James and Richard Gilkey also formed a life drawing class. Each time they met they would appoint a model, and the others would sketch or paint him or her. Turner also served as regular model for the group.

While Anderson was doing some of his best work during this era, painting with oil on two-ply construction paper, he seemed to turn his back on opportunities for national acclaim. He had no interest in becoming, what he called the "international big bananas."[1] The material he worked with was hard to preserve and in some cases paintings couldn't be displayed because they were too large to fit through gallery doors. He was offered several solo exhibits in New York, one by the director of the Museum of Modern Art in 1952, but he declined due to, he said, not enough available artwork to submit.[2]

Guy Anderson, Fishing Boat, Evening

In 1958 Richard Gilkey won a Guggenheim Fellowship which funded a trip to Europe. While in Barcelona, Spain, he decided to visit his icon, Pablo Picasso. On that day he was wearing an American-Indian sweater, and planned to make it a gift. "I went straight to Picasso's gate and was admitted. I gave him the Indian sweater, which he pulled on in mad glee!" Gilkey reported in a letter to Morris Graves and Graves' companion Richard Svare. He added that the famed artist "insisted that I show him my paintings and came to my car and helped me get into my suitcase and looked very long at everything that I showed him. He loved the chair paintings and tried to give me an old Spanish chair he said I must paint! (It was beautiful, but wouldn't go in my car—I tried!)"[3]

Richard Gilkey, untitled

Shortly after the 1962 World's Fair, Guy Anderson's art sales allowed him to buy a former liquor store in the center of the two-block commercial length of First Street in La Conner. He created a studio that accommodated his larger works in the front, with a room in the back to serve as living quarters, and a garden behind it for entertaining. He was now residing in comparative luxury with power and running water. Just as he had at the pea shack, Anderson would cook chicken on his grill, serve Bombay gin and Schweppes bitter lemon with a twist of lime, and dole out punch to any kids who came along.

Anderson wasn't the only one entertaining. The 60s were ushering cultural changes to the sensible Skagit Valley, with a growing stream of artists coming to town. Some came on a sort of pilgrimage to meet Anderson, and some were moving into empty spaces on farms, above stores and aging barns, many as seasonal instructors and students of Ruth Penington's summer school.

La Conner, with its new artistic sensibilities, soon drew the attention of young art critic Tom Robbins. Virginia-born Robbins

graduated from the Richmond Professional Institute, a school of art, drama and music where he took mostly theory classes. After discovering Northwest artists through Life magazine's Big Four article in 1953, his interest in the Northwest never quite faded.

Tom Robbins in La Conner Home

In 1962, Robbins enrolled in the masters program at the school of Far East Studies at the University of Washington. He drove his Plymouth Valiant into Seattle on a Friday afternoon in June, with $100 in his pocket. He put down $85 for an apartment, and Monday morning found his way to the *Seattle Times* to apply for a temporary job as assistant features editor. The art critic for the Art and Entertainment section, Ann Todd, had recently quit and the editor

was interviewing replacements. Robbins watched the parade of applicants come and go from the arts editor's office and came to the conclusion that the Seattle artist community would never advance or even be properly recognized if any of these people got the job. Robbins had written some essays about art in college and he showed the editor his work. "I walked over to the desk one day and said 'look at these, would you consider me?' He hired me that day." He went to work at the newspaper on Tuesday morning when he was down to his last $10.

Robbins promptly ended his academic pursuit and began a very different journey. He may have worried about finances, but he said, "The World's Fair was my ace in the hole. I figured if all else fails I can always sell cotton candy at the World's Fair."

Instead he took the Seattle art world by storm dubbing himself the newspaper's "Art Cricket."

"I stirred things up alright. They had been used to very gentle criticism, not anything real at all."

Robbins column caught the singular attention of SAM publicist and art patron Betty Bowen, and one afternoon she picked him up for a whirlwind tour of the artists in the Northwest. He recalled her wearing a flowing scarf that day, smoking with a cigarette holder and driving an expensive little sports car which zipped them around Seattle. "She was quite a flamboyant character." She spent three days introducing Robbins to Seattle's best artists, as well as touring the basement stacks of the art museum. When she was finished with this three day crash course on Northwest art she told him, "When you get a chance, go up to La Conner, a little town north of here on stilts."

Robbins stored this piece of advice away for future consumption. In the meantime, he met Seattle painter Doris Thomas in his capacity as art critic, while writing a column on women artists of the Northwest. The two took to each other immediately. "He was one of the most brilliant people I'd ever met," she recalled. In 1962 Ruth Penington, invited Thomas to La Conner for the summer to teach at the Fidalgo Summer School of Allied Arts.

Thomas had been to La Conner before, with a high school art teacher, to see Penington's school. Thomas, who had studied at the Frye Art Museum and the University of Washington Art School, was also an accomplished violinist but she chose against a career with

the Seattle Symphony to pursue painting. She experimented with landscapes in pastel, ink wash and watercolors, although her work expanded to abstracts and surrealism. By the early 60s she had developed a reputation for her art in Seattle and sold her paintings in galleries such as Woodside/Braseth Gallery and Zoe Dusanne Gallery.

Doris Thomas

Joe Petta, her husband, inspired by German collage artist Kurt Schwitters, employed a distinctive collage technique for much of his work. He taught children's art at the school as well.

"I loved it up here. I felt right at home," Thomas said. One of the attractions for her was the unique plant life growing in the area, and she would go on expeditions collecting unusual botanical specimens such as avalanche lilies or orchids around the islands.

The La Conner greenhouse apartment Joe and Doris rented from the Hedlin farming family was small—only one room—not large enough for their artwork, so they rented other store fronts or apartment areas downtown. Rent was next to nothing.

Keith Wyman

In the fall of 1962 Joe met La Conner local Keith Wyman, which would set off a chain of events that brought art critic Tom Robbins to the Skagit Valley. The Wyman family had moved to a home on Dodge Valley Road in La Conner when Keith Jr. was in fifth grade, probably about 1955, he recalled. His parents—Maxine a nurse, and Keith Sr. a fisherman— quickly made themselves at home and were known for their boisterous parties which attracted people from around the valley.

Keith Jr. graduated from La Conner High School in 1962 and took a summer job a year later for the Department of Fisheries counting dead, pink salmon along the banks of the Skagit River. The job required that he and a partner, Joe Petta, hack the tails off bodies (they presumably had completed the spawning cycle) and throw them up into the woods away from the bank to ensure they weren't counted twice. That year the pink fish were having the biggest run on record, and counting the dead was grueling, foul-smelling work, Wyman recalled.

However, Petta and Wyman became fast friends. Wyman recalled that Petta, about a decade older, had a sharp wit and an expansive view of the world; he was not only a painter, but also well-read and could talk about a wide variety of subjects. At some point that year, Wyman brought Petta to meet his parents. Keith Wyman Sr., and Maxine promptly invited Petta and his wife, Doris Thomas, to join them for a party, and then more parties, frequently featuring fresh-caught salmon, when in season, at the center of the meal. "It was always an excuse to have a party if you could barbeque a salmon," Wyman said.

The senior Wymans also found Petta a good conversationalist and

enjoyed hearing about his interests, the arts and the Penington school as well. As the couple got to know Petta and Thomas, they also began inviting other artists to their parties.

In 1963 Tom Robbins, accompanied by Seattle newspaper cartoonist Ray Collins, came to La Conner for the first time, to interview Doris Thomas and Joe Petta. "I had to have an excuse to come up here," he recalled.

Keith Wyman, Jr., came to Thomas and Petta's home at the Hedlin farming family's greenhouse the summer day Tom Robbins and Ray Collins were visiting, to invite Thomas and Petta to a party at his parents' house. When he met Robbins and Collins, Wyman invited them to come along.

At the time of the invitation, "We had nothing better to do," Robbins said. It was a Saturday, so he and Ray Collins joined festivities at the Wyman home on Dodge Valley Road (later they would move into La Conner). They found cars were parked up and down the road as far as the eye could see.

The Wyman party was unlike any function Robbins had seen before. "I walked in and saw this long table laden with every kind of food: wild duck, pigeon, huge baked salmon, and vegetables I had never seen before growing up in Virginia: artichokes and avocados. I was just blown away." It wasn't just the food that was overwhelming: the Wymans had set a large plastic bird bath on the floor into which each guest poured their contribution of bottled libation. Party-goers used coffee cups to scoop out drinks of the brew throughout the night. There were other delivery methods for this punch as well. Since Maxine was a nurse she had access to IV tubes which were placed in the vat, and party goers could lie on the floor and let the concoction drip into their mouths, Robbins recalled. Strains of Spanish guitar played from the speakers.

Keith Wyman

As Robbins was absorbing this new experience he ran until a handsome, nattily dressed, middle-aged man with a recognizable face. He remembered Guy Anderson at once from the *Life* magazine article published ten year before. And Anderson already was quite familiar with Robbins as the upstart writing the "Art Cricket" column.

Betty Bowen

Robbins and Anderson took to each other at once. Robbins recalled Anderson as warm, friendly, and a true gentleman. A friendship began.

That same first night at the Wyman's party Robbins threw himself into an interpretive Malaguena dance, fell over the TV, and had to be helped upstairs by Maxine, the nurse. She got him to bed and

woke him in the morning to join them on a wild mushroom hunting excursion.

After that event, Robbins couldn't stay away from La Conner for long. He started visiting almost every weekend, at first with the objective to interview artists, eventually just for the fun of it. "By this time hedonism had taken over," Robbins said. Keith and Maxine Wyman became like surrogate parents to the young writer. "We had a long and loving bond," he said. He also spent a great deal of time with Anderson.

The following year—1964 to 1967 or so—La Conner seemed to be in a non-stop party, Wyman recalled. There was perhaps a partying mood across the country at that time, but La Conner had a distinct attraction, with the Penington Art School in full swing, attracting artists from Seattle and the East Coast, and the Skagit Valley rich with good food that was easily accessible. People could stroll down the beach to collect clams, fish were still plentiful in the river, wild black berries and mushrooms grew fat and healthy in the forest.

"It was such a peculiar time, not only for La Conner but every place in the country, early to mid sixties there was a screwy war, the hippie thing then started happening and it was like the beat scene multiplied to a mushroom cloud," said Robbins.

Thomas and Petta stayed in La Conner until 1965. They moved back to Seattle at that time, but divorced in 1967, at which time Thomas returned with her two children. Again she lived in the Hedlins' greenhouse apartment.

Sculptor Phillip Levine came to the Penington School in 1965 from Seattle. He was serving as teacher's assistant for polychrome stoneware sculpture at the University of Washington when Ruth Penington decided Levine would be a good teacher. He taught at the Fidalgo Summer School of Arts in 1965 and 1966, first instructing pottery, then bronze casting.

Levine was married with three young children at the time. He and his family occupied an apartment above the school itself. The first year he taught for four weeks, the second—two weeks. While there Levine met Guy Anderson. Both were friends of Joe Petta's. Often Levine had lunch or tea at Anderson's house or later shared dinner at the Lighthouse. He got to know the other local artists such as Philip McCracken, Clayton James and Ray Jenson who taught at

the Cornish School of Arts. One of Levine's recollections was offering to trade one of his sculptures for a boat, and Glen Turner of Skagit Valley College took him up on that trade.

"It was easy to become part of the community." When it came to Anderson, he said, "He was something of a father figure for me. Just knowing Guy made me feel I could base my own processional standards on him. By working with Guy, by being part of that art scene," Levine said, "I had a feeling of being part of history."

Anderson also taught painting at Penington's school. Betty Bowen's sister Harriet brought Christopher to the art school first at Quaker Cove, then at the Penington Building in La Conner where the small girl would wait in the car while her mother took painting lessons from Anderson. She first met the renowned painter when she was about nine, she recalled, and he offered to sketch a picture of her. Her mother had already subjected her to the boring, and time consuming task of modeling, so she rejected Anderson's offer.

Christopher regretted that choice for years afterwards. Throughout her childhood, her recollection of the artist was of a true gentleman. When she met Anderson strolling in La Conner, he would smile and tip his hat. "He was a gentle soul," she said.

La Conner's native, Roberta Nelson, who had met Graves and Anderson so many years before, also took art classes at the Penington school. "The whole Northwest School of art fascinated her, and she always encouraged people to pursue the arts," her granddaughter Jessica Brady said. Farmer Anton Swanson took a painting class from Doris Thomas. "He had a wonderful eye," she recalled.

Amidst all the summer arts and parties, Robbins was settling into what would be his lifetime community. When he first arrived, La Conner struck him as amazingly sophisticated for a small town, based on its tolerance of eccentricity. "You could be yourself to the fullest extent of yourself. Normally you would have to go to a big city for that," Robbins said. This was a town where the operatic voice of Anderson, now set up in an art studio on Main Street, could be heard down First Street as he painted. Shoppers browsing for books in the store next door often heard him singing through the walls as he worked as well. Writers Jack Kerouac and Gary Snyder were said to each have stopped to take a curious look at the community.

Robbins moved to La Conner in 1970 into what is one of the

oldest occupied houses in La Conner, built in 1873. It had a colorful life to that point, as a church parsonage and a preschool led by Mrs. Cling, locally dubbed, according to Robbins, as "Mrs. Cling Cling's Ding Dong School." At the time he bought it, the house was succumbing to the aggressive growth of blackberry bushes. It was a risky move to leave the Seattle area and the employment it offered. There was no coincidence in the date of his permanent arrival, he said. "I do everything on April 1st so if it doesn't work I can say 'just joking'."

He had already been writing since the age of five, but now was working on his first novel. By this time, he said, "I was pretty much shaped aesthetically by many years of reading theoretical physics, books on Zen and Daoism," as well as by his experimentation in LSD. La Conner offered a great atmosphere to work on his writing. "Obviously I wrote about this area."

Robbins brought his own brand of iconic humor to his writing, and to his community, that suited the town well. Some townspeople reveled in the fact that they inspired his first novel *Another Roadside Attraction*.

In neighboring Mount Vernon, the Skagit Valley College was attracting students to an art program that had begun 10 years before by another renowned artist and close friend of the Big Four and other Seattle artists. Sydney K. Eaton founded the Skagit Valley Community College art department. Born in 1919 in Sedro Woolley, Eaton had been away from the valley for most of his adult life. He earned his Bachelor's degree at Whitworth College, Spokane, in 1942, which was where he met his wife, Harriet.

He was deferred from WWII services but reported to San Diego for the U.S. Navy and was shipped to the South Pacific, serving three and a half years. After the war ended, Eaton taught high school art in Chehalis and painted after school and on weekends. He held one man shows throughout the state. Instructors at Whitworth encouraged him to go for his Master's degree.

He left Chehalis in 1959 and came to the Skagit Valley. He had plenty of artist friends in this Northwest community; he was a close friend of Phil McCracken's, as well as of Guy Anderson and Kenneth Callahan. He shared the spotlight with Anderson in a two man Seattle show in 1958, and showed regularly at the Seattle Art Museum which bought one of his paintings.

Part IV – 1970s

Mystic Sons of Morris Graves
Seattle Lodge No. 93 Theme Song

(Sung to the tune of The Beverly Hillbillies)

Come and listen to our story
About a man name Morris,
An artist who flung ink
On papers that were porous.
He lived in the woods
On a lake that looked Chinese,
And every time the moon came up
He dropped to his knees

(Big gnarly ones, they looked like a couple of Redwood burls).

Well, one night when he was gazing
At the stars overhead,
He slipped into a trance
And thought that he was dead.
He saw a twinkling Buddha
In a shiny Cadillac,
And when he came to he said,
"I like it like that."

(It was the Diamond Vehicle. Perfect consciousness, none of
that 2 percent stuff)

So ever since that night
When Morris saw that Buddha,
He's been living like a yogi
And eating lots of gouda.
He's got a little garden
That he's stocked full of chives,
And he never has to worry now
About breaking out in hives.

(Hey, y'all come back real soon now).

—Charlie Krafft

Chapter 8

Founding an Artists Colony at Fishtown

By the end of the 1960s, a new generation of artists was descending upon Skagit Valley. The hippies, like the artists of the previous generation, discovered the valley as a low cost source of creativity-inspiring quiet. Many came as students or instructors at the Penington art school; some knew of Guy Anderson and his slough-side shack; and by 1971 some were seeking out Tom Robbins, whose first novel had been released.

As in the 1930s when Anderson and Morris Graves first arrived, the bountiful Skagit River delta and Puget Sound offered clams, oysters and crab, while berries grew wild, and the fields were abundant with food that starving artists were known to "borrow" without much complaint from the farmers.

This latest wave of artists was led by the ambitions of a single-minded teenager named Charlie Krafft. In 1965 Krafft graduated high school in Seattle at the age of 16 and promptly fled to San Francisco to pursue the life of a poet. UC Berkeley was hosting a West Coast Poetry Conference at the time. Krafft stayed with friends there for one summer, then returned to Seattle in the fall. His parents had new plans for their poet son—to attend Skagit Valley College.

Krafft, now 17, was unenthusiastic about studying at a small-town community college in Northwest Washington. Reluctantly, he made the move; however instead of moving into campus housing, as his parents expected, he found a caretaker's cabin at an abandoned farm just short of a mile away. When he first came upon the property he tracked down the owner, a widow living near the school. She rented him the cabin for what he recalled as a paltry sum. He walked or hitchhiked into school each day. For his first session he signed up for Writing 101 taught by Glen Turner.

Typically Turner assigned a preliminary essay to gauge his new students' writing skills. When Turner read what Krafft had written, he recalled, "I did something I had never done before—I gave him an A and said he didn't need to return to class." He added that though

he'd "never laid eyes on the guy," he knew this student had talent. Krafft, however, never missed a class. In fact, he and Turner became friends, and Turner, together with his wife Ellie, began including the teenage writer in their social circles.

Guy Anderson, Moonrise and Skagit Storm

Turner and other SVCC professors took Krafft under their collective wing. They invited him to poetry readings in Seattle, took him out to dinner, and introduced him to other writers and artists. By this

time Turner was living in La Conner and spent much of his free time with Anderson and the Jameses.

Krafft was already well aware of Guy Anderson and his reputation in the art world, in large part from stories told to him by his parents and their friends Mildred and Prescott Oaks from Edmunds, who knew Anderson and Graves. Krafft had also grown up within walking distance of the Seattle Art Museum and spent hours there as a boy perusing the art. He was especially drawn to the Asian silk screens and the Eastern-influenced, mystical work of the Big Four.

One evening Glen and Ellie Turner brought young Krafft with them to dinner at La Conner's Lighthouse restaurant overlooking the Swinomish Channel. They found Anderson there sipping a drink in the bar and Turner invited him to come join them. It was an important evening for Krafft. Over dinner he had his first chance to speak with a professional artist of some acclaim. "I remember I was impressed that 'I am in the presence of Guy Anderson'," he said. He was not as impressed, however, that Anderson ordered drinks for the group but insisted on a non-alcoholic drink for Krafft. But Turner shared his own drinks with Krafft that night and at the end of the evening Anderson accompanied them on the ride back to Krafft's home, where he was deposited him at the unpowered caretaker's cabin on the abandoned farm near campus.

At the age of 18 Krafft returned to San Francisco's Mission District with his girlfriend, Diane Barton from Oak Harbor. They were both employed briefly by filmmaker Scott Bartlett to run an automated psychedelic light show Bartlett had designed for a short-lived music club called The Rock Garden.

When they returned to the Northwest, Krafft and Barton moved into a houseboat in La Conner, then to a farm on the end of Dodge Valley Road where they were employed as au pairs for Skagit Valley College physics professor Robert Green and his wife, Jackie.

At the same time, Krafft was evolving from poet to artist, in part due to his conversations with Guy Anderson, and watching the painter at work. "Of course I respected Guy Anderson. He was a role model." Then there was the practical side; he believed he could make more money, and make it faster, with painting than with poetry. Krafft was not the only artist to be influenced by Anderson either. "If Guy Anderson went to Nelson Lumber Company and picked up

buckskin-colored floor enamel, everyone needed buckskin floors. If he put pinecones on the wall, everyone else did it too."

Graves, who had already left the valley several decades before, still influenced the artists of La Conner, especially Krafft. Krafft was attracted to the rapt attention Graves paid to each detail in his artwork, while Anderson, he said, was more like an artist who would dance with his brush.

Morris Graves

So while Anderson was an inspiration, Krafft said, Morris Graves was the one who influenced his style. "I had to decide whether I would be an Anderson or Graves guy," he said, and he leaned toward the iconoclastic prankster—Graves.

Krafft first met Graves through the architect Ibsen Nelsen, whose

two sons, Hans and Eric, were friends of Krafft. Ibsen felt that Krafft should consult with Graves before setting off to study yoga in India in 1969. He arranged for Krafft to visit Graves at the artist's house in Loleta, California.

At the time, Graves was surrounded by young people—drifters and artists—Krafft described as "Humboldt County hippies." He paid them to do chores around the house or to clear the trails along his private lake and in the 250 acres of redwood forest that grew beyond it. Krafft easily fit in with this environment and Graves offered the young artist some art-related work as well. He was impressed enough with Krafft and his art that he offered to give him a painting, waving a hand toward some small bird paintings he'd recently completed as he made the offer, Krafft recalled. "One afternoon a gaggle of local hippies showed up with a case of beer," Krafft said, and he shared the afternoon drinking with them while Graves was in his studio. "I decided to leave for San Francisco that evening with them—they were going to Garberville or Arcata—and I wanted to hitch a ride to highway 101." There he planned to hitch hike on to San Francisco.

Inspired to play a small prank on the elder artist, Krafft decided to take a painting, as Graves had offered, but not one of the bird paintings Graves had suggested. Instead he snatched a rendering of a Tibetan Buddhist Vajra pinned to a cork board near the elder artist's phone. In exchange Krafft left one of his own paintings on paper of approximately the same size. The painting depicted a grave—a stone sepulcher which he'd completed during the week stay at the Loleta retreat. "I pinned that up in its place and left the house without saying goodbye."

When Graves discovered the missing painting, he made a phone call to Krafft's mother in Seattle and threatened to contact the police if it wasn't returned. He also called Dick White, his art dealer in Seattle to complain. This was not the response Krafft was expecting. In fact, he said, he took the painting to use as a talisman, an image to focus his mind on during an anticipated acid trip. "I did this when I got to San Francisco and when I was done meditating on Graves' golden Vajra, I mailed it back to him with a tab of LSD lodged in the corrugated cardboard packing underneath it."

Morris claimed he never found the LSD. He did, however, run

into Krafft in the lobby of a San Francisco movie theater showing "The Dualist" about ten years later and forgave him. "Graves buried the hatchet at the popcorn counter," Krafft recalled. About 30 years after that first visit, Krafft said, shortly before Graves died, the elder artist told Krafft he wanted to give him another piece of art. It was a charcoal sketch of a squirrel shaped creamer on Japanese gold paper.

Like Graves, Krafft spent much of his time in Seattle, but mostly he yearned for a quieter, more secluded dwelling to focus on his art and he knew of such a place in Skagit County called Fishtown.

He first learned of Fishtown while early into his school career at Skagit Valley, in 1966. At that time, another Skagit Valley Community College English professor, Jim Kohn, often went hiking with Krafft. On one afternoon Kohn brought Krafft out to a secluded and seemingly abandoned community.

Fishtown was a seasonal and largely empty collection of gill-netter cabins located between the North Fork of the Skagit River and a forested property owned by the Chamberlain family. (One member of that family—Marty Chamberlain—coincidentally was a friend of Krafft's at Roosevelt High School.) Most cabins were raised above the marshy shoreline on stilts and connected by a rickety boardwalk, grown through with skunk cabbage. Actual ownership of the property on which they stood was subject to some opinion. Everything above mean high water was generally considered the property of the Chamberlain family, while everything below it belonged to the Army Corps of Engineers. Therefore, the properties on which the cabins stood were owned by multiple families. The area had a rich history, although it may have seemed, to look at it in 1968, thoroughly abandoned.

There were two sections to Fishtown. An area known as Gasoline Alley was managed by a group of hunters and recreational fishermen, while occasional visitors maintained a more remote cluster of cabins down river that would eventually house Krafft and other Fishtown artists. Access to these cabins required periodic hacking out of blackberries and stinging nettles but in the absence of visitors the foliage quickly returned. The air smelled of skunk cabbage and damp rot.

Outhouses constructed at Gasoline Alley emptied directly into streams flowing into the river or were dumped directly into the river at high tide, adding to the distinctive smell. At the more remote

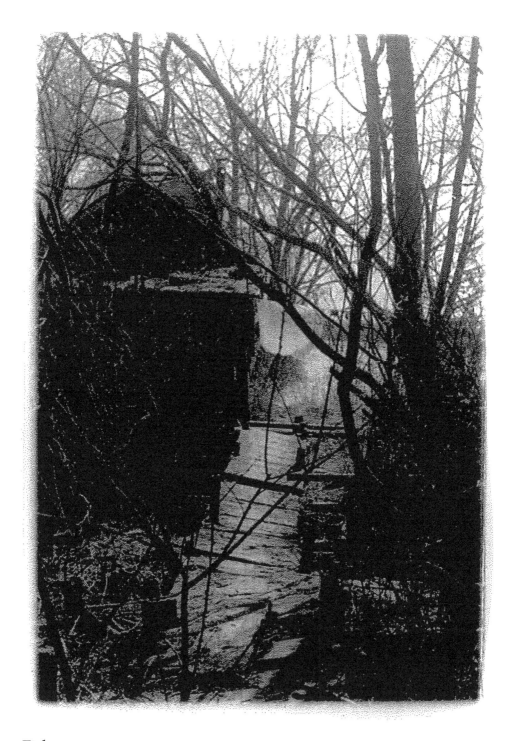

Fishtown

encampment, the hippies who adopted it buried their waste.

The serenity there was profound. Herons and bitterns stood in the water while red-winged blackbirds, gulls, sparrows, towhees and robins crowded the sky and trees. Eagles drifted in the updrafts off the bluff and nested in the fir trees on the hill. Dolly Varden trout swam in the shallow waters near the shacks and made good eating for anyone with a shiny lure—while salmon passed in the deeper Skagit waters in thick schools.

Charles Krafft, untitled

These salmon helped establish the community itself. From the 1930's to the 1950's fishermen took their turns, each floating his fishing boat down river, a net splayed out behind to catch fish. They drew numbers, then settled down in the shacks to wait their turn. Most of

these dwellings were just big enough for a table to play cards and a bunk to get a little sleep, according to the recollections of neighbor and historian Janna Gage. The 18 to 20 foot boats with inboard one cylinder engines would be tethered there on the river. Once a fisherman's number came up, the wooden roller on his stern put out the nets, and the following morning boxes of the night's catch would be delivered to Louie Nelson or other local fish buyers.

A few enterprising weekend duck hunters built their own shacks in the area as well. Because the area flooded so often, the shacks invariably suffered damage, then were rebuilt, sometimes farther back in the woods, out of range of the river. Over time the shacks became more complex.

Richard Gilkey, Evening Slough

As the fish population declined in the 1960s, gill-netting was restricted. A law known as the Boldt decision in 1974 granted gill-net fishing rights to the Swinomish Tribe, but by this time, the commercial fishermen had long left the area. The tribe continued gill-netting the river and sport fishermen appeared in dwindling numbers.

Before Krafft ever visited, the crop of shacks near the river's mouth had caught the attention of his high school chum Marty

Chamberlain while he was visiting Skagit County with his father. At Marty's prompting, his father took him out to explore the unoccupied shacks along the North Fork of the Skagit River and the boy had been captivated. It looked like the playground of Tom Sawyer and Huck Finn with a wide lazy river that nearly stood still when the tide came in and sandy beaches that stretched out along the shore during low tide.

Teenage Chamberlain found rides to the area to camp out in the shacks (one being a cabin where his grandmother had once resided) along with another high school friend, John Bisbee, who shared his affection for the place. Bisbee and Chamberlain designed and constructed a 12 by 16 foot cabin on the river, with one room and a loft, as well as a cantilevered deck, composed of two-by-fours from other structures, including the old Chamberlain property, and boards hauled in from a Burlington lumber store. While they were building, they often stayed in the neighboring cabin of best condition, belonging to Antone A. Woll, a former fisherman living in Mount Vernon who had long before retired.

By the time Krafft thought about moving to Fishtown in 1968, Chamberlain and Bisbee's cabin was constructed but largely unoccupied, as was the Woll cabin. (After high school graduation in 1966 Chamberlain enlisted in the Naval Reserves and served several years in the military before moving to California. John Bisbee helped start a commune known as "The Growing Family" on the north end of Lake Union on Eastern Ave, in Seattle, as well as a natural food store associated with that commune. While Bisbee studied architecture and urban design at the University of Washington, he took calligraphy lessons from an instructor by the name of Steve Herold. Chamberlain returned to live in La Conner in 1970.)

So in 1968 Krafft arrived in Fishtown to find that many of the cabins, mostly used seasonally by hunters, still contained sundry household items and clothing—a jacket, a pot, spoons—harkening back to the day not long before when gill-netters had been there. Although the river was now absent of these fishermen, tribal fishermen still travelled up and down the river in small boats.

Krafft recalled himself as La Conner's first hippie. He paid $1 per month in rent, delivered in an annual check for $12. He took his time moving in while serving as an au pair for a faculty family.

During that transition his free time was consumed with fixing up the best of the cabins, putting in skylights, and eventually entertaining there. "People would hear about me out there," he said, and when visitors stayed more than a day, "I would dispense cabins."

Philip McCracken, Dream of a Dying Owl

In the eight years that followed, Krafft lived there and influenced a new generation of artists. He later described himself as a, "junior varsity Northwest Mystic."

Shortly after Krafft's arrival at Fishtown, men, then women and a few children came to join him, making the series of shacks into an artist community of like-minded people—mostly an intellectual group, all with a hankering toward the arts, many coming from Seattle.

Charles Krafft, River Story cover

There were several gathering points for artists and hippies in Seattle around 1970. One such place was ID Book store, on 42nd Street and University Way (Seattle's "U District") owned by John Bisbee's calligraphy instructor: poet, scholar and calligrapher Steve Herold. In the back of the store Herold published a book of poetry on his own printing press and also printed books in calligraphy as well as making rock posters. In the late 60s the store was a popular hangout for Seattle's students, artists, writers and dropout intellectuals. Krafft frequented the store along with poet Robert Sund and Tom Robbins. Sund and Krafft also gathered at Seattle architect Ibsen Nelsen's house. During various gatherings Krafft would share the details of his Skagit lifestyle: the orchestras of frogs, the starry nights unspoiled by electric light, the eagles diving for fish in the river then rising into the forest to feast on their prey on a high tree branch.

Bo Miller, Cedar Nude

Krafft lived off spare vegetables from the fields, cooked over a fire, and spent hours in quiet mediation and in the solitude of his art, he told his friends. He felt the pangs of isolation there however, Herold said. "Being pure is wonderful but it's very lonely. He kept inviting us to come up and stay for awhile." Robert Sund, Hans Nelsen (Ibsen Nelsen's son), sculptor and architect Bo Miller, Herold and others began taking him up on the offer, hitching a ride north, hiking out of town, across the fields and then into the wooded sanctity of Fishtown itself.

Charles Krafft, Famous Poet Robert Sund

Leaving the City for the Rain

Off the hill from the shack,
Down the path in mud,
And limp leaves caught upright
In the footprints of those who have left before me,
I come slowly out of the woods laughing
Like a Chinese madman on an ancient screen.
It's winter.
The trees are cold.
They scratch like long grey fingers.
Slipping further down
To the plank laid cross the road,
I dance over it
Picking my way through more mud
Towards a piece of dry ground.
There standing still and not sinking
I listen to the earth in its bath
Hum fractions of wet song to itself.

—Charles Krafft

Chapter 9

Life at Fishtown

There were no roads to Fishtown and few maps pointed the way. The shacks were accessible only by boat or on foot, so those who chose to live in, or even visit the place, had to be committed. And in part for that reason, once they were there, residents found they had truly left the constraints of modern life behind.

Fishtown reminded Steve Herold of his childhood home in Magnolia, which in his youth was similarly forested and bucolic. "In the 1940s we had farms, stands of virgin timber, woods and streams, deer and bear and coveys of quail." By the 1960s the world had changed. The Vietnam War was a relentless distraction, and the city of Seattle was not the small pioneering town it had been decades before. By this time, he said, his book store was becoming—at times—more work than pleasure. He was also going through a divorce so the time seemed right for a change. Fishtown offered him a return to his youth and a license for uninterrupted creativity. "So at Charlie Krafft's invitation I moved on up there."

When selecting his new home, Herold took a liking to the cabin Chamberlain and Bisbee had built as teenagers. Herold wrote to Chamberlain asking for permission to move in, and the response was, "Sure."

Herold had been a calligrapher for 10 years, taught the technique at several schools, and had written books on the subject. Krafft loved the concept of thoughts and spoken words printed with visual images and he and Herold began to work together, writing and illustrating pieces of art with the Northwest style of mixing semi-abstract brushwork with more formal and traditional elements to convey their message. The growing, lower-Skagit art community started doing art shows together and getting wider notice.

Poet Robert Sund, too, was attracted to life at the Skagit River Delta. Born in 1929, he'd been a University of Washington pre-med student who had shifted his interests to poetry and art. He studied under Theodore Roethke, but eschewed the academic track many of

Fishtown boardwalk

his poet peers were taking. He left his graduate work in Comparative Literature to take a job on the eastern side of the Cascades in Walla Walla in the early 1960s, doing field labor for wheat farmers. There he completed his first book of poetry, *Bunch Grass*, published by the University of Washington Press.

Back in Seattle in the mid-sixties, as poetry program director for radio station KRAB-FM, Sund interviewed poets. He also learned to play the guitar.[1] It was during this time that Sund developed a friendship with Charlie Krafft. Around 1971 Sund moved to an area near Fishtown, known colloquially as "Shit Creek" as well as "Ship's Creek," the latter moniker intended to sound more acceptable to the public. It was not officially a creek but rather a tidal channel running off Sullivan Slough.

In 1971 an informal group of mostly Seattle artists and poets evolved—many who spent weekends or all their time in Fishtown—called the Asparagus Moonlight Group, led by Robert Sund. Artists would gather at LaConner's 1890's Inn or Planter Hotel Cafe to discuss art and politics, Vietnam and social reform.

Other members continued to fill the Fishtown shacks. Bo Miller first visited the float shacks on an excursion with Krafft. They'd arrived on a Greyhound bus in Mount Vernon, hitchhiked to La Conner and gone straight to the boisterous 1890's Inn on First Street.

The 1890's was a popular bar and eatery perched above the Swinomish Channel on spindly pilings. The back deck was typically filled to capacity and beyond with pot smoking and heavy drinking artists, draft dodgers and hippies, the music pounding. Live music was staged several times a week and La Conner police wandered through the tavern at night but rarely made arrests.

La Conner Tavern, competing down the street, featured a jukebox playing western and bluegrass music, and bore a sign in front warning against bringing in dogs. Guy Anderson could often be found inside this lower-key establishment, playing an enthusiastic game of shuffleboard with the locals.

On that first visit to La Conner with Krafft, Miller said, "It was like walking into another world."

By this time, it was obvious that the Skagit Valley was a sanctuary to young artists, and this was where Miller wanted to be. Like Anderson and Graves 30 years before, the Fishtown residents found

the local farmers relatively tolerant. After only a couple of weeks living in Fishtown, Miller noticed that even the people staffing the La Conner Post Office greeted him by name.

On the river, building and repair work were constant among the string of ramshackle Fishtown cabins and float shacks. Krafft's home was distinct, and not easy to reach. To access it, walkers approached a 20 foot cliff, then scrambled down a ladder on the cliff face to his large deck. Since the cabin hunkered close to water level, high tides in the river delta occasionally floated the planks of the deck loose. Once the waters receded, Krafft got to work repairing with hammer and nails.

Under the peaked roof, Krafft had two rooms—one with a majestic kitchen stove and art studio, the other with a bed. Krafft painted on the floor so those floor boards were colorful with paint drippings comingling with wax droplets from a candelabra that illuminated his late night work. There were times when the flooding river trapped him on his bed with several inches of water in his home and paint swirled in the water.

Miller recalled occasionally visiting the cabin just to absorb the atmosphere. "He had a real sense of Spartan style. When he wasn't home, sometimes I would just sit there looking at his paintings."

For his own part, Miller started out with more basic accommodations, first sleeping in a gillnet storage shed that served as the community's "temple." The big double doors opened out over the river and swallows swooped into the shed's loft and back out. Once a place of storage, now it was designated as a sanctuary for meditation and housing for weekend guests.

Krafft loosely followed the practice of Zen Buddhism, as well as Indian Vedanta philosophy. During group sessions he, and any new neighbors or friends who would join him, would sit in lotus position, facing the wall, for three days in the net shed "Temple," typically from 9 a.m. to 3 p.m. They rose every hour to stretch their legs, signaled by the ringing of a bell.

Needing a more permanent dwelling, Miller chose a weather-beaten structure built onto a barge that had floated away from its unknown origin and wedged itself aground near Fishtown. He dubbed it the floating hot dog stand. Bo Miller paddled out to the structure and began some basic engineering. Miller numbered each log on the

house, then took it apart, pulled the logs to the river-bank and rebuilt the house according to the numeric pattern.

Beyond locating and building their homes, there was a loose effort at organizing the community. When the cluster of scholars, artists and psychedelic mystics had settled in, Krafft was informally titled as mayor.

Life at Fishtown was most often consumed in three pursuits—enlightenment, art and survival. Depending on the time of year, the priorities between these three shifted.

Bo Miller, Lady Moon

Miller carved wood pieces in homage to Northwest Indian work, Krafft painted and Sund crafted poetry, calligraphy and Mark Tobey style paintings. A sculptor named Art Jorgenson worked in bronze castings.[2] He later died of a heart attack in a boat race. Hans Nelson (architect Ibsen Nelson's son), was creating crystalline ink drawings. Virginia Shaw was a frequent visitor to Fishtown rather than a permanent resident. She renamed herself Aurora Jellybean, drew psychedelic pictures with colored pencils, then went on to painting.[3]

For the most part, profound silence replaced the mechanical noises of the city. Only the occasional motor boat or a jet flying to or

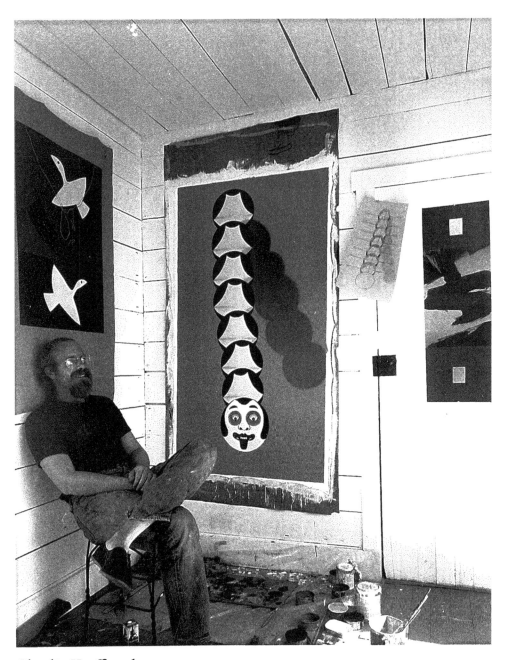

Charlie Krafft at house

from the neighboring Whidbey Island Naval Station served as re-
minder of the outside, mechanized world. In total, by the early 70s,
14 people were living in the shacks, without use of a single generator.
But even on the river, silence wasn't guaranteed. An archeological dig
was underway at the same time—orchestrated by Seattle Community

College professor Astrida Onat—which generated complaints from the residents about the noise of the pumps that interrupted their meditation.

Some nights the residents made music by firelight. They often began as impromptu concerts with banging of pots and pans. Eventually Miller started carving hand-made instruments. Krafft hung abandoned crosscut and circular saws from building rafters, calling them then the Asparagus Moonlight Chopstick Choir.

In addition to the temple, Fishtown had extensive libraries with each new resident bringing more literary contributions. Besides reading and painting, everyone could be found writing at all hours of the day.

As the artists created their artwork, at least at first, they made little effort to sell it. Unlike Anderson, Graves, Gilkey and James, these local artists who intermixed poetry, calligraphy and abstract mysticism on canvas were getting little regard from galleries in Seattle. However, one meeting of the Asparagus Moonlight group spawned an idea that changed that. They would host a Fishtown art show in the city's Second Story Gallery on 1st Ave South in Seattle. This 1971 show was intended to be a big splash on the more traditional art scene of Seattle. It would include 11 or 12 Skagit Valley artists.

"Socially it was wonderful," Herold recalled. A few artists had some sales; Robert Sund and Herold sold more art than most. The show had piqued the interest of Northwest art collector Marshall Hatch, and he was the primary buyer at the show.

Increasingly, art buffs, nomadic hippies, draft dodgers and curiosity seekers from Seattle and beyond found their way to Fishtown to see this oasis from modern life themselves. Charlie Krafft was the greatest draw. His cult status attracted art buffs not unlike the artists who came to Morris Graves on the Rock 30 years before. Fishtown, Krafft said, was something of a "Youth Quake. People came to check us out." Some of those people were what he called feral hippies. "In the day of peace and love everyone expected to be embraced."

It was not enough to be a fellow artist, or even to be invited, to survive in Fishtown. Krafft noted many itinerants who passed through either on foot or by boat—people he refers to as grass hoppers—would come by, smoke some weed, and hope for an opportunity to drop out of society with plenty of drugs and leisure. "Why gather

SHACK
WORK

by
Robert Sund

Shack work is good work.
After dark, around the table
we talk tools—
 good steel
 old wood handles

 what they do
 how you use them

 second-hand
 or a gift from a friend—

Lightning in the mountains!

Shack Work appeared in SHACK MEDICINE, published by Tangram
in the spring of 1990. One hundred copies of this broadside printed from
Bembo on Millbourn handmade, with illustration by Bo Miller.

Collaborative Shack Work, Robert Sund poetry/Bo Miller art

wood?" they might ask. "We've got plenty of time." The residents of Fishtown didn't feel that way as they had learned, the hard way, about the misery of wet wood in winter.

There were periods when the group's time was consumed by the unromantic tasks of survival. This meant wielding a hammer or dumping the bucket of human waste. And discomfort came with the territory.

For heating, the residents all had some kind of cook stove or woodstove in their cabins and all were accustomed to shivering into heavy clothes, splitting wood, starting the fire. In half an hour the cabin temperature might rise above freezing. Their paintbrushes occasionally froze overnight in the ink, and artists would have to warm them by the fire to loosen them.

The Fishtown community neighbored the farm of Buster and Margaret Lee, and could be accessed from their pasture, if the retirement-age couple allowed residents to park their cars or trucks there. As residents moved in, the Lees may have been skeptical about the hippies that were replacing fishermen and hunters on the river. Krafft was the first to talk with them about sharing their driveway to better access to the shacks. With their approval, he and his neighbors parked their vehicles near the Lees' house and hiked a path to the river from there. Robert Sund used some poetic charm when he got to know the Lees and the family just plain enjoyed some of these Fishtown hippies.

Herold was a gardener and appealed to their interest in gardening to gain their trust and assistance. He also was not above some heavy labor to help the couple around the farm. Buster Lee received some manual work in exchange for parking privileges. That, Hansen said, was in part to fill pot holes the Fishtown hippies created with their own vehicles—typically old pickup trucks.

The cabin dwellers also helped shovel manure out of the Lee barns and chase steers back to the field when they strayed. "Buster was a puck; humorous and wry, you had to be careful though, he still had a short tolerance for those who foolishly got in his way," Herold recalled.

Margaret often fixed them food and sold them eggs and whole milk in gallon jars floating with a layer of heavy cream, which the group used to make butter for shortbread. Fishtown residents seemed

to agree that the food they shared wasn't bad. Krafft was known for a culinary venture into mysticism; Zen crackers—with cream cheese, soy sauce and sesame seeds. Elizabeth Mabe Soderberg made Fishtown hotcakes from hand ground wheat, corn, rye, buckwheat and millet combined with molasses, yeast, eggs and milk. Food came from other local sources as well. Sometimes Swinomish fishermen would pass on the river, and throw a fish at Krafft's front door, he recalled, as a gift after a good day's catch.

Bo Miller, Chevy Ying Yang Mandala

To generate spending money, most of the men travelled into town to work. Farmer Ed Dalan employed Herold. "My friends were the people of the Skagit Valley, such as the farmers. I didn't want to hang out at the 1890s. I got jobs, I wanted to be one of the people, not just a leech," he said. Herold recalled one of Ed Dalan's friends asking

if he had hired a hippie. "And Ed replied, 'He isn't a hippie, he's the new guy on the river'."

Miller also worked for farmers, driving tractors and providing general upkeep around the fields. This periodic income, along with checks for his military service, was enough to live on. He eventually started to design houses and became a wood carver, carving intricate wooden boxes that he sold for $100 to $300.

Ralph Aeschliman who had visited Anderson at his La Conner pea shack many years before, arrived in Skagit County to live, on a snowy day in January 1974. His unemployment had run out and he was tired of the life he'd been living and the stresses imposed by society: Fishtown life seemed a good alternative. He pondered the river which he said "would rise and fall slowly with the tide—a great breathing," and he was ready to begin his new, very different life.

He inhabited a duck hunting cabin on float logs on Barge Island, just down river from Fishtown, named it Duck Hall, and carved his name onto a sign with Chinese characters. "I went through a long period of self-examination. Mostly, I wanted to reassert my commitment to art. I needed to find out who I was, and where I belonged, and I was determined to be an artist even if I had to starve to death."

Out on the river Aeschliman, for the first time, felt he could be himself. "You can get pretty crazy [when alone], and there is no one to get upset about it, except yourself. I began to give myself permission to be a human being, a natural human being, and to follow my instincts rather than my guilt… I had become quite comfortable with my own company. I had discovered the difference between solitude and loneliness."

He sketched and painted once he'd settled in. Creating art was the translation of a free exalted dream. And a work of art, he said is "both matter and mind, both form and content."

He enjoyed the complexity and sometimes contradictory aspects of the life he saw around him. In a series of paintings of the Great Blue Herons that waded around his shack, he sought to capture the moment they took flight, in which they were at once clumsy and full of grace. Although it was a frozen instant, it also transcended time, he felt. "A work of art is immersed in the whirlpool of time," he said, "and it belongs to eternity."

Paul Hansen came to Fishtown from Bellingham where he and

131

Ralph Aeschliman, Coots

his girlfriend—Elizabeth Mabe Soderberg—owned a bookstore. Hansen was a University of Washington alum and Chinese scholar a well as poet and calligrapher. He began visiting Fishtown in 1972 and a year later he and Soderberg settled into a shack on the river that was about a half-mile walk from the Lees' driveway. Soderberg took to the off-grid lifestyle better than most. She'd already learned how to live with few creature comforts from her rural North Carolina childhood. "I was used to oil lamps and wood stoves," not to mention scrubbing laundry on a washboard, she said. The first year at the river she brought in bottled water; the second year she boiled river water. "Then I saw Bo Miller walking to the river with a glass in his hand," she says, and she forwent the boiling as well.

While at the river shack, both Hansen and Soderberg pursued their art. Krafft gave her an easel and paper to work with and she created watercolors and oil paintings of the landscape around her. Hansen painted and drew, both landscapes and calligraphy.

La Conner resident and author Fred Owens recalled that the boardwalk was never in good repair. An alder branch grew across the walkway in one spot. "One had to push the branch down and step over it, or stoop and get under it. But no one ever cut it off. Two seconds with a lopper would have done the job, but the branch remained unharmed for years, and every day it was in the way—in the way of all visitors and all residents, going back and forth. Some visitors might have thought the residents were too lazy, or too spaced out to 'fix' the branch…they were welcome to that thought. Yet the branch was there because it was there, and things don't need to be fixed because they are not broken. The branch was not 'in the way' it was the Way—a concrete symbol."[4]

Painter Michael Clough learned about Fishtown in Seattle, moved north in 1975, but found the Fishtown shacks all occupied. He took a room in the Nordic Inn, where Robert Sund was staying just down the hall. "It was a good place to touch down," Clough said. Several months later, in January of 1976, he and fellow painter John Schaefer packed sleeping bags and paint brushes in a boat and paddled down the South Fork of the Skagit River where they camped out in abandoned duck shacks. Schaefer moved on, but Clough stayed decades, longer than any other artist, existing with the simple comforts of wood heat, battery powered lighting, and painting material. His

Winter Poems

I The Shadow of a cloud
 falls on the white mountain.
 A cowering dog
 jealously guards a bone.
 Once the fish have coveted the water
 the birds have fallen from the air.

II Colder now
 a new moon sets in the frozen marshes.
 Close to the wood stove
 I drift into the past
 remembering old friends & summer days.
 Leaving no more trail than the
 How quickly they setting moon
 pass by.

 Bo Miller
 1 9 7 5

Bo Miller and Steve Herold, Winter Poems

painting was self-taught and he worked with the landscape of the river delta. His paintings often featured mystical depictions of the sky, punctuated with symmetrical shapes that served as frames for the complex colors blended behind them. To accomplish the shapes he started with simple points, running lines between to create the patterns of circles, squares, triangles and hexagons.

Over time several children occupied Fishtown; Steve Herold's son William frequently visited from Seattle and Bo Miller and his wife, Gül Amies, had two daughters. The older kids spent time roaming the woods, building forts out of drift wood on the river shore, sailing down the river on pirate ships and reading. Miller's second daughter, April, was born toward the end of the family's stay at Fishtown and by the time she began to toddle, her parents decided it was too unsafe to live so close to the river.

By the mid 1970s Fishtown residents began to make their way back into civilization. Gul moved to La Conner; Bo Miller started taking architectural projects, many of which were in Seattle, and began the transition to the commercial world.

"What startled me at a certain point was I looked back and no one was following us," Miller said. "I thought this was part of a new society but the younger kids didn't seem to have the same spirit. We thought we were part of a renaissance but it didn't happen."

Krafft was one of the longest term residents. He continued to paint and exhibited at the Richard White Gallery and elsewhere in Seattle. (Rosie Nagatani, wife of a Japanese tree and strawberry farmer, hosted art shows in her garage that included artists such as Robert Speary, Phil McCracken, Ralph Aeschliman, James Farr, Ed Nordin as well as Krafft.) Krafft's paintings were heavily influenced by the landscape during this interlude.

Robert Sund eventually departed Shit Creek and lived in a series of homes in the Valley, often on people's couches. He had developed his own aura of celebrity as a poet, one of the few published poets many Skagitonians had or would ever know. Another poet who gained local acclaim was Clyde Sanborn, who once wrote: "One should always carry a pen. One never knows when one may run into a poem." Sanborn came to visit his friend Michael Clough at his South Fork Skagit River cabin, experienced the simple lifestyle of the painters and poets and never left the area.

Michael Clough, Four Seasons

The Fishtown group's relationship with Anderson and James had been complex and not always magnanimous. James, from another generation, did not approve of the prevalent drug use of the younger artists. But, on the other hand, the new generation of artists admired his work and that of Barbara Straker James as she now began returning to painting after decades of letting the men take center stage. Anderson would talk with the Fishtown artists for hours if they came to him, although he was not known to ever visit Fishtown. Krafft recalled inviting Anderson to the river shacks, but at the time Anderson was in his mid-sixties, and with no car, so the trip would have been an arduous one. Krafft did catch a ride to the trail to Fishtown once from Clayton James. "Clayton got up in the middle of the night and drove me out to the trail," he said, "after I woke him up yelling," outside the James' house after the bars closed down. "He put his pants on and packed me into his car and drove me out [there]."

Soderberg recalled one of her favorite compliments coming from Guy Anderson on the streets of La Conner. "I was wearing an indigo blue Tibetan shirt and a long skirt—hippie regalia," she said, and he stopped her. "He told me he loved the colors I wore."

Soderberg and Hansen went their separate ways. Hansen left in 1977. Mabe married David Soderberg and had a child, and when that child was old enough to be a safety risk on the river bank, she moved with her new family back to her childhood home in North Carolina.

She taught high school English in North Carolina and said that when her students were feeling restless she often brought out her Northwest-era artwork, showing them what she created in Fishtown and describing her life there. "I could always galvanize them with those stories."

In 1980 Krafft closed up shop in Fishtown and headed back to Seattle, leaving the area to what would be a second wave of Fishtown residents. He found a job as a guard at his old site of inspiration— Seattle Art Museum—and rented an apartment off Broadway. His time at Fishtown he said was "a rural interlude for an urbanite who rediscovered his urbanity."

However, off-the-grid style living was never really shut down for those who want to embrace the lifestyle, said Fred Owens, a long time La Conner resident and author. "Fishtown is a state of mind."

And even though Fishtown is gone, the state of mind for such a life-style elsewhere lives on. "You go to where the river meets the sea and you find an old cabin, or you build a shack and you live there. That's the story, and it's still true. Don't read the story. Go live in the shack."

Did Fishtown impact the Skagit Valley's nascent art scene? Absolutely, according to those who were there. "If it had just been Guy Anderson and Clayton James, that wouldn't have been enough," Herold said. But now artists were streaming into both Fishtown and the Skagit Valley itself.

Fishtown group picture

Chapter 10

Influx of Painters

In the 1970s Tom Robbins persuaded an old friend from New York—painter William Slater—to join him in La Conner, a place separated from the East Coast by several thousand miles, and a yawning cultural divide. The two friends hadn't known each other when they both attended Richmond Professional Institute in Virginia. Slater was several classes behind Robbins. However, when Robbins visited New York in 1964 to write a piece about Jackson Polack, mutual friend and RPI classmate Bernard Martin suggested they get together.

Bill Slater

By the early 1960s Slater's art career was on a successful trajectory in New York; he'd studied on the graduate level at Hunter College at the City University of New York, was studio assistant to Jasper Johns, as well as friend to abstract expressionist Mark Rothko and sculptor Tony Smith. He also was building an impressive body of work.

Among some of Slater's most iconic pieces was a series of beach

scenes with a soft, erotic feel: after he laid one layer of paint he sanded it down, painted again, and sanded again, developing an inner glow effect. He created the female figures in his work by tracing around the bodies of ballet dancers he paid to lie down on the canvas, so that their outline could serve as the template for his work.

However, Slater was not happy in New York. In fact, in the 1970s Slater was desperate to get away from the clamor, distractions and pressures of the city and find a quiet place to live and work. The Skagit Valley offered a gentle, quiet landscape, and the town of La Conner was populated with people who were tolerant of eccentric artists. Slater collected a few possessions and joined his author friend. He moved into a shack along the Skagit River and married Judy Brusegaard. The couple lived simply, with a wood stove for heat and lots of the quiet Slater had been seeking. When Brusegaard was

Bill and Japhy Slater

nearing the delivery of their baby, however, Tom Robbins stepped in. He couldn't imagine a baby being born in a shack without power or plumbing. He traded homes with them to allow the baby to be born in the relative luxury of his heated house in La Conner. In the meantime, in the Slaters' shack, Robbins said, he wrote a large portion of

his second novel, *Even Cowgirls Get the Blues*.

Although Robbins said Slater rejected the mechanism of modern society, once in Robbins' house he and his wife had no problem taking advantage of modern comforts. Robbins said he passed the house at night and saw it "lit up like Coney Island, with every light on in the house."

The Slaters returned to the shack with their new baby in 1975. When their son Japhy was six months old, the family was driving on the Swinomish Reservation when their truck was struck by a car. Japhy survived but Judy was killed. William Slater spent several weeks in a coma before embarking on a slow recovery.

Slater stayed in the area and raised his son from a home on Sullivan Slough in another shack without running water or power. Around 1980 they moved to La Conner, Japhy recalled, although his earliest memories are of the shack and traveling with his father by boat to get to school. He had an affinity for dories, Japhy recalled: small flat-bottomed craft that were nimble enough for the tidal rivers that could at times be too shallow for most vessels. The boat came with a wood stove, Japhy recalled, and he would sleep on his way down the river to school, warmed by the fire.

Slater had stopped painting while in New York, and hadn't brought himself to pick up a brush in any meaningful way again for 15 years. But in the 1980s he began a few small pieces on his kitchen table that were, Robbins said, "not ambitious, but charming." When a hummingbird crashed into his window, Slater laid the bird's body on a canvas and carefully traced it the way he had done with the ballerinas in New York two decades before. He created a compelling piece that Robbins bought. After that Slater returned to painting with a vengeance. Once Slater and his son moved to town, they rented a series of homes that had a space for his paint studio.

At one point Slater also used a studio provided by Clayton James.

The father and son lived on Slater's income from painting sales, with Woodside Braseth Gallery in Seattle and Lucia Douglas in Bellingham selling his work. Mostly though, "he sold a lot of his paintings right out of his studio," Japhy Slater said.

Sundays, Slater would host brunches at which he served corn cakes and mimosas and invited friends and art enthusiasts to come hang out, which often led to painting sales. Bill and Japhy were able

to sustain a minimalistic, bohemian life style in La Conner that centered on the arts and just enough sales to support them. Japhy Slater grew up waking in the morning to the sounds and smells of his father already hard at work. Bill Slater rose around 4 a.m., and got out the canvas and paints, so the air was redolent of linseed oil, turpentine and brewing coffee.

Bill Slater, untitled

Slater had a soft heart for the valley and for the wildlife living in it. Japhy remembered his father stopping his 55 Ford truck on Dodge Valley Road to move the carcass of a dead animal from the path of moving vehicles, just to let it rest in peace.

New York Sculptor Tony Smith considered Slater someone on the

verge of a "big art career." Robbins described Slater as the most talented artist in the Skagit Valley.

"He was both abstract and explicit, subtle and exuberant, rustic, yet sophisticated," he said. "His paintings straddled the divide between realism and abstraction." And, Robbins added, "Slater loved paint and nature with equal passion."

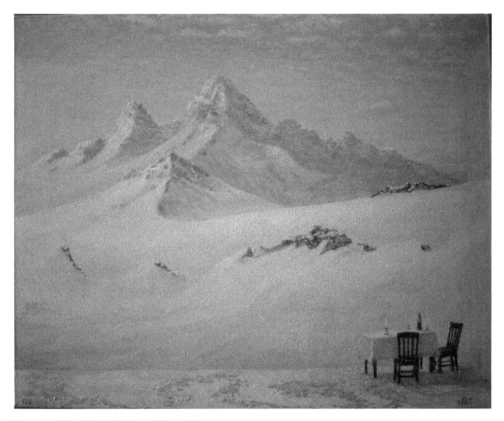

Larry Heald, Alpine Dancing

During this time, in the 1970s, La Conner's First Street was going through a cultural and business shift. Boarded up buildings which once housed farm supply stores and mercantiles were reopening with craft, macramé, pottery and quilt shops—those who shopped there were more likely to be tourists, travelling through the area for the weekend, than locals. In the meantime, to serve the residents, La Conner still operated one food market, a hardware store, two taverns, three restaurants, and the Nordic Inn, where its knights of the round table were fishermen, often still in their rubber hip boots. Locals who mingled with the artists included Jim Smith, who came to La Conner

in June 1970 to teach. He recalled not only the artists themselves but the art fans that came, often in search of Guy Anderson. In most cases the artist, now in his late 60s, still welcomed anyone with an interest in his work. It didn't matter if they arrived at 2 a.m., "Anderson didn't care, he would get up, pour someone a drink," Smith recalled. Smith was one of those invited into Anderson's home. "He was the first person I ever met who was living the artist life style. For me, there was an aura of mystery surrounding him."

There was something pure about the lives of the artists in Skagit Valley at that time, Smith said, "I don't know anybody that lived like they did; simple and just that Asian lifestyle. There was a big infusion of countercultural people who discovered low rent in La Conner." And they didn't need much, "They knew how to use an outhouse," he recalled.

Other artists of the day included sculptor Art Jorgenson, Paul Havas and Paul Hansen. "I'm sure they all came for the same reason," Smith speculated, "cheap prices, a place that respected their art, and people who shared the same Asian philosophies."

Larry Heald lived in the Skagit Valley from 1970 to 1974 and helped create yet another artist school there reflecting a new generation with very different sensibilities than those of Penington's art program. He was an artist himself, showing his paintings at the Manolides Gallery in Seattle. His work was included in exhibits such as the "Governor's Invitational" at the State Museum in Olympia; "American Landscape," at the University of Washington; as well as "Prospect Northwest" and "Skagit Valley Artists," at the Seattle Art Museum. As an art student at the U.W. he had been experimenting in abstract, expressionist painting, and after gaining his MFA there in 1964 he went to work teaching art at Pennsylvania State University. When he visited the Museum of Modern Art in New York, he was struck by the surrealist work of Belgian Rene Magritte, and his own work began to include landscapes with a humorous twist—combining a natural setting with manmade props such as chairs and windows.

Heald arrived in Skagit County to visit his friend, sculptor Larry Beck. Beck was famed for large-scale abstract-expressionist sculptural work with modern industrial metal and other found materials, as well as for masks inspired by traditional Inuit pieces (he was one-quarter native Alaskan). Beck was heavily influenced by his Inuit heritage and

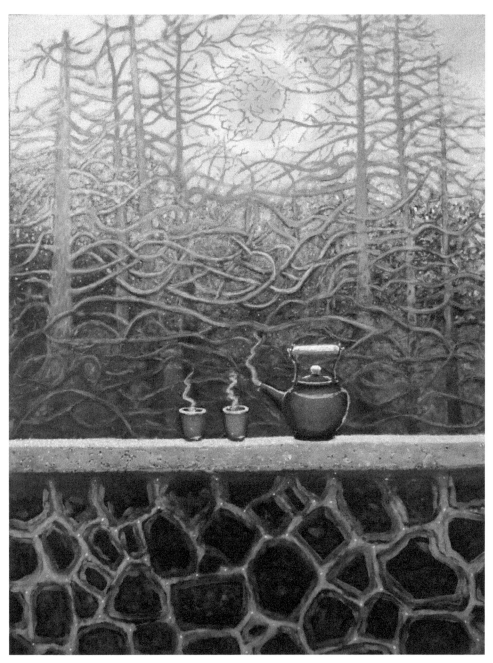

Larry Heald, for Paul Heald

his mask work nodded to the artists of that culture. While the Inuit gathered materials from the shores of the Bering Sea for their art, Beck combined, whimsically, his modern western heritage with that of the Alaskan Natives, salvaging hubcaps, whitewall tires, airplane rivets, kitchen implements and rearview mirrors into his own work.

Gertrude Pacific, with art in Bank Conway

Beck and his wife, surrealist and mystic painter Gertrude Pacific (also known as Trudy Beck), were living in a former bank they had purchased in Conway, about twelve miles east of La Conner. During the short period in which she lived with Beck in the valley, Pacific was inspired to paint the fields that stretched between Conway and La Conner and Mount Vernon. She also served as the physical inspiration for a character in Tom Robbins' novel, *Another Roadside Attraction*.

Heald was already familiar with the area he had passed through as a boy riding motorcycles with his brother, fellow artist Paul Heald. Paul also lived in Skagit County.

After arriving at Beck and Pacific's home in 1970, Larry Heald decided to settle in the area and bought a house "up river" on the Skagit for about $13,000.

Larry Beck

One year later, Heald and Beck were inspired to launch an art school in La Conner. They were aware of the Fidalgo Allied Arts program that had thrived in La Conner's Penington Building downtown less than a decade before. Although the school had been shuttered for several years, it still bore the painted sign of that former academy. So Beck and Heald met with Ruth Penington, who had settled at Rosario Beach, near the location of her first version of the school at Quaker Cove. She offered them some encouragement and a lease for their own summer school for artists which they entitled the Fidalgo Art Institute. That, Heald recalled, was close enough to the name of its predecessor that they were able to employ the same sign.

Inside the old school they found abandoned looms, potters' wheels, kilns, all set up as if ready to be put back to use in an instant. They opened the street level floor for classroom instruction and rented some rooms upstairs for students to paint or live in for $12 a week. School tuition for the six-week course was $100. The school enrolled about twenty students from as far away as New York, Los Angeles and in between and some local people as well, including lifelong resident Roberta Nelson.

Students weren't simply painting pretty pictures in the studio; they were out in the Skagit Valley interacting with nature, chasing down their creative muse. Nelson recalled a life drawing class in a La Conner field for which the model removed her clothes and the local males soon appeared, seemingly out of nowhere, to watch. The small town could still spread news at breakneck speed when the artists were involved. In another class, students took a boat to a nearby island to make a movie based on a story from *Mad* magazine, and enlisted the assistance of a passing fisherman to hold the camera while they performed.

In their enthusiasm, the young actresses shed the constraints of their clothes and the drama inevitably attracted an audience of fishermen who joined the cameramen.

Heald and Beck were the sole art school instructors but they invited artists up from Seattle for lectures and slideshows, and many of those lectures were open to people in town. The school also offered an exchange program in which students could visit Pilchuck, Dale Chihuly's fledgling glass school on Pilchuck Mountain, and the glass students could come to La Conner for painting and sculpture classes.

Students embarked on weekly drawing trips up to Deception Pass where they would spend the day plein-air drawing or painting.

By the end of summer, the school had earned a profit of $125, not enough for the two friends to live on. "But that wasn't the point, we were just having a good time," Heald said.

The artists formed friendships with the Swinomish tribal members as well. Robert Sund had a close friend in Rosie Cayou among others in the tribe; and artists and the Swinomish shared their food at potlucks. Smith recalled that Anderson and Gilkey were at the reservations regularly; the tribe understood them, he said.

New Yorker Edward Kamuda got out of the Navy in 1971, loaded

up his Ford and moved to the Skagit area after having heard about the tranquility and beauty of the Northwest from a friend serving with him. He enrolled in classes at Skagit Valley College and not long after he discovered La Conner. "I was looking for a quiet place to think and boy did I find it." He located a summer home on an unused float shack on a cove outside of La Conner, like Slater, not far from where Betty Miles was living, and lingered on his porch each night to watch the moon's reflection passing over the water, listening to frogs performing nightly concerts, enjoying misty mornings with herons wading past his front door.

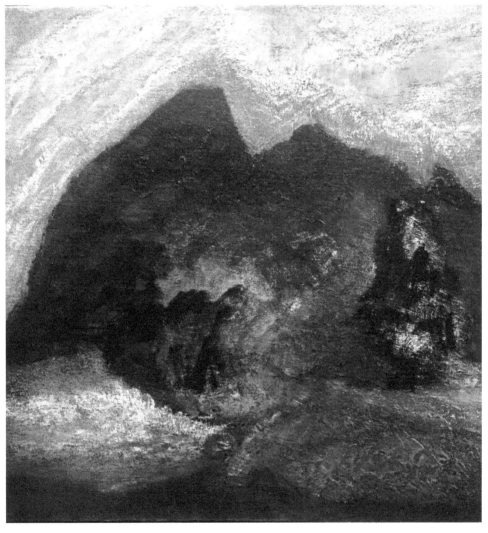

Ed Kamuda, untitled

One afternoon in 1973, he came across a man with a loping stride carrying two gallons of water down First Street. "He had a powerful aura about him and I said, 'Who is that?'"

His companion responded, "Oh that's Guy Anderson. He's a famous painter." Kamuda was painting himself at the time, although, like Krafft, he'd gotten his creative start with poetry, and then picked up a brush to experiment with art. The next time he came across Anderson he summoned his courage to approach him, introduced himself and asked the elder painter if he ever offered lessons. "I don't teach," Anderson responded. However the conversation had been started and Kamuda and Anderson developed a close friendship.

Watching Anderson work served to fuel Kamuda's own desire to paint. One day it would seem that the famed painter was idling the day away, immersed in reading about Michelangelo, the Egyptians, or perhaps listening to music; the next day Kamuda would return to see a large completed painting on Anderson's floor, inspired by the previous day's musings.

Anderson was at once playful and inquisitive, Kamuda recalled. "Tell me," Anderson would earnestly ask, "Do you know who you are?" On other occasions he posed the question, "Do you have a sense of our being on this planet, spinning through space?"

These were not simply idle questions. A decade later, in an interview for the Smithsonian with Martha Kingsbury, he described these fundamental questions:

"One of my difficulties is thinking that right now I'm alive in the universe at this second, that I am on the earth and I'm just as much in space as if I were way out in the constellation of Hercules. I know it cerebrally; I know it intellectually—but to really sense and know that right now I am as much in space as anybody who'll ever go out there. We don't know where we are in space; we think we're at the edge of the Milky Way, and in the solar system. This is one of the reasons we think about poetry, we think about history, and we think about painting; those are some of the important things. So I have to think [that] the preparation of the whole system is to bring about higher manifestations; and God knows why, I have no idea! Maybe if we even had quite an inkling of knowing it, we probably wouldn't have to do anything then; we probably would have arrived at some place of knowing. But I don't see that much in my experience, yet, and I'm

not very good at meditation. I can't really know for sure that I am in space. It's hard for me to know."[1]

Clayton James advised Kamuda to head outside and begin plein-air painting. The landscapes he saw struck a chord in Kamuda; the swiftly changing cloudscape, the fields, and most poignantly, a plowed field with its expanse of dark, churned up soil left a deep impression on Kamuda. He explored these landscapes with paint many times.

The crafts movement underway in the Skagit Valley continued to draw new artists, some from outside of the state, including potter Charles Talman who arrived in La Conner in June 1972 after being released from the Navy at Whidbey Naval Air Station. His and wife Linda's original plan was to live in Vermont or New Hampshire and market Charles' artwork in Boston. But La Conner had struck them as similar to Pennsylvania's Delaware River town of New Hope, another waterfront town with a large drawing of artists selling their wares. They initially made their way to Boston, but already the seed was sown, and soon they returned to Skagit Valley.

Keith Wyman, by this time a realtor, sold the Talmans a house with a studio where Charles could do his work. He built a kiln, modified his studio space to accommodate pottery, and went to work. The couple opened a pottery shop in a shed-sized building on First Street, where they sold stoneware and porcelain pottery. They were surrounded by like company: small businesses selling jewelry, ceramics and fabric arts as well as paintings.

Not long after the Talmans settled into their new home, Clayton James and Guy Anderson arrived at their door and introduced themselves: "We heard you're the new artist in town." Young Talman, barefoot and sporting an afro, felt the stark contrast between himself and the more conservative, middle-aged artists. However, he had no idea who they were. "Not being from the area, I was not part of the Northwest art scene."

A good percentage of La Conner's residents, like Buster and Margaret Lee at Fish Town, accepted this new younger group in stride, although the parties and drinking got bad enough that at least once the town's increasingly popular "Smelt Derby" was cancelled due to public drunkenness.

Another of the central meeting points for artists, farmers and anyone else in town was the Nordic Inn, owned by the Norwegian-American

Bakke family, where people gathered to buy a meal and in some cases even to receive a handout. Ruth Bakke bought the Nordic Inn 1970 with her daughter Kit (Katherine) LaMont. Formerly the Planter Hotel, the place had fallen into disrepair having been vacant for several years.

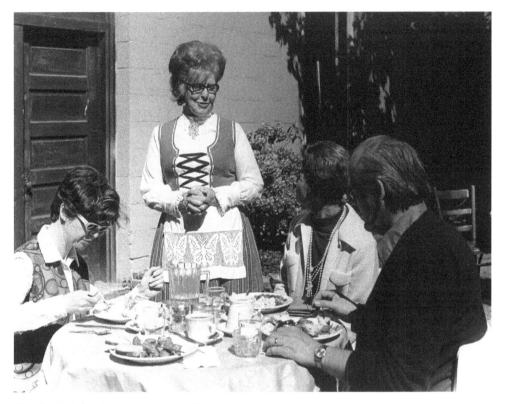

Ruth Bakke hosting Rita Hupy

The family cooked behind the dining area on the street level and rented out rooms on the second floor overlooking the Swinomish channel and Rainbow Bridge. The Bakkes used the rooms not only for residential tenants but also rented out commercial spaces for a beauty shop, antique shop and an architect.

As Ruth Bakke recalled, the customers consisted of locals—Puget Sound freight crew, Dunlap Towing employees, city workers, farmers, shipyard workers, cannery people—as well as tourists.

Sunday morning people crammed into the dining area for pancakes, cooked on the grill on an old stove, the batter mixed in a barrel, Bakke said, and in one day the entire barrelful would be consumed. They also put eggs on top of the pancakes and folded them

over; "they were our biggest attraction," she said. The favorite seating area was a big round table, specially built, where ten chairs could be crammed with locals drinking coffee and flipping coins to see who paid, fishing poles parked alongside the table.

While some of the artists quietly ate their meals without demands or disruption, "others were not so sophisticated," she said. Sometimes the staff complained, Bakke recalled, about hippie artists who would come in with little money to spend, or who would discard their newspapers on the floor. "They were well educated but they were careless."

Occasionally Bakke would exchange work for food. "To this day that has been my principle; if they need food I just give them something to do. I didn't give them money ever but I did give them food."

Not all the artists in the Skagit Valley were starving anymore; some were making a living in the arts and crafts shops downtown or teaching. And for the first time, many of the artists coming to town were women.

Sheila Klein, today a renowned sculptor whose work includes dressing of public buildings with hand crocheted and knitted steel, was born and raised in Pittsburg. She moved to Israel and then Mexico before meeting people from Seattle who encouraged her to move to the Northwest in 1972. She lives in Bow in the Skagit Valley part time.

Her attraction to the Northwest was the escape it offered from the crowds in Mexico. "I wanted to go back to the land." She found that opportunity at a house on Camano Island where she helped with chores like milking goats to make enough money to feed herself.

Fellow artist and friend, Charlie Berg, told her about a house he owned, which she described as "the chicken coop," in what is now the Southfield area of La Conner.

She was there about a month before Ruth Bakke suggested she rent the studio located behind the Hotel Planter. There was no plumbing, but enough room for her to have her studio where she was weaving tapestries. She earned extra money teaching weaving workshops.

In 1975 she bought a house on the Swinomish Reservation at the corner of Snee-oosh and Indian Road. Louie and Roberta Nelson helped Klein build a functional house there, she said. Today its remnants have succumbed to tangles of blackberries bushes.

She befriended Doris Thomas, the artist who had once been part

of Tom Robbins' connection to La Conner. The two launched a two-woman art show at Louis Nelson's lumber yard where art lovers and lumber buyers could comingle and peruse their work.

In 1977 Sheila moved to Seattle and began exploring sculpture rather than weaving. "I still came up here a lot," she said, for the social scene. In 1983 she moved to Los Angeles before eventually returning to a farm in Bow where she still lives today.

In the late 1980s her career took off with many sculpture commissions, first in Chicago, then in other cities nationwide. "I've always been concept driven," she said, and she pursues the idea of the interconnectivity of the world rather than one medium such as weaving or paint.

As a member of the Skagit Valley artists, she said, "I was more untraditional," as a weaver rather than a painter, but her connection with artists like Guy Anderson and Clayton James inspired her early. "What was cool was to see Guy, Clayton, Barbara (Straker James) doing what they did. That was very positive, very encouraging," she said.

New Yorker Barbara Silverman came to La Conner in the mid-seventies and applied for a job at the La Conner schools as art director, position K-12.

Silverman was fresh from an MFA program at Hunter College where her thesis consisted of a one-person art show in a SoHo gallery. In New York she had fallen in love with abstract "hard-edge" painting and stroked bold patterns over large canvasses. In school the common consensus was that art was dead, she recalled. She came to the Skagit Valley in the 70s disillusioned with New York. Her previous husband was a sculptor at the Kansas City art institute and it was there that a friend told them about a town he had moved to, La Conner, and the road where he lived—Pull and be Damned. She felt as if she was in hobbit land, when she arrived, surrounded by deep forests and soaking rains.

When she started her job at La Conner schools, there was no formalized art program. In fact, there were no art books, no slides and no templates. "I thought, how can I teach high school students?"

When she went to school Superintendent Paul Avery in search of guests to help inspire and train students, he gave her a lengthy list of local artists for some assistance. She sent each a written note

Barbara Silverman Summers, NW Woman

announcing an art show she was organizing for the high school and, "would you come?"

Guy Anderson called her promptly; "I have four drawings." Once she gained the nod from Anderson, she recalled, everyone else began calling, "Charlie Krafft, Clayton James, Robert Sund, everyone." Guy was uniquely interested in Silverman's background in the New York art world and her work in conceptual art, she recalled.

Meanwhile, the La Conner schools superintendent liked the 1974 show at the high school enough that he asked Silverman to put another one like it together in 1975. She complied and then gathered a third together in 1976. Paul Heald designed a silk screen for the 1976 show. Silverman also showed her own work. "I liked the feeling that here, in La Conner, art wasn't dead."

At that point Silverman invited Sund to teach in the high school and, she said, she gained some private lessons from him as well in calligraphic art. "I had so many people come in, paid them a certain amount of money and they would be artists in residence." But the program was short lived. In the late 70s the district's art funding ran out. The program had lasted from 1974 to 1978.

Silverman developed her own body of work in the meantime, approaching each painting as its own journey, she said. Like Anderson, she painted with spontaneous, energized strokes. She often painted layers upon layers, then etch them away until a rich surface emerged. She exhibited her paintings nationally and internationally.

Anderson influenced many of the local artists including Barbara Silverman, who said Slater was the artist who made her want to paint. He painted with quick gestured strokes, she recalled, following themes of vessels, females and boats. "His work was very sophisticated." On the other hand, "Guy, I credit all my circles to him," she said. Barbara became known for her bold calligraphy circles. All her life, she said, she liked the idea of depicting the idea of female with encompassing circles.

After Barbara Silverman came to La Conner, she said, her hard edge minimal painting changed as she looked at the mists around her and began incorporating Eastern and Western modern art. "I didn't ever consciously say one day I'm going to do this," she said.

Painter Betty Miles, a Cornish Art Institute graduate, arrived in La Conner in 1969. She had spent the past decade travelling and

collaborating with painter Jack Stangle in Seattle. Now, however, she left him behind and would pursue art and life on her own.

In La Conner she found that boarded up buildings and soaped windows still dominated La Conner's First Street. She got a bargain in housing—$50 a month for a room at the Planter Hotel. She shared the residence with a group of Japanese workers who had come to pack fish eggs to send back to Japan.

Betty Miles

The hotel was a temporary solution and in 1971 Miles built herself a float shack on the Swinomish Channel—just beyond the Moore Clark building—off First Street. She lived a Spartan lifestyle, she recalled, with no lights and no running water. She used a Coleman gasoline iron, clothesline and Aladdin lamps, and a hand pump for her bathtub—to keep up appearances, she said. "I had a ball. I threw parties. I had so many people on the float-shack it sunk once." They were all wild people who could appreciate a party: fishermen, farmers, artists.

160

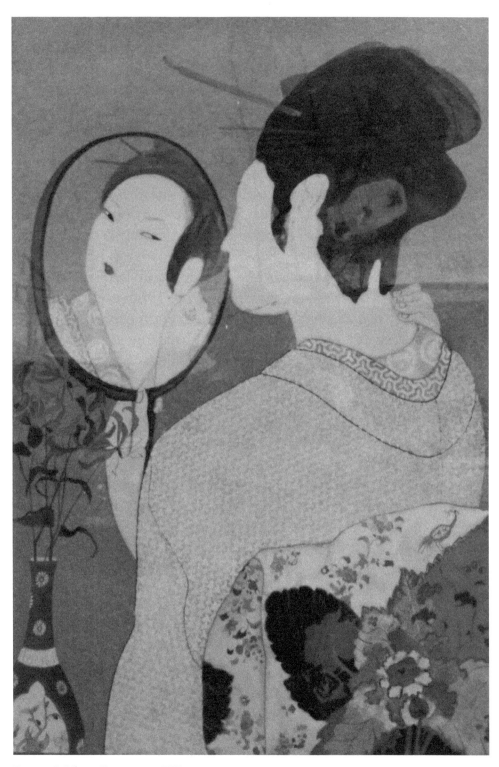

Betty Miles, Japanese Woman

Years later, Miles still waxed nostalgic for the old La Conner of the 1960s. "It was beautiful—empty buildings, empty shacks and wonderful people. Keith and Maxine Wyman threw wonderful barbecues. Everyone was welcome; they were wonderful to all of us."

In the meantime, Miles was painting. Her work, like that of so many of the artists, had an Asian, mystical influence. Stangle had introduced her to proprietors at the Kirsten Gallery that sold her work. "I was just painting, selling mostly in Seattle."

Fellow artist Maggie Wilder came to La Conner in 1977, moving aboard a boat and mooring it beneath the Rainbow Bridge spanning the Swinomish Channel. The boat would be her home as well as a cramped painting studio for eight years. "It set me amidst a wild confluence of energies."

Her high school art teacher had first brought her and another student to visit what was—at the time, in the 1960s—a dilapidated fishing village. Her teacher was drawn to the atmosphere, the rich textures of decay and renewal. Wilder felt that same attraction. "The valley, the estuary, the islands are geographically complex," she said, providing rich subject matter for artists, with the estuary blending fresh and saltwater, a cloud covered sky serving an ever-changing diffused light. The fog banks and vapors pulled over the valley, the dikes barely held back the tides. "The division between earth, water and sky are always shifting," she pointed out.

After eight years on the Swinomish channel, Wilder moved to a remaining structure in Fishtown and made a study of the luminescence around her new home and studio on the Skagit River. One of the most captivating subjects, she said, was the light-scape when dusk followed sunset, providing an opportunity to watch and listen as the color slowly faded and the nocturnal world came alive. Painting the following day was, in her process, a way to re-experience a light-event. She painted in the same kind of translucent layers she found in the atmosphere, hoping to reveal an inner glow beneath it all.

The place offered solitude and a contemplative life different than the isolation she'd felt in busy Seattle. She attributed the growth of the artists' community to the beauty of the environment.

Wilder developed friendships with the local artists, including Anderson and the Jameses, Gilkey and William Slater. None was pursuing notoriety, and she said even the more acclaimed artists treated

her as an equal, even during her earliest years as a painter.

"Nobody I knew came here to get famous or rich. It was a place to work: A place where the pressures of life were less."

Maggie Wilder, When Dusk Had Meaning

Wilder's link to the Northwest mystics was based on the local art history and her sense of animism that came from studying the light, both radiant and reflective, that abounded. Her life, she said, was a journey, "investigating the liveliness of all things."

La Conner local Lea McMillan, the former pea cannery coworker of Morris Graves, by this time older than many of the new arrivals, learned to appreciate the artists who migrated to La Conner in the 70s, bringing arts and crafts to the boarded up buildings of the waterfront. "I always say it's the hippies that made La Conner," she said.

"Our buildings were all falling apart. The hippies came over here, and became good citizens, they really saved the town. I give them credit for that," she said.

While some may have stolen corn from the field, or kept the town up at night with parties, they didn't cause any serious damage. In fact, she recalled with a laugh, they changed the landscape of La Conner in many ways, including the store front and sidewalks that were dotted with dogs waiting for their owners. "They all had dogs they'd bring into town," she recalled.

Lea McMillan

La Conner attracted the attention of Hollywood actor Kevin Tighe in the mid 1970's. He'd first visited the Northwest to attend a Lummi Indian Tribe powwow on Lummi Island, north of Skagit. He stayed up all night talking to a village elder, "my first mystical experience in the Northwest," he later recalled. Shortly after that visit he discovered what he called the mystery and humor of *Another Roadside Attraction* and was interested in meeting the author. A mutual friend facilitated that meeting at the home of Keith and Maxine Wyman. Tighe later remembered Robbins greeted him with a rose locked between his teeth.

Keith and Maxine subsequently drew Tighe to the Northwest. He described Keith Wyman Sr. as a "sometimes gruff mentor with a sense of humor reminiscent of Hemingway and Jack London." He could, when inspired, recite the poetry of Robert Service with singular flair.

Wyman, Tighe found, was as comfortable with a fishing rod and shotgun as he was with the inclinations of writers and artists, natives and non-natives alike. The Wymans provided local artists with an open door, and La Connor became a second home to Tighe. This was a place where he could be himself, "and share in the bounty of good conversation," he said.

Soon after he returned to California, he said, Keith Wyman called him and said "Get your ass back up here."

A few months later, Tighe traded his Porsche for a pickup, bought a home upriver, and embraced the quiet of the Skagit Valley. He acknowledged that the choice of moving away from L.A. reduced his acting options; he didn't mind. "I'm grateful for the friends that I've found and the time still remaining to write one good play and perhaps one good poem."

A decade later he would marry painter Rebecca Fletcher. They moved from the river to a house with an existing outbuilding well suited for an art studio, in a setting that featured a vast vista of the Skagit Valley and the visual drama of the Northwest sky.

In 1975 Guy Anderson was awarded a Guggenheim Fellowship which afforded him a larger income. By this time he was searching for a new location for his First Street living space and highly visible studio.

Architects Mark Pederson and Cort Liddell acquired what was Guy Anderson's home and studio and not unlike him, they worked in view of curious onlookers, where town people and tourists could walk by and peer inside.

Pederson got his license in 1977, opened his own office and when he was looking for a space in La Conner, he was directed to Guy Anderson. At the time, Pederson recalled, Anderson was preparing for a large show in Seattle and was using a former bookstore in town to stage things—hanging his big paintings in there.

"Oh I think that would be fine. It would be nice to have you next door," Anderson told Pederson when he asked to rent the property.

As Anderson's new neighbor, the architect found Anderson had

Guy Anderson, Purusa Series

a fleet of admirers and fellow artists coming and going from his residence.

"I learned from being around Guy; he had a perception of the world that made him very comfortable with life. I think his art was an expression of that." Pederson speculated on just how Anderson was able to manage his own success in such a way that it never cost him his privacy. "He was very clever," Pederson said. "He figured out a way to be moderately well known and still pursue his own life without too many people needing to know too much about him."

In the meantime, Anderson built a new house several blocks off First Street on Caledonia. "I think he enjoyed having us next door, but was spending more and more time at Caledonia and finally we asked him—'Can we have the rest of the building?'" About 1980 Anderson moved out and the architects rented the whole space. In the garden behind Anderson's studio, they found a wooden manhole cover with a handle on it painted by Anderson with his typical earth tones. Thirty-seven years later it still hung on their wall. "It's a personal thing," Pederson said.

"Knowing someone like Guy was very important in framing the philosophies I live by today," said Pederson. "He was a non-materialist person, without a lot of attachments. Someone could have taken things from him and he wouldn't care. He just had an unwavering happy state of mind." He added, "One of the rules of living in La Conner was that you don't judge other people as long as they are not being self-destructive or hurting others. We were all so different but no one judged."

Anderson's new Caledonia Street home included a fenced-in garden where he often kept his art work, despite its being thoroughly soaked on a wet day. He hung African masks, sculptures of the many armed Hindu god Shiva and other paintings, many on reinforced brown roofing paper spread out for the elements. His success was still understated. In fact, he rejected creature comforts like electric heating, and still washed his clothes in a large tub, churning his clothes in soapy water with a plunger. When friends expressed dismay, he said it was good exercise.

In the meantime, his old friend Morris Graves had moved to California and was living an esoteric life there, gaining attention from the Californian as well as the global art world.

Although he and Anderson had fallen out of touch decades before, Anderson still spoke admiringly of his old friend's work, and Graves also kept an appreciative eye on Anderson's career. In 1975 Helmi Juvonen, who was by this time committed to a mental institution again, thrilled in a letter to Graves, her close friend, over Anderson's successes, "Guy Anderson got a Guggenheim scholarship!"

In 1981 Ed Kamuda, Charlie Krafft, Michael Clough, Ed Nordin, Ralph Aeschliman, Paul Havas, John Schaffer and Susan Skilling contributed to a Pacific Northwest Invitational Exhibition at the Bayard Gallery on West Broadway in New York. It was the first time since the "Big Four" that Northwest artists were given an audience in New York.

Rain in the Chuckanuts
for Robert Sund, his 60th birthday

Robert, I can't say
I know the Skagit
never lived
by its banks
but tonight I'm happy
rain pelts the windshield
one wiper lame
between my legs
a bottle of burgundy.

I'm going home
to the Skagit, coming
down from the Chuckanuts
(how the lights have grown
and sprawled over the years).

I still don't know
the Skagit
its courses and eddies
barely know the mountain
of my mind.

Driving across the valley
home to Mount Erie,
to the crevices
filled with salal
bluffs spotted with
burned ancient fir
and Whistle Lake hidden
just over the ridge.

Going home
to Mount Erie
going home
to my mind.

—Bob Rose

Chapter 11

Gaches Mansion and the Museum of Northwest Art

Skagit Valley began its most concerted effort at organizing and publicizing its artists in the 1970s and 80s under the leadership of a handful of business owners, art patrons, and the artists themselves, as well as a tireless Northwest photographer and artist named Art Hupy. In his three decades in La Conner, Seattle-native Hupy would open the town's First Street art gallery, join a group of businessmen in creating the annual Art's Alive festival, host the annual event "Paint La Conner," and originate an ongoing artist workshop out of his home that drew students, painters and sculptors. Hupy had a vision for the valley's artists and the community they lived in, to be recognized on a world class level, recalled art patron and organizer Pat Doran. But Hupy's most permanent contribution was the creation of what is today the Museum of Northwest Art, making arts a permanent fixture in the Skagit Valley.

Hupy was born in 1924 in Seattle. He married Rita Manning (co-author of this book) and they moved to Los Angeles after World War II where he studied photography at the Art Center College of Design. From that point, photography and art were his lifelong passions. Hupy was best known and acclaimed for his architectural photography. He also photographed images for *Sunset* magazine, UPI and the *Seattle Times* and captured sporting events for local newspapers and magazines. Often his subjects were Northwest artists and their work. In addition, Hupy sold his photographic art—pieces that reflected the Northwest and those who lived there. He took his time with his imagery and used light as his medium to capture the mood of the subject. His work often evoked a haunting isolation, for example, the simple interior of a lonely cabin or abandoned home, or a tractor, dignified in its neglect.[1]

Hupy spent much of his time looking skyward, as did other Northwest artists, but in his case it was for the effects it had on the art of photography, especially capturing the essence of a piece of architecture in the best possible lighting, just the right moment, as clouds

passed over the sun. "You have to dramatize the form with the precise lighting," he told a *Puget Sound Mail* reporter in 1980. "The secret is lighting and form. And form is lighting." He was known to wait days to capture the right lighting for a picture of architecture that earned the architect awards for 30 consecutive years.

Art Hupy, self-portrait

Many artists and their work have been depicted in photographs by Hupy, including Anderson, Graves, Callahan and Bill Cumming. Often he traded photographs of the artist for a painting. His first sojourn to the Skagit Valley was prompted by a *Sunset* magazine photo shoot of the Penington Allied Art School at Quaker Cove. He also came north to La Conner for several other projects—to photograph Guy Anderson as well as the newly built Rainbow Bridge (the signature orange bridge that connects La Conner to Fidalgo Island at the Swinomish Reservation).

Interior of Hupy home in British Columbia

Like many of those who live in or migrate to La Conner, he had a unique take on life. In 1959 Hupy launched an award winning magazine, *Advent*, but published only the one edition and stopped. He was looking for something different and hoped to devote some time to his other interest—painting. Tired of U.S. Cold War politics—nuclear pressures building with the escalating Vietnam War and the Bay of Pigs in 1962—he decided he wanted his family to be able to live off the land in the event of nuclear war. In 1963, after more than a year of planning, he and Rita brought their three sons to a remote British

Columbia island in Blind Channel, where they lived in a one-room home they built themselves. They hauled their own wood, used a ten-gallon crock in a nearby stream as a refrigerator, and cooked over a woodstove which also supplied the cabin with their heat in the winter. Most activities centered around the table, where meals were eaten and where the boys did their school work provided by a Victoria correspondence school. Hupy painted in a loft studio. The neighbors amounted to a scant handful of loggers or fishermen, but when they visited, they too gathered around that table.[2]

After three and a half years, the family, in pursuit of like-minded people, moved to Vancouver, and Hupy drew income from designing company logos while he retired permanently from painting. He also returned to work in Seattle where he befriended former Quaker Cove and Penington art school resident Dick Fallis. When Fallis bought La Conner's only newspaper—*The Puget Sound Mail*—from Pat O'Leary in May 1973, Hupy agreed to visit the little town on some weekends to chronicle local events and people photographically. Art and Rita took a liking to the place.

Hupy's time was not all spent in the Skagit Valley. In 1970 Seattle glass blower Dale Chihuly with art patrons Anne Gould Hauberg and John H. Hauberg (who donated the property), were building the Northwest's first fine art glass school. The Pilchuck Glass School was erected on a former tree farm on the slope of Pilchuck Mountain about 20 miles southeast of Skagit Valley. Chihuly enlisted Hupy to photograph the buildings as they were constructed. Hupy and his family set up camp in a broken down cabin obscured in the thickets and thorns at a damp clearing in old growth forest with panoramic views over the Skagit Valley into the Puget Sound. Hupy covered the school's development in pictures as it came to life, and as artists and students arrived, long before the structures were complete. Some students, in their enthusiasm, slept in stumps and knolls, any place where they could stay dry for the night. The school opened for its first session in summer, 1974.

In 1970 Hupy decided to open an art gallery in La Conner. By this time he had met many of the local artists, including Anderson, and determined that the high quality of art in the area warranted a gallery where their work could be appreciated and sold. Located on First Street, it was initially open only on weekends; he and Rita slept

in the room behind the gallery which they rented for $100 a month from Bud Moore, future La Conner mayor as well as the nephew of Roberta Nelson.

Patrick Holden, a *Daily News Wire* editor, described Hupy's gallery as littered with wood, brass and ceramic sculptures, the walls crowded with oil and watercolor paintings. Holden also described Hupy—whom he referred to as Humpy—as disdainful of art critics. "The only way that you can criticize a work of art is if you are in the artist's head at the instant it is created," Hupy had said to Holden. "It's the only time you have the right to be critical." Otherwise, he said, "You don't know what was in there when he put the painting on the canvas."

Architectural designer Glen Bartlett and his wife Kay came to the Skagit Valley in 1966. Bartlett had been a journalist, poet, actor and radio operator in the Navy in addition to designing commercial and residential properties in the Seattle area. The Bartletts had been spending summers on Skagit Bay for years before they moved into La Conner, but in 1966 Glen bought property on First Street and opened a studio beside what became Art Hupy's gallery. The two became friends. Bartlett rented out a small café in the building and dedicated the exterior space as a courtyard for outside dining. The place was a popular gathering place known as the "Courtyard Deli." The locals who frequented the new deli were not what Bartlett might have expected of a small town. He was impressed with the conversations he heard at the tables around him, "They didn't talk about high finance or football. They talked about art. There were always the most unusual conversations going on in that little delicatessen," he said.

The deli was also frequented by the Bartletts' son Craig Bartlett, who sketched drawings there at the time, and went on to a career as animator creating several television series and live action films as well as serving as executive producer of several PBS animated programs.

In the mid 1970s some of La Conner's centerpiece businesses, such as the pea and fish canneries, now stood empty, home to seagulls, giant waterfront rats and pigeons. It seemed La Conner's early history was slipping away as the older buildings succumbed to the wet, mossy weather. While they made great subjects for artists to paint, the once thriving buildings were quickly rotting away.

The Gaches Mansion, a three story, 22-room home built in 1891

and inhabited by the wealthy George Gaches family, was a dilapidated apartment building known as Castle Apartments. The three-story Victorian home had been built during La Conner's oat-producing heyday and overlooked the Swinomish Channel and Fidalgo Island. In its 90 years of life it had served as a private residence, hospital, then low-cost dwellings. One late night in 1973, while a tenant was out, a fire ignited in one of the upper apartments. The fire gutted the top two floors and incinerated the roof; the building owners, Art and Mary Herrold, couldn't afford the repair work necessary. It sat vacant throughout the following winter.

Gaches Mansion fire

One winter day Bartlett toured the building to assess the damage with artist Ed Kamuda. "Here was this huge structure that was one

of the centerpieces of La Conner," Kamuda said. They couldn't let it disintegrate. Kamuda and Bartlett began exchanging ideas to prevent the building's demise. They wondered about calling a coffee klatch to decide how the mansion could be saved. In February 1974, Fallis published an announcement for that meeting at the Nordic Inn, in the *Puget Sound Mail*, with a simple message—if someone didn't act, the town's most historic building was going to disappear. The city council was already eyeing it as a hazard and public nuisance.

Twenty-three people attended the first meeting. The group went on to become what was called the La Conner Landmarks Commission, incorporated as a non-profit group including dozens of La Conner residents such as the Bartletts, local farmer Bob Hart, the Hupys and Fallis.

Membership eventually swelled to 183. When the owners announced they would sell the mansion, Landmarks bought the place with a 15-year mortgage, personally guaranteed by the group's board of directors, and then began the daunting task of raising money to pay the mortgage, in addition to the tens of thousands needed to repair the building. [3]

In October 1977, Landmarks members were already holding a "Burning of the Mortgage" ceremony after making the final payment on the loan. The group held work parties to do much of the repair work themselves, and teenagers, adults and the elderly ventured into the building's charred interior to tear down stairs and walls, pull out old wiring, and rebuild, with the help of several contractors. Craig Bartlett painted a mural on the ceiling inside while Ed Kamuda and Deryl Walls did exterior work, including painting the entire facade.

One of the most critical achievements for Landmarks on behalf of the mansion came from an interior designer from out of state, Judi Reeves. She and her husband Jim were living in California when they saw an article featuring the Gaches Mansion and the dilemma before the cash-strapped Landmarks group. Judi Reeves, who at the time was an interior designer working on a designer showcase in the Bay Area, sent her sister who lived in Washington, to meet with Landmarks and suggest a similar event in La Conner. Landmarks listened to her appeal and ultimately denied it as too ambitious. Despite that, the Reeves moved to La Conner, enchanted with the place. They opened an interior design business and joined Landmarks. With the support

of Bartlett they again broached the designer showcase concept to the board and this time convinced its members. Landmarks proceeded with a showcase event, drawing from local interior designers to decorate each room in 19th century style, at their own expense.

Kay and Glen Bartlett

The designer showcase was held in September 1978 and about 7,000 people attended, greeted by a crew of 200 volunteer hostesses, many from the neighboring community of Shelter Bay. Visitors paid $3.50 for admittance.

The mansion's restoration funding also came from local contributions. The Dunlap family, which operated Dunlap towing in La Conner, had traditionally given to regional causes (Jim Dunlap often gave money to programs such as college athletics at his alma mater)

Connie Bartlett Funk with wearable art

and his wife Phyllis got interested in this effort. "I remember Jim said, 'I don't know what they can do with that mansion,'" Phyllis Dunlap recalled, "and I said to Jim 'I think if you can give $1,000 to WSU (Washington State University) athletics, we should be able to give $1,000 for the mansion.' So we did."

Other contributors were "Nasty Jack" Wilkins who loaned antiques from his store, and Louis Nelson, who gave the group keys to his hardware store to take whatever they needed.

Once the mansion was restored, Hupy, who was looking for a new rental space, moved his gallery there and took over the second floor, leasing it from the Landmarks Commission.

Museum interior

In 1978 Hupy launched "Paint La Conner" with the Puget Sound Painters which summoned artists from Vancouver and Seattle to slog into the fields and mud flats with paints and canvas in tow. They worked there for a day, painting their own version of what they saw and selling the results at a garden party that evening.

In 1981 Hupy closed the doors of his art gallery and re-opened them as the Valley Museum of Northwest Art. The mission was to preserve the Northwest tradition for future artists. La Conner's first museum, and one of the few art museums in the Northwest outside of Seattle, the Valley Museum included the works of Anderson, Gilkey, Bill Cumming, Kenneth Callahan, Philip McCracken, Clayton

James, Robert Sund and Charles Krafft as well as William Ivey and George Tsutakawa. Hupy looked for artists with a discerning eye and was open to multiple mediums and abstract, landscape, still life as well as sculpture in stone or wood. The museum became one of the best ways for local artists to gain prominence. It was also a way to feature the masters, such as a 1984 "Tobey reflection" exhibit, in which artists who had been influenced or taught by Tobey displayed their own work—a moody, mystical show resulted.

Paint La Conner, art program

Hupy didn't forget the town locals who had supported the mansion. As he put the museum board together he paid a call on Phyllis Dunlap. Later, after the construction was complete and the museum established, Dunlap recalled that visit from Art Hupy. "He came out and introduced himself and asked if I would be interested in being on the board for the art museum. I said I don't know anything about

art." Not to be discouraged, Hupy indicated it was the family name of Dunlap, well-known and respected in town, that he wanted her to bring to the board; no experience in art was required. Dunlap not only agreed to join, she began learning all she could about painting and sculpture. "Then I began to look back and realize that those artists who were up here were quite famous."

Art Hupy's school with Bill Cumming

Hupy had started several other art programs in the meantime. In 1979 he began the La Conner Workshops, an art program presented by the museum with teachers such as Seattle's Bill Cumming, painter and graphic designer Fred Griffin, and watercolorists Jess Cauthorn and Deanne Lemley. The school continued for 18 years under Hupy's direction. Students took their instruction from professionals, learning some basics of painting or sculpturing and eventually other crafts as well, while Rita cooked expansive meals for the attendees. Many stayed nights at their bed and breakfast, known simply as "Art's Place."

Then, in the early 1980s, Martin Hahn, owner of the Black Swan Café on First Street, came up with an idea for an annual arts festival.

For years Hahn had served meals to artists as well as employing several of them. Ed Kamuda, for example, worked there, as well as Michael Clough and Paul Hansen. Kitchen conversations often covered philosophy, literature and art. Guy Anderson, who could stroll to the restaurant from his home next door, often came for dinner and would join dignitaries such as Seattle painter and collagist John Franklin Koenig at a table near the front door, where they would linger over long meals and conversations, not unlike the discussions taking place in the kitchen. Anderson worked out a trade with Hahn to pay for meals with a painting. Hahn often took art in exchange for meals from locals and also hung the work of his employees on his walls in exhibits.

One evening in 1984 Hahn and his staff were sharing a meal and a bottle of wine after hours and began discussing the concept of a festival that would highlight the art community as well as local businesses. What Hahn envisioned was an event that would extend La Conner's commercial season—bringing people from Vancouver and Seattle at a stark time when few ventured into the waterfront town: November. This would be more than just a static exhibit though; Hahn thought it would be interesting to bring artists into businesses and other public places to actually do their work for an audience. They would call it "Art's Alive," representing the live feature of real artists at work. First he approached Rich Machen, wine merchant and owner of Marine Chandlers—a wine shop catering to boaters. They agreed on hosting artists at his business, as well as organizing other businesses and artists. The two also brought in Hahn's wife Kelly Matlock, owner of a fabric shop known as Chez La Zoom that sold its products to fabric artists. The threesome next took the idea to Hupy, who enthusiastically joined their effort. Michael Hood, owner of Barkley's restaurant, and Stuart Hutt, owner of the Wood Merchant, joined in the first year's planning as well. Barkley's offered a local beer tasting; Wood Merchant would feature wood carving, and the Black Swan would hold a poetry reading. The festival would also be a fund raiser for the museum.

At Hupy's request, Dale Chihuly donated a blown glass vase for the event, and wine and food author Angelo Pellegrini donated his own wine to put in the bottle. The Valley Museum held an expanded art show featuring dozens of artists, some showing their art in a

formal setting for the first time, at the mansion.

While Hupy rarely painted or sculpted his own work during this phase of his life, he became the town's promoter and was enjoying a reputation of a photographic artist of some note. He held photo exhibitions at locations such as the World's Fair in Moscow, New York, Washington DC, San Francisco, Seattle, and at the Earthenworks Gallery, where his work depicting the evolving art scene in the Northwest is now housed at the University of Washington Library Archives.

Arts Alive Poster

Guy Anderson, Birth of Prometheus

For eight years Hupy served as director and curator of the art museum at the mansion, while locals, including Bartlett and Dunlap, held seats on the museum board. The Landmarks Committee rented out the lower floor for weddings to cover the building's upkeep expenses.

By 1985, the same year Art's Alive was launched, La Conner was embracing its artistic nature on an official level. With renovation of Town Hall, the city began hanging paintings donated on a revolving loan from the Valley Museum. This too was the idea of Hupy. "I knew the town was remodeling and I knew they didn't have a public art budget," he told the *Skagit Valley Herald*. To the town's credit, the offer was enthusiastically received by the town council, which agreed to cover insurance costs. "This gives people the opportunity to see the work when they pay their water bills," Mayor Mary Lam proclaimed.[4]

By 1987 La Conner was in another transition; retirees were moving to La Conner from the Seattle area and beyond for the boating, the quiet, and in some cases, for the art. And that transition was reflected as new members began joining the museum board. The art in the Valley Art Museum was outgrowing the space at the Gaches Mansion, but there was no clear idea as to what the next step should be. Guy Anderson weighed in, arguing that a regional art center with museum and art school should be permanently established in La Conner. "La Conner and Skagit Valley is the perfect place for a new museum. When you drive north from Seattle and drive down into these river flats there is a completely different feeling. The beauty as one looks out to the San Juan Islands is great, rather like looking at the islands of Japan," he said.[5] Hupy favored the idea of an arts center comprised of museum and school in a newly constructed building. New arrivals, many from Seattle, had their own more modest visions for the museum that clashed with Hupy's. For Hupy, the very existence of a board had always been a necessary evil. While a board fulfilled the legal requirement to maintain the museum's non-profit status, Hupy was not a committee-minded person. He didn't work well with groups, or committees, and formulated his own ideas without the help of others. But by this time the museum had grown beyond a single-captained vessel, and his visionary ideas of a new building with more space and more programs for the arts raised dissent. Hupy

seemed to be moving forward alone. Many of the board members balked at his plans—ambitious for a small town and worrisomely expensive, even as Hupy gained the support of wealthy art patrons. The board and Hupy were in agreement about one thing: the museum, gaining in status and influence, needed a larger space, and Hupy began entertaining architectural recommendations. The board hired a Seattle association known as the Collins Group to help the transition from a museum in the Gaches Mansion to something larger, in a more conservative plan—while Hupy envisioned an arts center designed by architect Roland Terry. This plan was supported by Guy Anderson as well as most of the local artists and Anne Hauberg. But not the museum board.

Guy Anderson at work

While the board rejected his ambitious plans for an art center, Hupy responded, "Since I founded the museum eight years ago, I can't compromise its original objectives to suit this particular board. A compromise in the arts is a downhill road to mediocrity." In the meantime, board chairwoman Vala Younquist remarked that Hupy was proving to be "difficult to work with."[6] In 1988, when he refused to sign a contract with the board that would have required that he lose the title of director, he was fired.[7] The museum was renamed

Museum of Northwest Art and located in an existing building, the Wilbur Building on First Street in La Conner which the museum took ownership of in 1994. Today this museum—initially a scaled down version of Hupy's larger than life vision—is one of the prominent museums of the Northwest.

Richard Gilkey, Lunation

In the meantime, the town's most renowned artists were continuing their individual careers. In the 1980s Richard Gilkey, who was in an apartment in Seattle for much of the decade, was experimenting with what he called poetic fantasy, painting surreal elements into his landscapes. He painted a yin/yang of poppies and fish hovering above a valley landscape while in another a massive sunflower hung in the sky behind a barn. Local critics were not as impressed with his surreal work as they had been with his realistic landscapes, but he was gaining attention anyway. In 1982, Gilkey's work was included in a show of Pacific Northwest artists at Osaka's National Museum of Art, along with art by George Tsutakawa, Guy Anderson, Paul Horiuchi, Ken Callahan, Morris Graves, Leo Kenney, Philip McCracken, Carl Morris, Hilda Morris and Mark Tobey.

In December 1984 everything changed for Gilkey. He was driving a rental car on a New Mexico vacation with Janet Huston and Jan Thompson when a pickup truck lost control. Gilkey swerved to avoid the collision and was hit by a tractor-trailer. Gilkey's resulting head and back injuries rendered him unable to paint for three years.

Five years later, he had his first exhibition since the accident—his work no longer in oil was now done in alkyd, a non-yellowing emulsion of acid and alcohol. Even as many artists considered the light, Richard Gilkey was also probing the dark. Gilkey's mystical explorations in his work in the 1980s examined the nature of consciousness itself. He studied the idea of black light following the teachings of Lao-tzu. "Mystery and manifestations arise from the same source. The source is darkness…Darkness within darkness, the gateway to all understanding." Of a canvas titled Winter Stone, he wrote: "Consciousness is a mirror in which energy patterns reflect nature. The Universe perceives itself!"

Anderson continued to thrive in an eclectic circle of friends in La Conner. While his close friendship with Gilkey, the Jameses and Seattle-based artists remained, he spent much of his time with the Nelsons, the Jensons, the Bartletts and Kamuda, as well as some young artists such as Sheila Klein.

In the mid 1970s Kamuda introduced Anderson to Deryl Walls, a sculptor, writer and longtime native of Skagit Valley. Walls recalled he became aware of Anderson, first by reputation, and then personally through Kamuda, who was modeling for Anderson at the time. Kamuda invited Walls to join him at Anderson's house for dinner, a common event after a long day of painting. Initially Walls was reluctant to impose on Anderson, but Kamuda persuaded him. The renowned painter was as gracious to the unexpected guest as his reputation. "I felt as if I'd always known him, a kindred spirit," Walls said. He became a regular among the small group of friends who gathered at Anderson's home.

At this stage in his life, Anderson was exploring work beyond paint. One day Walls brought a 20-pound bag of clay to the elder artist's home, thinking he might like to try his hand at sculpting. Anderson used that clay to create figures—among the works was a portrait of Kamuda—which Walls later arranged to have cast in bronze.

Anderson still frequently entertained. He kept his days free to

paint (and occasionally to sculpt and carve linoleum and woodblocks for printing) and enjoyed a gathering of people around him when his work was done, to share a simple meal, with Billie Holiday or classical music on the record player, candles lit and wine opened on the table. A bouquet of flowers gathered from his garden or along the roadside often graced its surface.

Eventually, after the group had eaten (usually teriyaki chicken), Anderson would settle into his favorite seat: one of his Mexican pigskin chairs.

He strolled daily down the streets of La Conner, often with a spray of wildflowers and weeds, or with a loaf of bread under his arm. In the town post office he might be found leaning comfortably on the counter talking about an early twentieth century composer, never questioning whether those he spoke with had ever heard of such a person. "He was a true homme du monde," Walls said.

Anderson never lost a sense of humor as he aged. The Black Swan's Hahn recalls witnessing the old artist, at his most natural, from a shaded window in his business one day. As Anderson passed in front of the restaurant, he came across fresh cement recently laid on the sidewalk. He paused and looked around him, unaware of Hahn behind the window. Anderson then set a foot squarely in the wet cement that lay before him and "he did a little jig right there on the cement," Hahn said. "Then he just stepped out and walked away." For years Hahn made it part of the café's attraction; he proudly pointed out Guy Anderson's footprints in front of the restaurant.

Part V – 1980s and Beyond

Chapter 12

Quilt Museum and Fabric Arts

As Ruth Penington helped propel crafts to prominence in the valley, La Conner's business people and artists furthered that effort. By the 1980s the Skagit Valley, reflecting trends on a national and global stage, was looking beyond painting and traditional sculpture to pottery, jewelry and weaving that had previously been relegated to a lesser position. Part of that movement led to a growing interest in quilts and fabric or textile arts as well.

By the mid 1970s Rita Hupy had become a quilter; she'd learned to stitch together fabric in ornate designs, with bedspreads in mind. In some cases she then traded the completed works with local artists for their paintings. While the Gaches Mansion was being refurbished by the Landmarks Committee members, Rita Hupy organized a casual group of women with an interest in quilting. Many were already members of the Landmarks and its Gaches Mansion recovery efforts. They began raising money for renovation projects at the mansion beginning in 1977. The quilting group occupied the third floor for once, then twice, weekly meetings, circling a quilting frame in numbers of about six, creating each year's raffle quilt stitch by stitch with proceeds going to the mansion. The meetings continued after the gallery became an art museum and carried on after Art Hupy was no longer director. When the museum was moving out of the mansion and into its new permanent home on First Street in 1990, the quilters remained but in dwindling numbers.

In the meantime, however, Rita Hupy was learning more about the quilting tradition and who the major players were. One of the quilters who would play an important role in La Conner came from the other side of the world. Miwako Kimura and Rita Hupy met through a close friendship Art Hupy had with Japanese-American Seattle camera store owner and Nikkei skier, Nobuyoshi Kano.

Kano's wife, Tamako Niwa, was known at the University of Washington as a strict Japanese language instructor. At that time Kimura, originally a Nagasaki resident, had been living in New York

for several years, teaching Japanese language to Americans. Decades before, she had adopted the art of quilting—which she discovered in the U.S.—modifying it with a uniquely Asian style that included Japanese textiles such as silk. She often worked with the luxurious fabric of Japanese kimonos to create artwork that hung on the wall rather than draped over beds. Kimura had friends in Seattle, one of whom was her own language instructor, Tamako Niwa, at the University of Washington.

Niwa mentioned Kimura's work to Art Hupy and he was intrigued. He invited her to come to La Conner with Niwa and Kano, and she brought her quilts to show the Hupys. Art promptly invited Kimura to teach a class in quilting at his art workshop and she agreed, beginning a relationship with La Conner quilters that continues today.

By the 1980s, several stores in La Conner and Anacortes sold quilts as well. Roberta Nelson had been selling quilt supplies at her store, the Barbershop Exchange; and quilt appraiser Ann Nash opened a store on Morris Street that sold them. In fact, growing more enthusiastic about the trade, Rita Hupy was employed there herself. Nash's store sold new and antique handmade quilts along with folk art. Her quilting experience began at quilt auctions in the Midwest, and she was inspired to bring the art back to La Conner. She roamed rural northern Indiana and Pennsylvania, bought an armload of quilts and brought back about 15 to sell locally.

For four years Nash bought and sold handmade quilts in a rented space on Morris Street, then enrolled in the American Quilters Society's quilt appraisal training program in Paducah, Kentucky in 1993 and earned the distinction as the 19th AQS certified quilt appraiser in the country. With the training, she became expert on the condition of quilts, their rarity, value and dating, within a 10 or 20 year range from early 1800s to the present. By this time quilting was becoming big business in some portions of the country, and much of the organizing was done at the Paducah, Kentucky, home of the American Quilters Society.

By the mid 1990s, with the Museum of Northwest Art moving out of the Gaches Mansion, Landmarks had a new problem to tackle: a vacancy in the mansion. It served as a historic home, open to tours, but no longer earned the revenue from a museum occupying its top two floors.

One evening, in the dining room of the mansion, the Hupys, Louie and Roberta Nelson, the Bartletts, as well as a handful of other La Conner residents met to consider this new problem. Rita blurted out a suggestion, "I could start a quilt museum there." There was a pause.

Quilt Museum exterior

"What's a quilt museum?" she was asked. In fact there were no quilt museums on the West Coast of the U.S., but the Hupys knew galleries and museums, and they knew quilts. Bartlett gave the idea some thought; "Okay, write down your proposal and we'll have a look."

Hupy invited Nash, as well as some members of her quilting group, to the first quilt museum meeting; those who attended that meeting—a group of local, amateur stitchers—would comprise the new board. In January 1997 the group held a quilt walk in which visitors could see the art on display at the mansion, city hall, and several local businesses. Ruth Newell and Hupy distributed quilts to those locations and thereby began a yearly tradition that not only drew attention to the quilts, and money via raffles for the mansion, but also brought business to the merchants.

The museum was officially launched in July 1997 with its doors permanently opened in September. The first show was then held in the mansion in September 1997, exhibiting a collection of Nash's

antique quilts. Because Ann Nash's appraiser status provided her with connections with members of the Quilters Hall of Fame, Rita Hupy, who was director of the museum, was able to connect with quilters and quilting followers from around the world.

Shortly before the first anniversary of the museum's opening, Kimura came back to La Conner as part of the Japanese Folk Textile Quilts show featuring Japanese quilts, overseen by Kimura and some of her students from Tokyo. The group, known as "Hanatsunagi-kai Quilt Club" meaning Flower Circle Quilt Club, arrived on a flight from Tokyo and brought 47 quilts with them in their carry-on baggage.

Miwako Kimura

Over the years the museum came to be a central point for the growing number of fiber artists in the Skagit Valley as well as the Northwest as a whole. Possibly the most celebrated quilter of La Conner was Joan Colvin. Like many fiber artists of the 1990s, Colvin challenged the limitations tradition placed on the concept of quilting and what fabric can do. For Colvin, strips of fabric served as broad paintbrush strokes on a canvas and each of her quilts told a story—the kind of narrative images that women were increasingly bringing to a previously male dominated art world.

Colvin loved being on the beach. She took daily walks, during which she collected barnacles and shell fragments that would go on the quilts. In the solitude of her studio, she laid out a big white sheet of fabric and contemplated it. She studied photographs of fish, crabs, blackbirds and made cut-out images traced onto paper, and ultimately cut out of fabric. She incorporated wire edge ribbons, paints, taffeta, and various sheer fabrics in her work.[1] And not unlike some of

Joan Colvin

the painters of the area, Colvin worked with materials such as Tyvek house wrap, which she hand painted and sometimes melted to create the desired effect. She contributed to the La Conner quilt museum frequently.

When Colvin fell ill, her work became that much more prolific. Her goal was to complete one quilt a month in the final stage of her life. She spent six hours a day for five or six days a week working as her health deteriorated. She showed her work when possible, especially at

198

the quilt museum, but sales were never particularly of interest to her. Colvin continued working into the summer of 2007. On September 9, 2007, Colvin died at the age of 73. Altogether she had completed 149 quilts. About 95 have been sold and the rest are with family.

Joan Colvin, Dungeness Crabs

"There's something about the feeling of fabric that's symbolic to me," Colvin said in a newspaper interview.[2] The process is inspirationally creative, she added, in much the same vein as an image forms with brush strokes or a hunk of clay is brought to life through a sculptor's hands. "I love to nudge fabric until it says something to me," Colvin said. "As I form the fabric I'm mentally painting, drawing and sculpting."

Joan Colvin, Tree Bark

Beyond the quilt museum, others in the area were looking to fabric as their own canvas. Anita Luvera Mayer of Anacortes focused on wearable art rather than quilts. She worked in weaving, embroidery, surface design, all with clothing that she wore; none of her work was for sale. Admirers of her work began asking to learn how to weave; so she launched a class at Skagit Valley College. She attended the first national conference of hand weavers in Detroit where she met 900 people like herself.

Anita Mayer

"I went to a session on hand-woven clothing, and I knew I'd found my focus," Mayer said. First, she created contemporary wearable garments constructed from simple shapes inspired by different people's cultures and times. "I wear on the outside who I am on the inside."

Anita Mayer, wearable art

Gail Harker, a lifelong textile art educator, brought a British program in textiles, City & Guilds, to the Skagit Valley. Here in the U.S. she began teaching students the skills they could use to create nearly anything out of fabric, while also passing down a passion for textile arts.

The Gail Harker Center for Creative Arts, was initially located in Oak Harbor and moved to La Conner in 2011. The school offers courses and certification in color, art and design, hand stitching, machine stitching and embroidery. The school's students, hailing from around the world, work in a design studio to develop their work, and in a stitch studio for needle work. The center is located in the renovated dairy barn space that served as home and studio the decade before for Chris and Allen Elliott. From this location, students work overlooking gardens, a pond, and fields beyond. Patios allow them to take their work outside.

Penny Peters, Roadside Attraction II

The art of stitching is a long and respectable tradition for women who have needed to earn a living, but it had not been coveted as an art form, Harker said. "So for women there is a freeing aspect in being able to do this kind of artwork. This is not the first generation of women who are creating stitch, appliqué or quilting as an art form, but the current generation is vigorously using art and design to create textiles and increasingly receiving better recognition for their art."

In the meantime, quilters continued to exhibit at the La Conner Quilt and Textile Museum in the top two floors of the Gaches Mansion and visitors paid $5 to see it. Four exhibits were held annually featuring an artist or group of artists from the Northwest or elsewhere.

Gwen Lowery, Corona I

Miwako continued to come every few years from Tokyo with some of her best students to display their Japanese work at the museum. La Conner became an important showcase for her, she said, in what she called a quiet, peaceful village, just about as strong a contrast from Tokyo as there is. This is a place, she said, where she can feel relaxed, not unlike the way Graves and his own colleagues did in the past. The La Conner Quilt Museum, she said, gave her the opportunity to display her ideas, and while she added she's not always sure people understand them, she knew it offered them a window into Asia and Eastern ideas. "My hope is that they would understand Japan not from Toyota and animation, but from our quilts."

Chapter 13

The Vision of Carvers

While painters were coming and going from the valley, the Swinomish Tribe was little affected by the art fluctuations and transitions in the non-Native part of their community. One of their key forms of art was and continues to be carving. While painters, quilters and sculptors came and went, Swinomish carvers continued their own art—taking knife to the soft woody flesh of a red cedar. For the Swinomish as well as the Samish, carving was one of their more ingrained forms of expression.

For much of the tribe's known history, however, carving was more a utilitarian function than decorative; the long canoes that slice through the waters of the Puget Sound and the Swinomish Channel are one example. Even the functionality of carving had its aesthetics however—if a carver whittled a fish hook, he would create a design to identify it as his own work, while a weaver might do the same in a blanket. "It was pragmatic," said Larry Campbell, Swinomish Tribal Historic Preservation Officer. Often the use of a symbol such as a fish, frog, owl or eagle might have signified ownership.

As an artistic expression, carving allowed the artist or artists to tell a tale or express an idea. Art among the tribal members was not always openly shared with the outside community, in part due to early white pressure to reject the old traditions and spirituality—for spirituality and art were intractably linked. "Our artwork is spiritual, so when spirituality is suppressed, so is the art," said Campbell. After children were sent to boarding schools and the old religions were banned on the reservation, in the early part of the 20th century, the traditional ceremonies went underground and artistic expression dropped off. That was beginning to change when Campbell arrived in the Skagit Valley in the 60s. In the next few decades several carvers were actively creating and selling their work at that time, including Bill Bailey (no relation to the Bill Bailey who worked for Morris Graves decades before) and Kevin Paul.

Finished pieces of art for Swinomish carvers often reflected

something they saw in their minds. They may have come upon it in a dream or a vision, through meditation or prayer, but once the inspiration was there, the piece created itself through the vessel that was the artist. Those who opened themselves to the voice, or visions of the Creator, were recipients of those visions and thereby created art.

Kevin Paul, Heron

It's a philosophy many of the Northwest artists were embracing as well, and one of the reasons artists such as Anderson and Graves attended tribal ceremonies at the invitation of the Swinomish, and gained so much inspiration there. On the part of the Swinomish themselves, Campbell said, invitations to people like Graves, Anderson, and Juvonen were a simple case of being neighborly; "the basic nature of the Swinomish people is to be friendly and good neighbors; we look for ways to create good relationships to enhance the livability of the area."

Carver Kevin Paul's family is known for drumming both within and outside the Swinomish tribe. It was the Pauls who brought summer ceremonies to the tribe and often performed as well for La Conner townspeople. The family directed annual summertime pow-wows around the solstice, when tribal and non-tribal people would share in the festivities. Out of that family, Kevin Paul—half Swinomish, part Colville and French—became one of the best known and iconic carvers in Skagit Valley, recognized for work that is at once typical of the Northwest Indians and yet unique to his own style and aesthetics.

Paul's interest in carving was piqued around the age of nine at a summer school class in La Conner in the 1960s where a fellow Swinomish member was teaching wood carving. Paul gave it a try. "I cut myself but I liked the act of carving. I liked what I produced."

On his daily walk to school, he would stop in on another carver, Elmer Cline, who maintained a woodshop along the way. Cline kept an open door for whoever dropped by as he carved out rattles, totem poles and bowls which he then sold locally. In his late teens, Paul visited his late father's brother, Michael Paul, in Spokane. Paul's father, Alexander Paul Sr. and brother, Alexander Paul Jr. were also carvers; in 1988 they carved a totem pole to replace the one Charlie Edwards carved in the 1930s, that stood in the center of the village.

Paul attended Skagit Valley College and in 1988 married Patricia Harris (Witkowski), who became a local attorney. He went to work in water quality, his mind focused on supporting his family. All the same, his interests lay in carving. Prior to Kevin's marriage, his uncles Michael and Narcisse Paul lived with him for some time. Kevin watched his Uncle Mike employ his hands with a carving knife, sending a spray of shavings around his feet as he brought life to the wood before him. (Kevin's Uncle "Froggy" Narcisse Paul painted the carvings that Mike created.) Watching Mike at work, Kevin Paul recalled, "I said, 'Boy, I'd sure like to do that.' He gave me a knife and said, 'Here.' It was like magic." Paul studied the work of the Niska, Haida, Kwaguitl and the Tlingit—all coastal Northwest tribes. Initially he focused on learning the basic form, so he imitated the work of others. There came a time when he felt compelled to create his own style that his own people—the Swinomish—could identify with and say "that's K. Paul's style."

Like so many Northwest artists, Paul worked with subdued tones;

Kevin Paul, Skagit Valley College Totem

the color of the earth and a cloud-covered sky. "I felt those colors had more feeling to them. If I did a totem pole with lots of glossy color, that would not be coming from the soul." He worked with the softest, most pliant as well as plentiful wood found in the Skagit Valley—red cedar, yellow cedar and alder. Paul drew his inspirations from the wildlife around him: eagles, whale and salmon.

Kevin Paul with carving

His big break came when the Discovery Channel aired a documentary in 1993, giving him national attention. That same year, he visited the La Conner High School shop teacher, Michael Carrigan, who watched Paul at work, and asked him to teach carving at the high school. Since then Paul has taught carving to teenagers—male and female, Swinomish and not. The funding came from the tribe. He chose to mentor future carvers the way Elmer Cline once did

for him. Kids came by his house to watch him, and sometimes he stopped what he did to let them give carving a try, or to sketch out a picture for them. Paul carved a public work for the City of La Conner, the "Spirit Wheel," in 2001, that stands at Maple Hall where people can give the wheel a spin and watch the cycle of salmon and eagles pass in a smooth circle.

From his grandmother, Elizabeth (Scott) Sampson, Paul learned to keep his spirit positive and to resist the kind of bad energy that could infect his work. "If you have bad feelings in your spirit, don't do something like art," he said. He likened it to cooking a meal when angry, "Someone can eat it and say, 'This doesn't taste right,'" another lesson he learned from his grandmother. "I try to put a lot of good thoughts, good energy and good feelings into my work." He also uses his work to let go of stress. If the energy turns too negative, he said, "I stand back."

Perhaps more than any of the local artists, Paul is known to help others by donating his art to charitable causes, especially youth. "If you have three pieces of art and wonder why they aren't selling, give one of them away and never look back; don't ask about it; let it go. Then you may find the other two pieces selling."

In the 1980s and earlier, some carvers blurred the lines between Native and Anglo art, sometimes borrowing from multiple cultures, selecting that which is most inspiring in each. Tracy Powell had been one such artist; the early part of his story as a local carver is largely defined by the legend of a Samish Indian maiden. A 24-foot "story pole" towers on Rosario Beach where she was once said to have stood, before marching into the sea forever. The pole, carved by Powell, depicts the legend of young Ko-Kwal-Alwoot. According to legend, she still lives in the waters of Deception Pass, off the sheltered cove of Rosario Beach in the cold churning waters of the Puget Sound, not far from the location of Ruth Penington's art school in Quaker Cove.

The Samish tribe's story goes that Ko-Kwal-Alwoot made the ultimate sacrifice to the angry waters to save her people. It was a time of starvation for the Samish people. The water had pulled away from the shore, cutting them off from the sea-life they survived on. To appease the ocean tides, Ko-Kwal-Alwoot swam out so far that only her hair was floating on the water, but rather than drowning, she was transformed into a spirit of the sea. Today the kelp, 100 feet or

longer, swings with the waves, much as her hair would have done. Powell's totem pole that commemorates her is a combined effort of both white and tribal hands and it has brought the Samish Tribe something it hadn't had for a long time: a central point to call home.

Powell's ancestors were Welsh and Irish. He went to high school in Anacortes and spent a tumultuous decade protesting the Vietnam War before he went into the arts.

In 1981 Powell and his wife, photographer Maralyne Powell, moved to a home on Reservation Road and raised their two kids. He honed his carving skills when helping his shipwright brother repair wood boats in Anacortes. That was where he first learned how to bend wood.

In 1982, Powell was approached by an Anacortes friend, mural artist and historian Bill Mitchell, to carve the Maiden at Deception Pass. Mitchell already had an interest in local stories and depictions of those stories in art. He'd been cartoonist, painter and carver his entire adult life. He was responsible for a series of life-size historic portraits of people around Anacortes beginning in the mid-1980s, representing everything from local characters of the past to the first traffic accident on 6th Street, all reproduced and installed on the sides of buildings in the commercial district. In some cases the story of that mural, which Mitchell painted at home and then mounted on public walls, is written on the image as well.

Mitchell's goal in painting and mounting murals throughout his town was to people the city with the citizens of its past, who gaze out at those of the present as if they too are part of the current street scene. His work was so numerous that he and fellow artist Terry VanDyk mounted the art work with no fanfare. "We just make art, screw it up and go home, without asking for a lot of credit," he said.

VanDyk helped him cut the wood and install the pieces, while Mitchell did most of the painting. He used acrylic paint over the medium density overlay plywood.

The result is the largest and longest running art project in Skagit County at a rate of five pieces a year for 33 years and continuing. By 2017 the amount of plywood that composed the 170 murals would have been one-quarter mile in length, and 10,800 pounds. Mitchell and VanDyk produced two dozen versions of Bobo the Gorilla, alone, to be installed throughout Washington and other U.S. states. Bobo

Tracy Powell, Maiden of Deception Pass

was a Northwest icon in the 1950s who was raised in Anacortes, where Mitchell knew him well as a boy. They called it "Bobo the Gorilla Family Art Project."

When it came to the Maiden of Deception Pass, in 1983, Mitchell brought the idea of a totem pole at Rosario Beach to Tracy Powell. The pole would commemorate a Samish legend and serve as a Skagit County Centennial art project. He enlisted Powell to carve a model sized version based on Mitchell's drawing of the maiden. Once officially approved, Mitchell assigned Powell the task of carving the

actual pole. The carverv drew much of his help from the Samish and Swinomish tribes. Laura Edwards, a woman known more commonly as Grandma Laura (who had been married to the son of totem pole carver Charlie Edwards) was one of his early teachers, as well as Linda Day and Larry Campbell who, he said, taught him to respect tribal traditions and behave properly as he worked. That behavior included learning to keep himself spiritually clean when working. Ken Hansen, chairman of the Samish tribe, tested Powell's convictions and skills at Bill Mitchell's house when they first met. "Explain yourself, white

man," Powell recalled the conversation beginning. That started a conversation that went on some 20 years, and Hansen became Powell's prime mentor on the project and a friend for life.

Tracy Powell, Embrace

Jim Dunlap (of Dunlap Towing) donated lumber and logs for the cribbing to provide a carving space for the Maiden. The U.S. Forest Service then invited Powell and Hansen to select a cedar log on Forest Service property. They found one 40 feet long, five feet in diameter, better than they could have hoped for. Hansen started singing when they saw the enormity of this long single log. Grandma Laura Edwards chose the spot where they erected the Maiden, a spot above

the beach where the carving could gaze out at the water. When it was finished a year later, Samish families arrived from all over the country, gathered around the finished sculpture and held a potlatch. They borrowed racing canoes, including one carved by Charlie Edwards, in which they paddled out to sea to feed the maiden.

Tracy Powell, Ska-atl

In the following years, Powell and Hansen set up a carving school for the Samish with a grant from the National Endowment for the Arts, folk arts program. They put together a slide collection with 3,000 images that became part of the Samish Tribe archives.

Eventually Powell turned his interest to his "Euro-pagan" heritage—the pre-Celts, now commonly referred to as the "Black Irish" and in 1992 he first tried his hand at stone. He carved a granite statue

of Jasper Gates and his grandson in 2005, which stands on Main Street commemorating Gates as the first man to file a claim in Mount Vernon in 1870.

Dick Fallis, who had been part of the Penington Allied Arts School at Quaker Cove several decades ago, asked Powell to carve a sculpture for Skagit Valley Hospital's cancer treatment center in dedication to Fallis' wife Bernice. The Embrace is a six-foot granite piece that serves as centerpiece for the Cancer Care Healing Garden. He carved the limestone Single Mothers Memorial for the Big Rock Garden Park in Bellingham, and began a series of doves in response to the 2003 invasion of Iraq. The $1500 he and gallery owner Dana Rust gained from the sales was split and donated to two charities.

Another sculptor, Paul Luvera, was a renowned totem pole carver in Anacortes. Luvera's totem poles have been installed not only locally and in Tacoma, but in the Netherlands, Japan and Sweden. He hired Mitchell in 1976 to illustrate his book *How to Carve and Paint Totem Poles*.

By the 1980s, Philip McCracken, one of the most renowned artists of the area since the 1950s, was internationally known for both painting and sculpting. His sculpture work appeared in public places throughout—in parks, schools, and at the tribal center of the Swinomish Reservation. He felt a connection to the people of the Swinomish tribe and said he appreciated and shared their reverence for nature. He first created a sculpture for the tribe at the request of architect Henry Klein. The sculpture depicts two pairs of swimming salmon mounted at the entrance of the Swinomish Community Center and marks the bank of the tribe's fish trap. "The beauty of the tribe's approach to fishing was the trap; the fish came to them, rather than they going out to capture the fish," he said.

As a young man McCracken had developed a friendship with Andrew Joe, a Swinomish carver. McCracken recalled sharing a book on Northwest Indian tribal carving with Joe and the two discussed philosophical questions. "That relationship with the tribe is very meaningful to me," he said. Nature is his other inspiration. The McCracken house faced the sea, Lummi and Samish Islands, as well as Mount Baker. "There are a lot of strange forces at work with the air coming down the Sound, over them," he said. "The light is very active."

One can't overestimate nature's role in McCracken's work; he has worked with metal, stone, bone, owl down and plaster, but may be best known for the sculptures he has summoned out of wood. McCracken's art is that of a man enchanted by the universe, "And fully cognizant of the dark side. His work expanded across his famed bird sculptures, some warm and welcoming, while others hint at violence and destruction."[1]

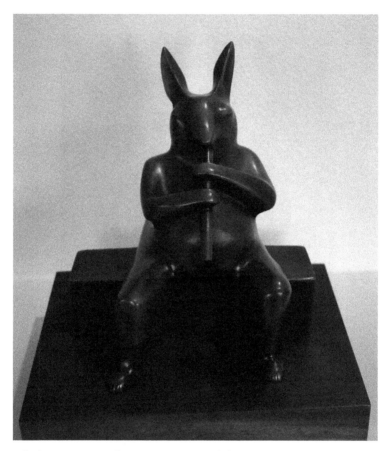

Philip McCracken, Piping Rabbit

The La Conner school district displays two McCracken pieces. One is a relief—birds flying in formation on the side of the Middle School—the sculpture had been rescued by Art Hupy from a bank in Mount Vernon that had vacated its existing building. Hupy kept the relief in storage at the Valley Art Museum for years before it came out, at the request of School Superintendent Tim Bruce.

The bronze bird family installed near the school administrative building came later, a commissioned piece for the school district.

McCracken also created the Mountain Bird on Mount Erie in Anacortes and a playground sculpture of three giant autumn leaves at the Skagit County Park, Guemes Island.

McCracken continued working into his 80s. "That's what you do when you love something that much. I've dedicated my life to it," he comments. Despite a few aches and stiffness, he enters the studio and leaves everything behind but his work and the exploration that takes place with his sculpting.

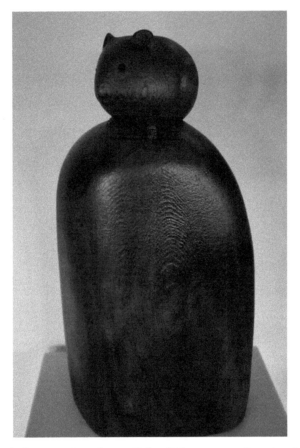

Philip McCracken, Pika Mountain Sentinel

Most recently he was exploring science—cosmology—new discoveries in astronomy and the cosmos. That curiosity led to a series of sculptures depicting fragments of night sky. He liked to explore what stressed wood could tell him. The same universal forces in everything else are existent in that wood, and are most clearly expressed in material that is stressed, he pointed out. It's all part of his life's explorations—which now focus on the mysteries shrouded in physics,

218

astronomy, geology and beyond. "Sculpture evolves through exploring the material," he said. "Every new material is a new language."

While some of his pieces have been preconceived images carved into wood and stone, such as many of his bird sculptures, he said there's an evolution involved in exploring form. Henry Moore, his longtime mentor, was also focused on form. Moore once advised McCracken that when discussing sculpture, "Don't talk about it. Put your energy into the work."

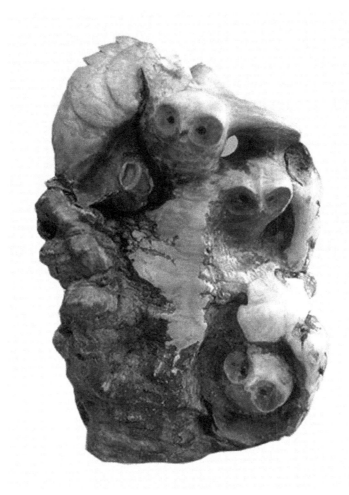

Leo Osborne, A Gathering of Owls

When it comes to questions about the sculpture or the artist's intent, McCracken added that, "The art answers the question." Does everyone see his art the way he does? This isn't a concern of his. "It's never bothered me if it's interpreted widely."

His more recent work examines the global unrest of the early 21st century. He just completed a series of pieces titled, "five brains, four hearts and other spare parts." Some really edgy artwork resulted, including, "On the Road to Kandahar," "Lab Rat Brain and Spine," and "Beached Sea Mammal Brain and Spine." They were exhibited at the John Sisko gallery in Seattle in 2008. "Two years ago I wouldn't have imagined that I would ever do these pieces. That's a rewarding aspect of my work," he said—the surprises. "I look on the horizon and here they come," he laughed.

Maine poet, artist and sculptor Leo Osborne came to the Northwest in 1990 after many years of corresponding with Philip McCracken, whose work he had discovered and admired early in his own career. Three years after he moved to Oregon, he visited McCracken on Guemes Island and within six months had permanently moved to the island where his mentor lived. The woods of the Northwest fuel a certain mysticism in his creativity, he said.

"I've come to love the mystery of the artistic process even if I don't understand it. I'm in constant evolution, constant flux." He worked with a variety of mediums but was especially acclaimed for his wood sculptures that have sold worldwide. He liked to work with big ugly burls of wood, he said, wood that he could have a dialog with. "I am not the master of it, nor is it the master over me, but through a dialog we co-create the piece."

Alone in Fishtown

It's raining a lot so the river is soupy
All the leaves blown down,
The far-off islands show clear
The south wind on the firs
Moans in my solitude
On a pillow of lost ambition
I smoke my pipe & doze.

—Paul Hansen

Chapter 14

Beyond River-life

By the early 1980s many of the early artists had left the Skagit River shacks, and a new generation moved in with a variety of interests, no longer centered around art, poetry or spirituality. In 1982 Ben Munsey, who lived in neighboring Edison, was a salmon fisherman before opening a book store on La Conner's First Street, known as North Fork Books. Around the same time he and his wife Meg began considering dropping off the grid.

The couple moved into Bo Miller's former abode on the river with their four children. As decades of inhabitants had experienced it before, the solitude of the place was complete: no traffic sounds, no motors, no hum of generators, just the occasional roar of a Whidbey Naval Air Station jet.

About a dozen inhabitants still lived there by this time, a less cohesive group with fewer artists. Fresh water, tidal lowlands enabled a cultivated, self-watering, secluded garden of marijuana. And like the wave that came before it, the residents of the 1980s had no electric power and no running water. The community's few members still carried water from Margaret Lee's well. The hippie life-stylers had been losing some of their luster with the Lees, however, and there was a dwindling, select few who earned the right to park at Buster and Margaret's property, as well as access their water.

Poet Clyde Sanborn—well known for jotting inspirations as gifts to companions on cocktail napkins—lived there. Sanborn drowned at the age of 47 in 1996 when his boat capsized on the Skagit River. In tribute to him, business owner Joan Cross employed artist Maggie Wilder to paint a poetry walking circle on the parking lot beside the Museum of Northwest Art. The circle surrounded a large cabbage with Sanborn's minimalist Zen poetry: "Spring can be tedious when one has not been sprung." His funeral, which drew a significant percentage of the town, was described by Clyde's brother Roger as a combination of an Irish wake, Methodist pot luck and spiritually laced Asian funeral.[1]

By 1988 Fishtown was nearing its demise. The Chamberlain family decided to log a 60-acre growth of forest on its property that separated the riverside shacks from Dodge Valley Road. Fishtown residents had been promised that loggers would spare a section of forest around the immediate community. Fishtown residents began organizing protests to protect what they called the last really big old-growth forest in the area. They were led by preservationist groups from outside the valley and joined by high-profile personalities such as Tom Robbins and Richard Gilkey. In January and February of 1988 several hundred protesters gathered on Dodge Valley Road, carrying signs and blocking the entrance of a new logging road built there.

Richard Gilkey being arrested

Richard Gilkey was among a handful of protesters who were arrested early on, and in January of 1988 he wrote a letter to the *Seattle Times* objecting to his arrest but especially objecting to the logging plans. "As a matter of conscience and social responsibility, and as an individual concerned with aesthetic and environmental integrity," he

wrote, "I stood in the path of logging trucks and was arrested for criminal protesting. I was pleased to be standing with fellow artists, mothers and fathers, architects, a carpenter, writers, and university graduates, among others. My position was that the logging operation should be halted until the outcome of the court hearing is known. The fate of eagles, herons, and 400-year-old trees deserves our careful study. Also, I feel that Fishtown woods should be a refuge for wildlife, plants, and other threatened species, such as artists."

The logging took place despite their efforts and in 1989 Fishtown residents paid the price for their protests. Property owners terminated the leases; the shacks were torn down; and police removed the final few residents. Fourteen people were arrested including Munsey's wife, Meg. "There was some yelling involved," Munsey recalled. Police removed personal effects from the cabins and deposited them on the side of Dodge Valley Road. It didn't take long for the underbrush, black berries and fresh trees to reclaim the river side and very little of Fishtown remains.

Still, artists were migrating to the valley, and their story has many more loose ends, in part because of the nature of the people who have come to live here. La Conner was shaped by more than just the museums, festivals, galleries, or the artists of Fishtown in the 70s and 80s. Throughout the conception of museums, the logging protests and dissolution of Fishtown, a steady stream of painters, poets and sculptors kept coming.

Painter Dederick Ward came to Anacortes from Colorado and the University of Illinois in Urbana, Champaign, where he had a background in geoscience information and library sciences. His wife, Susan Parke, served as executive director at the Museum of Northwest Art and board member for the Anacortes Arts Festival. (While in the capacity as the MoNA's executive director, Parke hired Barbara Straker James as curator).

Ward, like so many artists, said he was drawn to the beauty of the landscape and the unique atmosphere, but his early focus was on a more ancient influence—the geology. Ward is a completely self-taught painter. He pursued art through oil paintings as he studied geographic time as told by the rocky topography of the western U.S. More recently, he also explored how to capture the color, light and atmosphere in the Skagit Valley air.

He developed a friendship in the early 1990s with Clayton James that lasted several decades, and the two went on many painting expeditions together. When James selected a good spot to paint, Ward recalled, that worked for both of them.

The social aspect that connected the artists to each other as well as to the locals in the first half of the 20th century wasn't as distinct in the later decades. But when artists did come together it was a memorable event for them and for the valley. Throughout the 1980s and 90s, artist John Simon brought together some of the valley's most renowned creative minds in a barn on the property of fellow painter Lavone Newell Reim, for an annual event frequented by several generations of artists.

Simon received a B.A. and M.A. from Western Illinois University, and an M.F.A. from Cranbrook Academy of Art, Bloomfield Hills, Michigan, before moving to Chino, California. Then, in 1973, he packed his car and headed north, pursuing a teaching position offered in British Columbia. While passing through Washington State, he stopped to camp at Smokey Point in Snohomish County. He found a pay phone to call about the new position and learned that it had been filled. His life plans were suddenly cast adrift. Simon camped there for three weeks, visited a realty office in Mount Vernon and met a couple who rented him some space on Riverbed Road in Mount Vernon. He liked the Skagit Valley. It was close to Seattle but quieter, and seemed to be teeming with artists and craftsmen. This would be a chance for him to immerse himself in art.

Simon first taught stained glass at Skagit Valley College for several years. He explored carving and printmaking as well as painting, and developed what he called an abstract style with an environmental consciousness. He was a dedicated and avid environmentalist, and his work often centered around wildlife like salmon and herons, as well as natural settings: brooks, waterfalls and moonlight.

Newell Reim was a painter and one of the few artists who grew up in the Skagit Valley area, although she was born in Kansas. She earned a degree in art education at Western Washington University and proceeded to teach art for several decades. By her retirement in 1992 she was dedicating all her time and attention to painting, working largely on abstracts. "I paint to celebrate, to better understand my role in the web of life," she said.

Lavone Newell Reim

Reim and her late husband invited Simon to rent a barn on their La Conner property, and he moved in on April 1, 1979. In the barn he was able to expand his workspace, painting with canvas laid on the surface of the large wood floor. He typically painted a bottom acrylic layer, then spread oil on top. But the content of his work defied categorization. "I do that on purpose," he told a reporter for Art magazine in July 2004, "Somebody told me an artist should have one voice," he said. "Well, I have many voices."

John Simon, Deer

Simon had organized the first valley art show in 1986 in a location on Morris Street that drew many of the artists who were spread around the valley. But when Simon came to Newell Reim's barn on Fir Island, he began planning more annual group shows, the first of which coincided with Newell Reim's birthday in November. The shows were loosely called "The Barn Show" and later given the more official title of Skagit City Studio Open House Fine Art Exhibit. The show, which ran yearly until 2003, featured artists such as Anderson, Clayton James, Michael Clough, Paul Havas, Max Benjamin, Ann Martin McCool, Maggie Wilder, Paul Heald and Kevin Paul.

By this time, Simon had noticed a transition underway, both nationally and locally, in which art's commercial influence was nudging out the spiritual or mystical side of the art scene. The annual art show offered an alternative to that trend. "We were pagan naturists," Simon recalled.

1990 Barn Show Group Portrait

The valley was serving up the same filtered light through a glowing cloud cover, towering cedars and gentle rain that had caught the attention of Graves and Anderson 40 years before. "What a great place for artists to find their spirituality, with the natural landscape and mists making everything so diffuse—it creates a poetic dialogue," Simon said. And in the late 1970s and 80s the beauty of the landscape still came with the low cost of living. "It was easy to survive. We knew we wouldn't starve. We might be street people, but we wouldn't starve."

One of the Simon arts show participants—Anne Martin McCool—came to the valley just as the shows were launched, in

1979. She recalled going to Art Hupy in La Conner, soon after her arrival, to show him a portfolio of her work. Hupy could be as blunt as a hammer at times, but in McCool's case he liked what he saw. She was painting abstract landscapes full of the sweeping color she experienced in contrasting parts of the world—California, Arizona and now the Northwest. She painted voraciously from sparks of imagination generated by the first layer of color she laid on the canvas, and the rainy days simply drew her further indoors where the canvas and paint awaited.

John Simon, untitled

Hupy agreed to display her work in his gallery on the upper floors of the mansion, and that inclusion at the gallery may be the first event that brought her to the metaphorical table of the Skagit Valley artists' community. He introduced her to Janet Huston and John Simon, among others, in the La Conner area. Huston showed McCool's work alongside artists such as Richard Gilkey, and eventually Huston placed a phone call to her friend Morris Graves in California to tell him about this promising young painter.

Graves bought one of her paintings, unseen. Philip McCracken,

who was heading south to visit his old friend, delivered her painting to him. Graves liked it enough that it hung in his living room for many years. McCool, in the meantime, was acquainting herself with the Northwest artistic tradition. She had seen Graves' work and been captivated with the mystical quality she saw there. She'd visited his former home at The Rock in Anacortes and heard stories of his celebrity as well, but it was the quality of his work that caught her attention most.

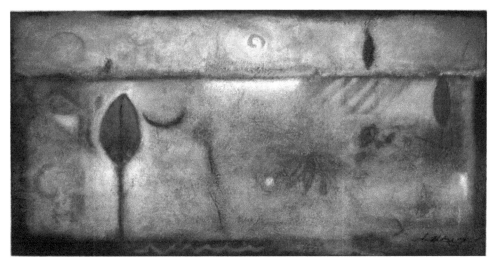

Anne Martin McCool, Magic Valley

Years later, McCool was invited to show her work in California at the Humboldt Art Center, for an exhibit known as "Northwest School, a Sense of Place Within," and was invited to meet with Graves in his home. His shacks long since forgone, he lived in a forested estate known as "the lake," the same place where he'd been visited by La Connerites Tom Robbins and Charles Krafft. The elderly painter invited her in with an embrace, went through pictures she had brought of her work, and examined them with rapt attention.

As they talked, Graves stood, suddenly in agitation, McCool recalled. She'd been trying to describe the meaning of her work. He led her to a table of sculptures he had been working on entitled "Instruments of a New Navigation."

"Look closely," he said, and she examined the composition of those sculptures that was coincidentally quite similar to the one she was describing in her painting. After she had given the work her attention

he simply commented, "Never explain anything." Art simply doesn't require it. That piece of advice has continued to serve her well, she said.

Morris Graves

In the 1980s Morris Graves was most known for his flower paintings, a far reach from the more heavily symbolic as well as more abstract work of his previous years. And in contrast to the Northwest earth tones he had begun his career with, his flowers were regaled in bright colors. Long time friend, composer John Cage, was underwhelmed by Graves' new technique, saying the flower paintings lacked vision and suggested he seek a more challenging botanical variety such as the zinnia which dies and wilts into what Cage called "magnificent madness."[2] But if Graves wasn't seeking magnificent madness he was still earning much acclaim. On February 28, 1987, he addressed a conference in New Delhi called "Tradition—A Continual renewal."

"My first interest is Being—along the way I am a painter," Graves

said. "As a painter, I am aware of the Sky of the Mind." This sky of the mind he referred to was, he said, the third dimension, sharing importance with the dimension of internal space (dreams and imagination) and the second—the external world. This third space, he said, was a place he had always accessed in his art. "I, in my non-intellectual way, have determined that beauty is all pervading and has no opposite," he said. He added in the somewhat meandering presentation, that, "an even greater paradox of the universe is that the center is everywhere and the perimeter nowhere."

The early home of Graves, The Rock, where he painted some of his most iconic work, had continued to serve as an occasional retreat for artists and transients over the years. Graves sold the 20 acre property in 1947, but for decades it was a place Graves' fans surreptitiously visited to pay homage to the artist. Around 1985 a caretaker who was also a painter by his own right—Terry Smith—moved into the shack. He was able to live there, with relatively few creature comforts, despite being restricted to a wheelchair. The high, moss and woods-covered perch, and the cabin Graves had built on it, served Smith as a place of contemplation and creative inspiration in the late 1990s just as it had done for Graves more than a half century earlier. Smith reported finding some of Graves' work under the cabin, and rescued and preserved it.

In the meantime, gaining recognition in Asia just as Graves was, Graves' old friend Richard Gilkey had reached the pinnacle of his career. First he was selected to receive the Washington State Governor's Art Award in recognition of outstanding contributions to the art of Washington State. Shortly after, he was named grand prize winner of the Osaka Triennial 1990 Exhibition, a juried competition that drew 30,000 entries from 60 countries around the world.

Gilkey received word of his win on the same day that he had to evacuate his Fir Island studio when a levee broke and the Skagit River overran its banks, burying the island under nine feet of water. He rowed a skiff out to his house to pick up a coat and get the papers to fax an acceptance back to Osaka. His winning painting, August Field, was an oil on linen nearly 7 feet tall by 10 feet wide. It depicted countless small symbols floating in a space streaming with white light. It became part of the permanent collection of the Osaka Contemporary Art Center.

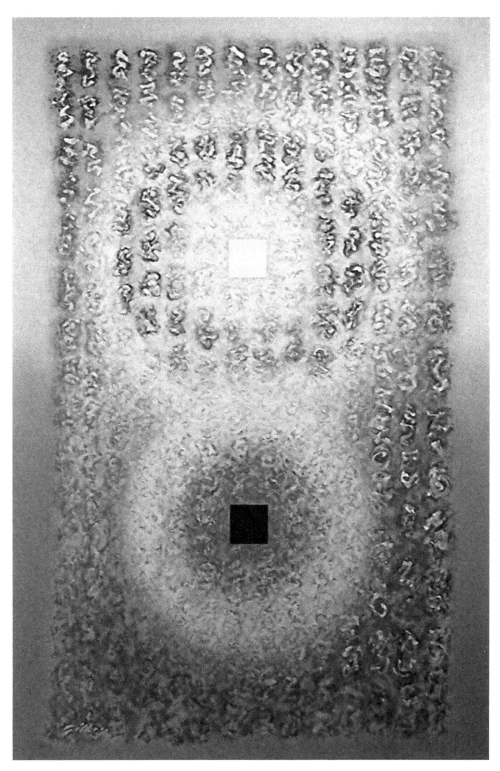

Richard Gilkey, Tibetan Spheres

The La Conner painter was becoming increasingly philosophical in his work and outside of it. He copied and enlarged a 1988 quote from physicist Richard Feynman: "To note that the thing I call my individuality is only a pattern or dance, that is what it means when one discovers how long it takes for the atoms of the brain to be replaced by other atoms. The atoms come into my brain, dance and dance, and then go out—there are always new atoms, but always doing the same dance, remembering what the dance was yesterday."

Richard Gilkey

In 1990, when asked to describe his work he said, "I think if I could articulate it, I wouldn't paint it."[3] In 1997 Gilkey, a heavy smoker, was diagnosed with lung cancer. Already he had heart trouble and had been in declining health. The prognosis for the cancer was bleak. He drove east on September 29, bringing nothing with him but a revolver, while his clothing and his heart medicine remained at home. When he reached Jackson Hole, Wyoming, four days later, he pulled onto a dirt road at the Togwatee Pass, a mountain pass on

235

the Continental Divide. He left his car there and hiked into a meadow where he was surrounded by the dramatic skyline of the Grand Tetons. Near a small brook, he shot himself in the head. A forest ranger discovered his body.

The note that was found on him was from the Meditations of Marcus Aurelius and read: "This is the chief thing: Be not perturbed, for all things are according to the nature of the Universal, and in a little time you will be no one and nowhere."[4]

Rather than mourn his loss, his longtime friend, companion and agent Janet Huston chose a celebration of Gilkey's life in her gallery. She displayed all the work that had been in his studio. She gathered all the photographs she could find, including childhood pictures that his niece Shannon Gilkey provided. The photographic chronicle of his life as well as the art work in the gallery on display included some of the abstracts he painted later in life. "They were just heartbreakingly wonderful," Huston says. "His best paintings were his last paintings."

In La Conner, the Fishtown era artists were aging, but remained true to their simple lifestyle long after most of the country had moved on. Still, people gathered at the 1890's Inn while their dogs slumped at the door, waiting.

At the same time Anderson represented a quietly vanishing part of a former La Conner, the face of the early Northwest school. He had spent a large part of his life teaching, but on the subject he told *Seattle Times* columnist Delores Tarzan Ament in 1977, "Tricks of the trade are not the way of education…someone who wants to paint can learn all the necessary techniques in a year—all the processes he or she will need, including printmaking. Then they should spend their time looking at great things—not just contemporary art but older things. The greatest pitfall is to try to keep up with the latest innovations."

Bill Matheson came to La Conner in 1975 with a very different vision than the aesthetes of the past. "The only reason I was able to make a living at art is my sales background. Selling the art is just about as much fun or more fun than producing it," he said. Seattleite Matheson had a metal working background when he started coming up to Earthenworks Gallery, where he was able to sell some of his work. He found a little shack for seaplane passengers on the waterfront and made it his studio. He would be visible there, where the tourists could watch him work.

His approach to La Conner was different than the old artists. They came as a retreat from Seattle in many cases, while Matheson came because this tourist town was a great place to sell art. "I came as an opportunity to sell and have a great place to work." He didn't associate with Anderson or the Jameses. "I was considered a commercialist." He shrugged away this label, "I'm the new breed of artist. I'm out in the public. I work in the public. I love to sell. I do realism; most of the artists up here are abstract which is very hard if you're going to make a living."

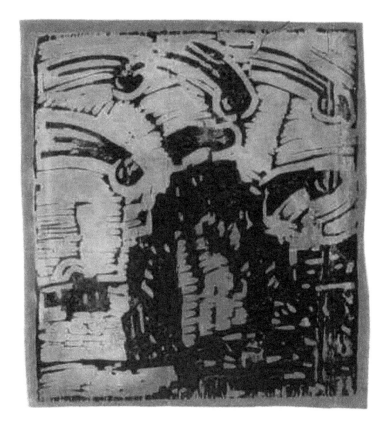

Guy Anderson, Angels Frolicking over McGlinn Island

Matheson still idled his time in the same establishments the other artists did. There he got to know a celebrity canine in town, a feisty mongrel lovingly dubbed "Dirty Biter." He had a tooth growing out the side of his mouth giving him a face only his closest friends at The 1890's could love. The dog spent his time lounging out front, but was well known to mingle among those on the barstools. He died in a

dog fight and Matheson created a metal statue in Dirty Biter's honor, and the dog was placed outside the restaurant, quickly leading to a renaming of the courtyard in which he sat as "Dirty Biter Park."

"The kids love it," Matheson commented.

In the early 1990s the Hupys were still hosting the La Conner Art Workshop with a dozen or more teachers, many of whom were old friends of Art's. But Hupy was in poor health and by 1994 Rita Hupy was laboring under the weight of most of the program's responsibilities. Painter Carol Merrick had been taking classes at the workshop in years past. One of the instructors, watercolorist Rex Brandt, nurtured Merrick's passion for watercolor, so she was attached to the workshop program.

Merrick had a history organizing the arts and artists, but she was, first and foremost, a painter herself. From Butte, Montana, she'd studied illustration at Pratt Institute in New York, and later moved to California where she gained her teaching credentials. After being employed as a clothing designer in Seattle for ten years, she took up a job at the Bellevue Art Museum and was one of the founders of the Bellevue Arts Museum School. She also helped organize the annual Bellevue Arts Fair and met Art Hupy there when he came to photograph the event.

Merrick later worked for the Whatcom Museum of History and Art in Bellingham as it was rebuilding from a fire. It was at this time she began painting full time after a hiatus as her children grew up. When she and her husband David moved to La Conner in 1989, Merrick had more than enough experience to help take the reins of the La Conner Art Workshop. Merrick, voracious in her painting as well as directing the arts, placed herself front and center in La Conner's artistic causes. In this case, Merrick and Rita Hupy hosted the program in 1994 at the town's Maple Hall second floor space. Until that time, the workshops had been held outdoors: in fields, in backyards, with meals and gatherings at the Hupy house. Now, with Hupy ailing, it made sense to bring the workshop to a central location elsewhere.

In 1998 Carol Merrick and several other artists and art enthusiasts formed the La Conner Arts Commission to stimulate and support the arts in La Conner. Each year the Arts Commission selected new sculptures and exhibited them on a walking tour throughout town.

The Commission purchased one piece of art each year based on the reviews of the public.

That same year, the La Conner Art Workshops were adopted by another artist—Chris Elliott—who served as director and organizer. She had moved to the area from the South Seattle area in 1988 with her architect husband Allen Elliott. They lived on Fidalgo Island until they discovered an aging barn just east of La Conner. After extensive restoration and remodeling, the structure served as living space, as well as Allen's office, Chris' art studio, and a studio for the La Conner Art Workshops. The space also included a jewelry arts studio Chris shared with her father, Warren Stine. There, father and daughter collaborated on works that were sold to galleries in the region and beyond.

Over the years, the Elliotts hosted events and fundraisers for the Museum of Northwest Art, the Skagit River Poetry Festival, the Skagit Symphony, La Conner Institute of Performing Arts and other art related community events.

Meanwhile, under Chris Elliott's leadership, the La Conner Art workshops ran from February until November with teachers such as Alex Powers, Christopher Schink, Carol Barnes, Karen Guzak, and Peggy Zhering. Local artists including Joel Brock, Ann Martin McCool, Carol Orr, Teresa Saia and Kathy Gill taught there as well.

Elliott found creative inspiration in the seemingly opposing forces of creativity versus destruction, light and dark, positivity and negativity. In much of her work she made the human figure a center-point subject for these forces, "as we experience the highs and lows of life." She also worked with abstract themes that could express larger elemental forces crashing, moving toward balance, and eventually returning to chaos, on and on. "There is a beauty and even heroism in all of it, micro and macro. This is life!" she said.

When Bill Slater was in recovery from cancer in 2006, he began planning a new life. He still held a love for boats and intended to move onto one to live a simple life on the water. He sold his studio and home on Pull and Be Damned which he had built himself over the course of seven years on the money he earned from art sales. He put the house up for sale, waiting for a buyer that would appreciate the space he had hand-crafted and was introduced, by fellow painter Larry Heald, to a young Seattle artist, Theodora Jonsson.

As it would turn out, Jonsson had her own connections with the valley. Her father, Ted Jonsson, was a renowned Northwest sculptor and had been a close friend of several Skagit Valley artists, including Larry Beck who was, in fact, Theo Jonsson's godfather. As a girl in the

Bill Slater with Tom Robbins, untitled

late 1970s, she would come to Skagit Valley and play with the local children while artists like Beck and Ted Jonsson lectured at Beck and Heald's art institute. Ted Jonsson also brought her to see other artists he was close with, including Margaret Tompkins whom Theodora recalled as being very private. "Her large abstract paintings spoke of a bold and emotional skeleton of forms underlying the landscape," Theodora Jonsson said.

When she met Slater he took her through the house and she accepted his purchase offer instantly. "There's something really significant about this place, and I think it was because I felt I was made of the landscape; I felt there was a symbioticness between what was outside and inside. I recognized it as home the minute I stepped on the rock."

Bill Slater, untitled

If you want to look closely at how light travels and breaks up, she said, sit on a slope above Puget Sound as the sun is setting. Once living in the studio on Pull and Be Damned, she would walk to the waterfront for the sunset to capture that light in charcoal drawings as it performed in the sky and then in the water. The changing light provided a certain moodiness that captivated her and seemed to correspond with the edge of uncertainty she feels and follows in her creative process.

At the time Jonsson moved to Slater's house, the elder artist was feeling the effects of the cancer again and as a result he stayed in the

studio, along with Jonsson, and eventually his son Japhy came to join them. They put a hospital bed in the living room where Slater spent much of his final months. But on his better days he continued to paint and served as a mentor to Jonsson. Similar to Robert Sund and Steve Herold in previous decades, he was able to turn daily tasks into poetry. As a reminded not to let the woodstove go untended, he left Jonsson a note:

Fire is alive … must be tended
like a living
thing to be
looked in on.
Neglected it becomes no longer,
simply sighs
and
goes out.

In July of 2007 Slater succumbed to cancer at the age of 67, but he painted until nearly the end of his life. After having severed his friendship with Tom Robbins for several years, he and Robbins had a reconciliation toward the end of his life. "We became very close in those last months," Robbins said. Slater's final paintings were landscapes; his work drew from his external reality in combination with his own inner reality to manifest abstract paintings with allusions to nature.

Since Slater's death, Theo Jonsson made his house into her own, and it continued its function as a living space and artistic studio where she painted large depictions of dance and movement and worked with print making (she refined the technique with the help of another mentor, John Simon, before his death). Her work included an osprey that resulted from a dream in which a Native man presented her with the dead remains of the last osprey. The oil painting resulted.

"This land embodies Eros and I felt pierced by a connection with something as old as the land itself. I knew that I was at home when I felt I was becoming an instrument for a new expression. I feel the passion to create here," she said.

Theodora Jonsson, Skagit Ludovica: Ecstasy with the Land

Grief

Word Comes
My lingering old friend
The artist,
Gone – at last.

And the sky suddenly fills
With mute colorless birds

—Glen Turner

Chapter 15

Passing of the Northwest Masters

By the 1990s Guy Anderson was in declining health. One night, at the age of 89, he suffered a fall inside his home. This event convinced Anderson, in consultation with his doctor and Deryl Walls, that he could no longer live alone. He moved from the hospital to Walls' house on Maple Street, just two blocks from his own home, an event Walls had been long preparing for.

Ed Kamuda and Guy Anderson

Earlier, in 1986, Walls returned from a winter in England where he had sought a producer for his play, *The Uroboros*. He decided to settle in La Conner to assist Anderson, whom he knew would need more care over time. From a house and garden that had been in shambles, he created a simple, comfortable home. Walls also designed a European-style garden where Anderson could sit on warm afternoons and entertain those closest to him. The elderly artist spent his final days there, where he could gaze over the same stretch of Skagit fields that his first burned-out home—shared with Morris Graves— had overlooked. His brush, by this time, was permanently retired. If Anderson was asked if he was still working, or why not, he would respond, tongue in cheek, "No, I'm resting on my laurels."

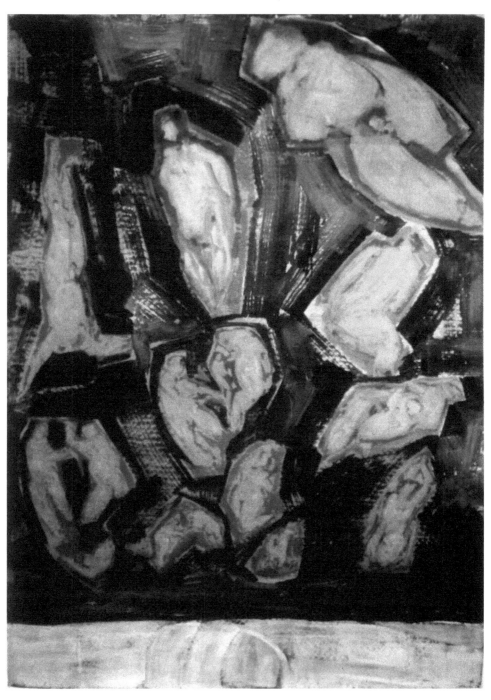

Guy Anderson, Falling Fragments

On April 30, 1998, Anderson died at the age of 91. With his death, La Conner's arts were set adrift with only Clayton and Barbara Striker James to represent the area's early artistic roots, while shoots of new artistic forms continued sprouting in the valley.

Morris Graves died the morning of May 5, 2001, following a stroke, at his home in Loleta, California. He was 90 years old. Robert Yarber, his friend and caregiver, was present at his death and later reported that a great blue heron let out a long, eerie cry just as Graves passed away.[1] Today the mystic artist's legacy is strongest not in the Northwest but in California where he spent a large percentage of his career, and the Morris Graves Museum of Art in Humboldt County speaks to his influence there.

In a tragic irony, Graves' cabin at The Rock met its demise just weeks after Graves died. Terry Smith, the artist and caretaker of the cabin, suffered from Lou Gehrig's disease, was isolated to a wheelchair, and yet managed the three-room cabin without water or electricity. He had been using propane for his only heat. His sole connection with modern society was his cell phone.

In the middle of the day on May 10, 2001, a fire ignited in the cabin and Smith called for help. He told dispatchers, "My house in involved and I'm not able to get out."

By the time the Skagit County firefighters were able to reach the remote cabin, the shack was burned to the ground and Smith was gone with it.

Barbara Straker James reported she couldn't help shuddering at the coincidental timing, just five days after Graves had died. "I'm thinking Morris is throwing thunderbolts down on The Rock so it won't be there anymore," she told the *Seattle Times*. "The symbolism of the whole thing boggles my mind."[2]

Barbara James died in 2007; Clayton painted as long as he could and died in 2016. Until his death, several dozen members of the community served as his caregivers, taking turns bringing the elder sculptor and painter meals, cleaning his house and caring to his needs. He died in the same house that he and Barbara had moved into nearly 70 years before.

Art Hupy died in 2003 at the age of 78. His thousands of photographs and negatives were donated to the permanent collection of archives at the University of Washington Library.

Skagit Valley was in the meantime settling into its role as tourist mecca. The Museum of Northwest Art focused on an audience beyond the valley (it represents artists from British Columbia and five Northwest U.S. states). But artists have continued to spread around the Valley and the islands, finding homes where they can best do their art, often in solitude. Their interests and styles have become increasingly eclectic.

A few examples tell part of the story of the continued dedication to the arts in all the valley's communities beyond La Conner. In 1988, Dana Rust, a retired Skagit Valley fisherman, began featuring local artists at his gallery, the Edison Eye, in the tiny town of Bow. He hosted some of the most popular and memorable art openings over the next two decades, often with smoked salmon or oysters cooking on the barbecue in the back yard.

Rust said Guy Anderson was behind his commitment to art. Rust was a sports writer for the Skagit Valley Herald and 18 years old when he came upon a shack in a lonely field outside of La Conner, not an unusual site for the Skagit Valley. He recalled music—classical piano—emanating from its open door. He approached the shack, which stood on Jenson's property, and found Anderson, seated at a grand piano, a tranquil smile on his lips as he played, completely oblivious to his visitor. Even more striking than a grand piano in use in a solitary shack was the artwork displayed on the walls; nearly every space was covered with art. At some point Rust caught Anderson's attention and the two introduced themselves. History contradicts the details, since Anderson didn't acquire his piano until after he left the pea shack. It's more likely Rust came upon Anderson at his home on First Street, since the artist procured the piano after he left the pea shack, although Anderson was known to periodically return to live at the shack during warmer months for many years.

With these time and setting details aside, the meeting made an impression on both Rust and Anderson. Rust said that at the time, he had never been exposed to art or artists but he could talk sports, and Anderson had an interest in baseball. The two struck up a friendship that soon included art. Around 1970, Rust began running a skiff for a seining operation, then bought his own boat and made his living fishing, and operating the former general store on Main Street, Edison, which had stood vacant for four years.

Rust maintained a friendship with some of his favorite artists, including Anderson, the Jameses, Virginia Shaw (known as Aurora Jellybean during the Fishtown years) and Bill Slater. In 1988 he opened a gallery in Edison, calling it the Edison Eye to focus the public's view on a deeper level of art, by offering an alternative to what he calls the pictorial art (pretty pictures) seen in many galleries—and instead showing the kind of work that can be viewed at many levels.

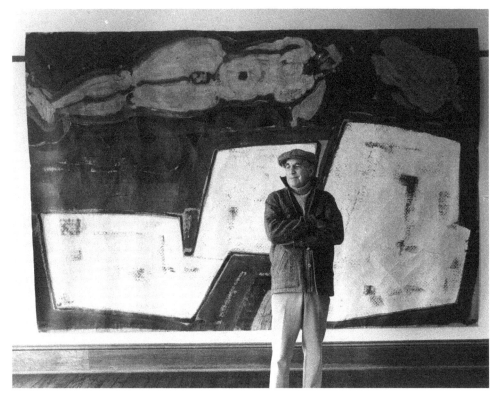

Guy Anderson poses with his work, circa 1990s

Rust commented in 2006, in a letter to the *Skagit Valley Herald*, "I speak of this country needing to 'make peace' rather than war. After consideration I thought, 'Is this possible? Who is going to do this?' and I thought that the only real humans who can start this process are the artists."

In the early part of the 2000s, Rust cleared out his former net shack, at a bend in the Samish River that runs behind the main street storefronts, and offered it up as a painting studio for landscape painter Joel Brock, a California transplant, who painted with moody earth hues that were well received by critics and that fetch high prices from

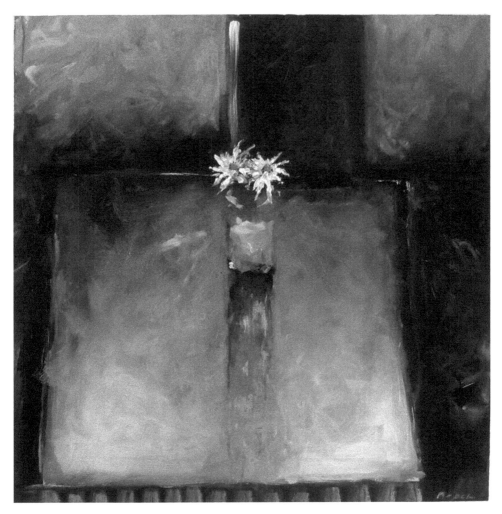

Joel Brock, Flowers IV: Mr Anderson

well-to-do customers.[3] Brock first visited the Northwest with his new wife when they traveled to Victoria, BC. Eventually his wife's work brought them to Centralia, Washington; then they bought a two-story farmhouse on Chuckanut Drive, Whatcom County, in 1986.

Brock taught all subjects as a substitute in the La Conner schools while painting in his free time. He had no inkling of other artists painting in the area or the history of those who had come before; "I was as green as spring grass," he said. "I didn't know about a Northwest school of arts." Instead, his early influences came from California and Arizona: his instructor, humorous pop artist Wayne Thiebaud, working in rich bright colors, and abstract painter Richard Diebenkorn, a Stanford professor.

Joel Brock, House

"It was quite a shock coming up here," Brock said, where he discovered that in the Northwest, "No one had even heard of these guys." And while Californians were stroking bold, brilliant colors across their canvases, here the colors were muted. He saw a mystical influence in the work that intrigued him.

Soon Brock was hanging out at openings, seeking out Anderson or Richard Gilkey—the "Northwest big guns." Over time he became acquainted with both and in the meantime opened a studio in La Conner in the late 1980s, across from the town hall building. Down the street was Guy Anderson's house, and the elderly Anderson would stop in on his daily walks to see what Brock was working on and talk. Richard Gilkey was less sociable with Brock; he was not one for small

talk. "He was a tough customer. I never talked to him much, but I really liked his work."

Brock recalled a conversation with Gilkey at a Janet Huston Gallery opening that illustrated Gilkey's dry humor. At the time he asked Gilkey why he always brought sloughs in from the side of the painting. Gilkey's response: "If I brought it in from the middle I would be painting in the middle of the slough." After Gilkey died, Brock inherited his T square (a drawing instrument), a gift from Huston who admired Brock's work. Not only a landscape artist, he

Joel Brock, portrait by Peter de Lory

painted still-lifes and architecture, often working with acrylic, pastels and blending charcoal into some of his work. When it came to his architectural paintings, he said in an artist's statement that he was struck by Andy Warhol's "Can of Soup," and how Warhol could take a simple can of soup and describe the entire psyche of America. "This is what I have tried to do with my art. Instead of a soup can, I use little houses, the places we live—simple farm buildings and structures seen in our daily lives. In this way I hope to capture the essence of American life."

According to Lisa Harris, Joel Brock was especially pleased with the last body of work he presented at her Seattle gallery in May of 2013, shortly before he died. It included found objects like cigarette

butts, blades, bullets, coins and painted forms, including American flags and houses. "He didn't want to make pretty pictures, but instead comment on our culture," Harris said. He died when his work was becoming some of his best, Janet Huston noted.

Just beyond the reaches of Skagit Valley, Jack Gunter came to Camano Island and brought some satire to the valley's art scene. When visitors came to see his satirical Secrets of the Mount Vernon Culture, for example, Gunter served them part paleontology, a little fantasy and a lot of tongue-in-cheek; he'd don an archeologist's hat and deadpan his way through an explanation of an ancient culture of nude women ice hockey champions, the 18 digit numbering system that Microsoft adopted and the comet that prompted cult members in California to bring on their own death. He had "discovered" an ancient vase in Mount Vernon that clearly depicted his version of the Skagit Valley five thousand years ago, complete with figures wearing black sneakers, just as the suicidal cult had done in California in more recent history. Gunter's show has been displayed throughout the Northwest, notably at the Skagit County Historical Museum in La Conner, and he didn't expect it to go any further, or even want it to. He enjoyed his obscurity. Although on the one hand he has been known as the painter "who paints flying pigs," he'd rather that reputation than a more serious fame that would impose on his freedom to paint the way he wanted to. Gunter said his artistic spark in the Northwest came from the ghost of Mark Tobey, whose presence he felt in the log cabin where he lived in the forest. "He's on the roof," he said.

There is a story behind the pigs: When his brother Steven fell ill to AIDS, Gunter was his caregiver and one day brought him one of a series of clam digger paintings, for which he is also popularly known. Steven found the painting calming, and later Gunter sold that painting to Everett General Hospital, where his brother was treated. "I started doing little paintings to make him smile." Steven had asked for simple images, so Gunter drew a pig with a tree and had it leaping into the air. "I made four little pictures of pigs leaping and my brother thought it was just charming. He taught me by telling me to be simple. So then I painted a pig flying over Stanwood to make my brother happy." Years later people still say, "That really makes me smile. I'd like to have been in your head when you did that."

Jack Gunter, Garden of Surgical Delights

Gunter later worked with a dot matrix representational surface, with which he connected photorealism and early impressionism but also used words and exaggerated forms to tell satirical stories. With both styles he still uses the medium of egg tempera.

Like Graves and Anderson, Gunter was drawn to the area for the anonymity and obscurity he could embrace there. "I think I'm very fortunate that I've never really been discovered by anybody. I've had extraordinary freedom to do pretty much anything the hell I want. If I had made a certain notoriety, my life would have been a lot more complicated and a lot less within my own control. There's no success mountain I'm stuck on."

Jack Gunter "with" Guy Anderson

Textile artist Allen Moe moved into Robert Sund's cabin in 1988, where he carried on Sund's artistic tradition, although his medium contrasted sharply from the poetry, calligraphy and Asian art of his predecessor. For one period in his artistic career, Moe made delicate pots from startling materials—chicken feet, deer sinew, cow stomachs or fish heads. He also molded prints that studied the patterns in accumulated drift or crack-lines in low tide mud flats, as if freezing one moment in the time of an ancient story. He kept a studio on

Guemes Island, as well as a cabin in northern California, but his primary home is at the former Sund shack which could only be accessed by boat. The shack was largely unchanged from Sund's years in it, with no power or running water. Moe has lived that way nearly all his life.

Moe grew up in Yosemite National Park where, during summer employment at the Ansel Adams Gallery, he was exposed to Southwestern Native American pottery. He went on to study biology at the University of California, Berkeley, and while there took a pottery class at the local junior college. Once he'd completed his pot, he felt compelled to cover it with suede, laced with shoestrings. Although it didn't look quite right, that concept of skin covering a pot was the seed of the work that followed.

Allen Moe, Vase

Moe spent the next decade living in Alaska—he homesteaded in the Eastern Brook Range and pursued a subsistence lifestyle. It was there he gained a knowledge of working with animal skins.

During the summers he worked as a ranger at Mount McKinley and then as a biologist studying the environmental impact of offshore drilling on seabirds. Part of this work involved sorting through the stomach contents of seabirds, arranging the bones of consumed

animals by size and shape for identification. This, too, carried into his future as an artist.

In 1978, at the age of 30, Moe learned the art of stained glass and moved to the Sonoma coast to pursue the making of stained glass windows—he sold the windows at street fairs in San Francisco. But he never let go of his attachment to Alaska. At this time he learned to hand-build pots with coils and to fire them in a five gallon can—technologies he took back with him to the Alaskan bush.

Allen Moe, North Fork Skagit River Delta

As he further explored pottery in Alaska, he tried stretching animal skins over those pots, discovering that while the skin was still fresh he could wrap it tightly over a surface and it would shrink as it dried, forming a wrap that clung so tightly to the pot that it defined the shape underneath it. And the patterns of the skin as it dried were sublime. He moved south in 1988 to caretake a privately-owned island in the Canadian Gulf Islands. He frequently kayaked to Guemes Island, where he was developing friendships among artists such as

Philip McCracken, Earth Rhythms

Ed Kamuda, Red Seed

Philip McCracken, and within a year rented a converted garage there. Eventually he moved to Robert Sund's shack near Fishtown. By this time Sund was living in La Conner.

All three of his homes were shacks without power, but Sund's former shack is the most remote because it can't be accessed on foot or by car, which reminded Moe of his life in the Alaskan bush. Sund was a master at creating efficient, livable space in tight quarters and Moe recognized the fact; he made few changes in the decades following; he simply kept it from disintegrating into the marsh.[4]

Like the Fishtown artists who came before him, Moe maintained a life close to the earth: chopping wood, cooking over fire, and hauling water. His main concession to modern technology was a cell phone and a website. Clayton James gave Moe his Nissan car, but he didn't take it out often, preferring his bicycle.

Moe showed and sold his work at Lucia Douglas Gallery in Bellingham and exhibited at the Museum of Northwest Art. He made no effort at marketing. "I've never put my work out there; it's always been asked for," he said. "I've just said 'yes' and that's been enough," Moe saw himself as a regional artist. "People all know my work, and when a stranger comes up to tell me about road-kill they saw, that's really gratifying," he said, at the time that he was using animal remains as his medium.

His work illustrates the beauty in nature that is more typically overlooked. The pots, his prints and his castings prompt the viewer to see the natural world at a deeper level. "What I'm after is surprise, the jolt of surprise which sometimes comes with humor," he said.

He evolved toward other mediums as well, such as castings of the ripple effect left by tides on Northwest mudflats and paintings evoking a molecular sense that blends science and art.

Moe looks unflinchingly at life and death, and uses his art to encourage others to directly contemplate life and its beauty, without imposing any doctrine. "I'm a realist. I believe in what is there. There's nothing besides what is actually there, but it is there and it's our job to look."

"As artists," said Joe Kinnebrew, a sculptor and painter who came and went from La Conner in the early 2000s, "the effect of Zen is seen in our work but not heard by our words." Kinnebrew shares a spirituality that the early mystics brought to the area from Seattle.

"My sculpture to this day remains tied quite clearly to minimalism and you could easily conclude that I, like many others, have been drawn to it. It is something experienced, not openly communicated."

"When you think about it, it's quite natural that artists would be drawn to this kind of spirituality." He said artists, like research scientists, willingly venture into what Kinnebrew referred to as the void, a place of unknown, of quiet contemplation, where social, political and artistic ideas are born.

"One of the values of art is that because it presents itself in the language of metaphor it can present very big ideas and often very troubling ideas in a metaphoric way that allows people to cope with them." That, he sees, as the responsibility of artists anywhere during tumultuous times.

"I think visual arts are in a transitional phase," La Conner's print-maker Elizabeth Tapper said. "I see more figurative painting recently, which may be a reflection of how consumerist-driven this society is; being clever is so worshiped, so the motive for making the art has been contaminated." There is, amidst that more commercialization of art, another trend that gave her more hope, "Some of the art I've been seeing is moving away from that glibness; it's had its time and sometimes something that goes on a long time, it outgrows itself."

Spring Poem in the Skagit Valley

The birds are going the other way now,
passing houses as they go.

And geese fly
 back
and forth
 across the valley,
 getting ready.

The sound of geese in the distance
is wonderful:
 in our minds
 we rise up
 and move on.

—Robert Sund

Chapter 16

The Future of an Arts Community

Some of the artistic culture that came to La Conner in the mid twentieth century migrated to the neighboring village of Edison. With a population of 236, Edison has no less than four art galleries. In part that may be the result of a rising cost of real-estate in La Conner, but it was also inspired by the presence of Dana Rust's gallery, the Edison Eye.

By the early 21st century, on any given day or night, hundreds of artistic pursuits are underway in the Skagit Valley and outlying areas. Many of the artists claim the same inspiration the earliest arrivals in the 1930s did.

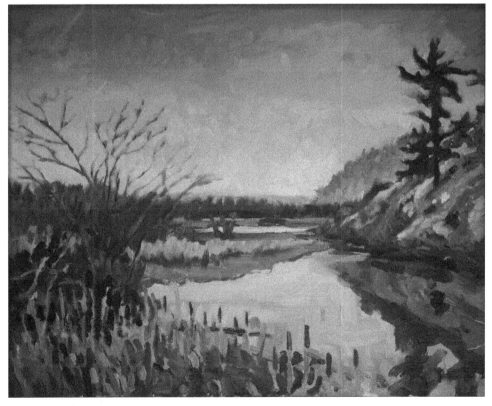

Thomas Wood, Looking South from River Shack

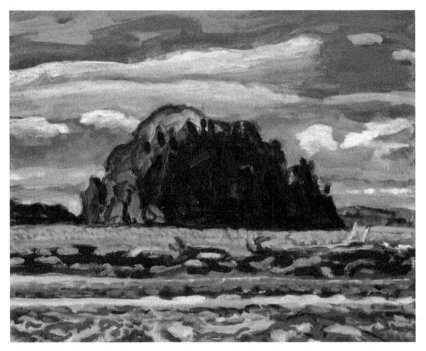

Thomas Wood, Ika Island from Beaver Slough

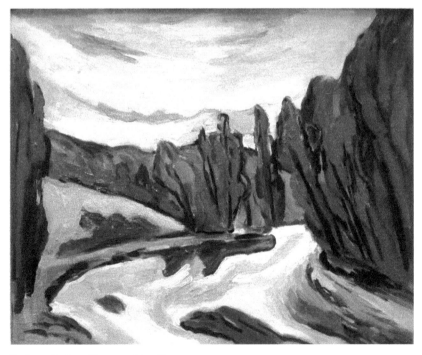

John Cole, Skagit Drift

When Thomas Wood, of Bellingham, has an insomniac night he draws energy from the sky, painting the moon or the punctuation of stars on a dark canvas. Although he lives 30 miles to the north in Whatcom County, the painter and printmaker has created a large body of work in the fields and beaches of the Skagit Valley, where he met his personal mentor Guy Anderson (who admired Wood's work). Skagit Valley's expanse of fields reminded Wood of his traveling days in Holland. For two decades he concentrated on pastel work in the Northwest valley fields, capturing the varying light cast on the furrowed soil, or the blooming crops. His work includes printmaking, paintings and murals, inspired by "creatures of the sky" and other abstract realism, some satirical, some coming from deeper places, or from his dreams.

Wood has been labeled a visionary artist. His work suggests the mysteries of life, the unexpected and the unexplainable, by connecting real and fanciful worlds. He studies the relationship of mankind and nature with, for example, his etching of "Kissing Fish" which have startlingly human faces, and the fantasy based print, "Harvesting the Magic Tree."

Wood was encouraged to paint the Skagit Valley by his mentor, artist John Cole. Cole is one of the most prominent landscape painters of the Northwest, known for bold rather than soft, dramatic rather than pretty, imagery. London-born, Cole came to the Northwest in the late 1960s. He worked outdoors, sometimes combining fly fishing with painting excursions. Often he travelled with friend Clayton James. Sometimes he brought the young Thomas Wood on such excursions and the three of them would paint the sky and stretch of valleys around the Skagit River, the Delta, and the San Juan Islands.

Clayton James,
photo by Dederick Ward

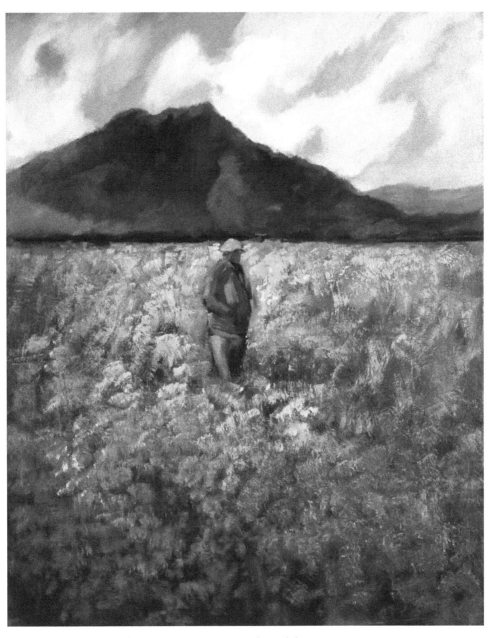

Clayton James, Clayton in a Mustard Field

Dederick Ward, Beginning to Clear

Clayton James, Snow King

Rebecca Fletcher, artist and wife of actor Kevin Tighe, was hoping for instruction from John Cole when she enrolled in an art class in Bellingham, but Wood was teaching in Cole's place. She'd already earned a degree in illustration from the Art Institute of Boston but had yet to pursue art on her own terms. She recalled that Wood taught her one of her most valuable lesson—to paint without fear.

Rebecca Fletcher, Valley Mists

Her early career was in commercial art, graphic design, and painting cute animals for wrapping paper. Moving to California, she embarked on design work for Savoy Studios in Eureka, where she designed and painted stained glass commissions. That association led her to meet Morris Graves at a potluck luncheon he hosted for her co-workers and herself. She recalled gathering at his home in Loleta, where he made a memorable entrance by rowing to the estate shore in a small boat. He was a warm host, and she sent him a small piece of glass in a thank you note. She was surprised to receive a response and kept it as a remembrance. He thanked her for the "gift spectrum—glass jewel." He went on to say, "The jewel I keep as a nimbus over the Buddhist Sangha sculpture from Nepal and the thought and feeling of your note I keep in my heart."

Having moved permanently to the Northwest, Fletcher settled primarily into painting with oils. She continued a lifelong study of shapes and light, whether in rolls of cedar or birch bark, the curve of an animal bone or granite boulder, or the shadow of a tree against a mountain slope.

She works best in the early morning when she can listen to silence and give herself to the artistic process. That process, she says, serves as her teacher. Although she clarifies her intent as she starts her work, she says she can't know where the process will take her.

In the long run, Fletcher says, she hopes that her art will serve "as an invocation of the vivid appreciation I feel for the natural world." She has principally shown her work in venues north of Seattle.

Even as artists flow into and out of the valley, Thomas Wood says he is a great believer in regional art movements and supports the Northwest "art scene" with the Museum of Northwest Art at the center in Skagit Valley. "I think regional art movements are important." For one thing, he argues, they bring a sense of collective aestheticism that no longer exists on a global scale. "My feeling is that the system is set up to break apart groups of artists." Museums draw artists from around the world, while art is shared electronically and lacks any geographical or regional focus.

"I get bored with the international flow of information (the Internet fueled social networks for example), they never have time to strengthen a vision." Most great art grows out of centuries, not years," he points out, and for his own part he prefers to study the work of Northwest masters. "If you're a Roman, you choose your gods. I've picked my artists, and they were located in this area," he says, numbering Anderson, Graves, Ward Corley and Tobey among his list. The Skagit Valley Art Museum, which went on to become the MoNA, was established he says, as a reaction to the fact that people were ignoring the Northwest tradition. "If you don't support a local scene, you won't have a local scene."

Several groups devoted to keeping a regional collective art scene in the Valley were launched in the 1990s. The Art League North was founded in 1990 and included painters such as Pien Ellis, a California transplant originally from the Netherlands, who discovered the Skagit area while on vacation. The Art League North members travel to parts of the valley for "paint outs" where they embark on plein air painting for their own benefit as well as the tourists. They also sponsor programs to support local arts. Ellis painted in a studio she built from excess pieces of her own home construction in Eagles Nest, overlooking Martha's Bay near La Conner. In the meantime the goals and efforts of artists as a group are changing.

With an eye to the plight of the planet, several Skagit Valley artists have focused on group action with a goal of saving earth by joining forces with scientists to bring attention to the planet's plight through art—offering intense conceptual art intended to spark moral debates.

While the art world moves forward in disparate directions, the remnants of much of La Conner's artistic past are succumbing to the perpetual growth of blackberry bushes, moss and the kind of swift decay that comes from year-round rain. A local who's been around long enough can point out the homes where Guy Anderson lived or the general direction of Morris Graves' former sanctuary, "The Rock." Fishtown remnants are nearly impossible to find, even for its former residents, despite a good pair of boots or a boat.

All of this obscurity is as it should be, said Janet Huston; the early artists came here for that obscurity in the first place, she said, and after their death their names and memories are rightfully fading.

The continuing art scene, then, has its own identity. The La Conner quilt museum, now known as the Pacific Northwest Quilt & Fiber Arts Museum, attracts visitors from around the world and shows quilts from all continents. In 2009 there were 8,100 visitors and the number continues to grow each year. It still shows the work of one of La Conner's earliest quilt exhibitors, Miwako Kimura, and as many as a dozen of her fellow fabric artists in Japan. Lately Miwako has been working in cotton and silk. "I feel that we Japanese learned quilting from the American culture, so it's very nice to return our gratitude by showing our own culture and explaining it."

"Good art is never just about itself: it is a sharing of ideas," sculptor Tracy Powell said. "Painting, poetry, song, dance, and sculpture are all just some of the languages we speak when we celebrate life, and our various visions of it and each other. When we make messages of peace, love and respect for Mother Earth, we are affirming and honoring our deepest human aspirations."

Ed Kamuda has lived in the town of Bow in Skagit County for several decades and continues painting and selling his work at the Lucia Gallery and Lisa Harris Gallery in Seattle. He works with a palette knife rather than brush and finishes his surfaces with a wax varnish.

The natural environment still influences Kamuda's work. His paintings are known for simplified shape, heavy on symbolism and

Guy Anderson, untitled

pictography. They have a mystical feel, as well as a reverence for nature. He rejects most modern communication, including email and phone. That allows him a certain order in his life; he wakes up and begins painting; phones, Internet and television, he says, seem like absurd intrusions. For a good part of his life he's managed without a car as well, but he did trade a painting for a car. For the most part, however, he says, "I see all these gizmos and think if I can get along without them, why not?"

He still finds himself painting a freshly plowed Skagit Valley field.

Ed Kamuda, Skagit Morning

Until his death in 2010, John Simon lived in Edison at the home he called "Fort Edison" (where he said he was making his last stand). It consisted of a small hand-built out-building and a trailer about a five minute walk from the one-block long downtown. Until the end of his life, he traveled on foot to Edison art galleries.

In his later years his work was sought after the most it ever had been. Rather than dwelling on personal successes, he felt an allegiance to the other artists of the area. He found the greatest commonality among Skagit Valley artists was the fact that they each have their own separate spiritual quest. It kept him close to the community and the people there. Although he imagined going to Costa Rica after a big sale, or selling his work in Japan, he never intended to leave Edison permanently.

Ed Kamuda, Bow Hill Spring, Harris Gallery

He had his struggles with alcohol at one time, but his last years were some of his most productive. He said, just a year before the end of his life, that he faced his artwork with new vigor. "With the help of friends I have been able to survive," he said and for that final year he had vision. He sold a painting to the Museum of Northwest Art just months before he died. "Now my purpose is clear," he said in 2009. "I'm full of unbridled enthusiastic drive to do the best with what I've got."

"Today," John Simon said, "there's a black and white thing happening in art" that flies in the face of Skagit Valley's tradition of the spiritually oriented or philosophically oriented artist. He was disappointed with what he saw as a rising level of ideology in the art shown in the valley. "An idea is formulated and followed with ideological art. It's very dogmatic; there is no debate."

Simon found there were no more art heroes in the valley, so existing artists were leaning toward commercialization or "thinking of cutting their ear off like Van Gogh." He still had hope that, "Spirituality and philosophical orientation will grow in consciousness. Nature is going to be the major teller of who will survive." After three decades in the Skagit Valley, Simon died of cancer at the age of 62.

John Simon, Chuckanut Ridge

Lavone Newell Reim continues painting what she calls her inner calligraphy—abstract paintings based on her love of dance, music and being alive. "I paint to paint, not for people. I just paint my reaction to what is around me." She follows an internal creed to live each moment. "If I feel like dancing I dance. If I feel like painting I paint. First and foremost I express the joy of being alive in sumptuous, incredibly beautiful landscapes." Her imagery includes coyotes, trumpeter swans, and expansive sunsets. "At times as I contemplate, painting takes its own direction," she said.

The valley's past, according to Robert Allen Jensen, known as R. Allen Jensen, can be planted six feet under, literally, for those valley residents yet to come. He developed concrete "seeds" that contain

art work and photographs for future generations. Jensen lived in Stanwood most of his adult life, commuting through the Skagit Valley on his way to teach art at Western Washington University (WWU) in Bellingham. Several decades ago he hosted a commune in his forested Stanwood property and said he's always preferred the solitude the woods afford him. As a painter, he's always been involved in the darker side of life (its ending), calling himself the Dr. Death of the valley. On a personal level, he resists the description of dark, moody or morose but his work definitely looks death directly in the eye.

By the early 21st century he was looking to a future after we are all gone—planting his seeds to offer our progeny a glimpse into our world. He took photos depicting an area, along with his own painted landscapes of the area, then drilled down six feet to plant the concrete pod filled with the pictorial artifacts, to be discovered dozens, hundreds, maybe thousands of years in the future.

The seeds could go anywhere, but he's hoping to plant some of them in the Skagit Valley. With dwindling eye sight, he took his art along a new path as well, developing a blind contours project in which he draws and paints the contours of what he sees. It's an exploration, he said, into just what art can accomplish when you lose something otherwise taken for granted—sight. With less precise vision, he still focuses on the artistic process and what it can mean "when the curtain gets drawn down."

For Jensen, the environment where he lives has been central throughout his artistic journey. The valley itself, he says, is more of a state of mind than a geographic area. That state of mind includes a history of people migrating to the solitude of the area from Seattle. "It's a mindset that people who identify with nature have," he said.

Former Museum of Northwest Arts director Greg Robinson saw directly into the heart of the artist scene in the valley for several years, and he said, very simply, "This is an area that supports artists, and artists don't stay somewhere that's not supporting them." Most of the artists who live in the valley sell their work here as well. "There are a number of collectors who may be under the radar but they love art, they appreciate it, engage in it, they want to know artists. This region is strikingly supportive that way."

The museum includes crafted jewelry, fiber arts and glass within its gallery. He acknowledged the need for regional art but, "I think

the whole region has been embellished by people moving here from other parts of the country exploring the world." While there are clearly artists whose work is strongly influenced by the valley, there are many who draw their inspiration from outside the area. "The New York art scene almost seems like a more confined world than the Skagit Valley—this environment allows for more diversity of expression, nothing that would be considered top dog. Even when I lived in New York and went to galleries there was a 'what's hot' feel, but in the Northwest there are many stories being told, not one 'in crowd.' I'm amazed how many artists live in this region and survive." That's not just because there are patrons in the area but because Robinson found there was little prejudgment as to what was acceptable. That attitude, he said, "allows the viewer to be exposed to so much more. Even within the galleries there is so much variety."

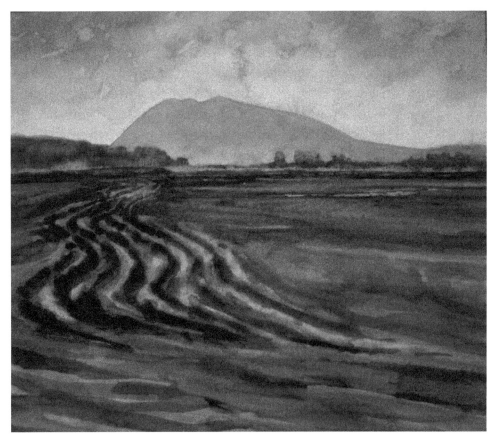

Paul Havas, Gouache on paper

The list of artists is so voluminous that two annual programs the MONA participates in—its art auction and Art's Alive—do not accommodate more than a fraction of them. "No matter how you launch a juried show or a festival or auction, you'll end up excluding hundreds. No matter what you do, you can't possibly include them all. That's a compliment to the region."

The mediums of art in the valley are still broadening. That fact is vividly illustrated by neon sculptor Michael Wirth, who brought his skills in bending glass and infusing it with colored gases, from the urban Northeast in 2003.[1] Wirth created neon sculptures that twist and glow their brilliant colors from trees or even underwater.

Far removed from the mystics of the past, Wirth acknowledged an energy flow that artists can access in the forest, water and sky. But he also saw a distinct circular rhythm in the struggle of arts in parallel with that of the spawning salmon, a repeated journey upstream when, for the artists, the cultural flow is moving so strongly in the other direction. "Why does the artist struggle up the creative river? What is that about?" he pondered. The salmon would seem to have the same conviction that their direction is what they must pursue.

In most parts of the world, Wirth commented, people are separated from their environment by modern life, but the Skagit Valley brings the artists in connection with nature, and that alone may keep them "swimming up the creative stream."

The debate over the future of the arts and the future of the Valley can be expected to go on as reliably as the rain gently soaking its inhabitants. Tom Robbins said he misses the La Conner of the 1960s with its funkiness and bemoans the encroachment of tourist shops. "The whole world is changing," he said, and whether it's the media, or a growing commercial drive among the individual inhabitants of the world today, "there's a creeping meat-ballism taking over, we're losing our diversity worldwide." But La Conner still sustains Robbins and, by the publication date of this book, he had lived in the community for four decades and more. The magic that attracted him in the 60s might not have died entirely, he said, "You still feel it on a January evening when the moonlight is on the channel."

In the meantime, though he commented, "If we don't go into the future hand in hand with nature there's not going to be a future."

"The past has been made into a permanent present," Jesus Guillen

277

said in 1993. "Time and emotions are kept forever in the mind. What I have seen, heard and touched. What I have endured or enjoyed. These things I have kept and are expressed in my art for inexplicable reasons. We humans must communicate our spiritual feelings, a commitment to beauty, our precious heritage and the honorable values we hold."

The best explanation for what has happened here and what lies ahead for the Skagit Valley and its artists may come from the early members of the Skagit Valley's artistic roots, when they pondered the activities of man, man's role in the environment, and what it all means for an artist. Their musings could as easily speak of the history and future of this small community. "I do remember Tobey and I were walking one time," Guy Anderson said in a Smithsonian interview in 1983, "We had been to dinner, so we walked out in the evening. We got out there in one of those kind of empty [spots]—a place where they had bulldozed and everything—it was kind of ruined. It was dry; it wasn't muddy or anything like that. So we were looking down, and he finally just said, 'Well, I have no idea what it's all about at all.' And I knew what he was talking about." Anderson chuckled. "At least he admitted it. 'I have no idea what it's all about.'...So that's the beginning."

Guy Anderson

IMAGE NOTES

Chapter 1

Morris Graves, untitled (Northwest Landscape with Church), c. 1935, oil on unsized Bemis bag on stretcher in frame, 27" x 33 ¼". MoNA, Gift of Mary Randlett, 2003.105.001.

Morris Graves painter, with dog Edith, Edmonds, circa 1940's University of Washington Libraries, Special Collections, Mary Randlett, photographer, UW38023.

Guy Anderson circa 1940's photographer unknown, with permission Deryl Walls.

Guy Anderson, *Scene of Edmonds,* c. 1935, oil on canvas, 33" x 27.5". MoNA, Gift of Maxine and Al Francisco, 2011.285.084.

Guy Anderson, charcoal lion sketch, 18" x 24", with permission Tim and Gail Bruce.

Chapter 2

Roberta Nelson, with permission Nelson Family.

Austin Swanson on tractor, circa 1940's, with permission Swanson Family.

Nelson & Pierson Groceries, La Conner storefront, photographer unknown.

Morris Graves with dog, photographer unknown, with permission from the Clayton and Barbara James estate.

Chapter 3

Roberta Nelson on a sleigh, circa 1930s, with permission Nelson Family.

Morris Graves, untitled (Dalmatian or Hepburn Panel), 1934, oil on canvas on board, 77" x 26 ¾," 77" x 26 ¾," 77" x 26 ¾," MoNA, Gift of Donald Allyn, 1995.031.003, 1995.031.001; Graves painted a series of emaciated dogs on six canvas panels intended for Katherine Hepburn who had expressed an interest in buying his work. She gave them a glance and ordered them out of her sight. The three remaining of the panels reside at the Museum of Northwest Art.

Helmi Juvonen, *Wolf Dance: Charlie Swan dancing at Swinomish* 10"

by 6.5", with permission from Tim and Gail Bruce.

Mark Tobey, photograph by Art Hupy.

Chapter 4

The Rock, home of Morris Graves, pictures by Thomas Skinner

Morris Graves, circa 1944, with permission Clayton and Barbara James estate.

Richard Gilkey and musician Ray Tufts in Ballard, University of Washington Libraries, Special Collections, Mary Randlett, photographer, UW38029

Clayton and Barbara at Waldport with permission from the Clayton and Barbara James estate

Barbara Straker James, University of Washington Libraries, Special Collections, Mary Randlett, photographer, UW38031

Guy Anderson, *Reach,* oil on Heavy Paper, 72" x 120", with permission Gallery Dei Gratia and Deryl Walls

Guy Anderson at work, photo by Art Hupy.

Chapter 5

Morris Graves, *Spirit Bird,* 1950, tempera on paper, 18" x 25 ¼". MoNA, Gift of the Caterall Collection, 2004.142.013

Home of Guy Anderson, Jenson Farm property, photographer unknown.

Barbara James, Clayton James, Louise Johnson, Guy Anderson, unknown, Susan Jenson and Axel Jenson. Photo by Ivar Johnson, with permission from Sybil Jenson.

Guy Anderson at home, circa 1960's Art Hupy

Barbara Straker James, *Double Image,* 1959, tempera on paper on board, 48" x 30". MoNA, Gift of Clayton James, 2005.050.001

Chapter 6

Philip McCracken, *Mole Greeting the Sun,* Bronze, 6.5", with permission from Philip McCracken.

Betty Bowen in her Seattle home, with Gilkey landscape, University of Washington Libraries, Special Collections, Mary Randlett, photographer, UW38025.

Philip McCracken at work in his barn studio, circa 1950's by William Conchi, with permission.

Guy Anderson, untitled, 1959, oil on newspaper mounted on
 Masonite, 27 ¼" x 20". MoNA, Gift of Mr. and Mrs. James
 McKinnell in memory of Eloise Kinnell, 1987.024.001
Ruth Penington, date unknown, with permission from the
 American Craft Council.
Dick Fallis as news editor, photo by Art Hupy with permission.
Ruth Penington, untitled silver piece, with permission from the
 American Craft Council.
Clayton James in his studio, La Conner. University of Washington
 Libraries, Special Collections, Mary Randlett, photographer,
 UW38022.
Vera Helte Strong, unknown photographer, the Riverside Press
 Enterprise.

Chapter 7
La Conner, photo by Art Hupy.
Jesus Guillén, untitled, oil on canvas, 37"x 41," ca. 70s, with per-
 mission from the Guillén Family.
Jesus Guillén, photo by Cathy Stevens, with permission.
Guy Anderson, *Between Night and Morning* oil on heavy paper, 96"
 x 144", with permission Gallery Dei Gratia, Deryl Walls.
Louie Nelson poses in front of the 1890's, photograph by Art Hupy.
Guy Anderson, *Fishing Boat, Evening,* 1962, oil on board, 7 ½"
 x 24". MoNA, Gift of the Blair and Lucille Kirk Collection,
 2004.138.001.
Richard Gilkey, untitled (Marsh Grasses), 1960, oil on canvas,
 23" x 60 ½". MoNA, Gift of John Hauberg and Anne Gould
 Hauberg, 1985.009.026.
Tom Robbins in his La Conner home, University of Washington
 Libraries, Special Collections, Mary Randlett, photographer,
 UW38032.
Doris Thomas, circa 1960's, with permission from Doris Thomas.
Keith Weyman Sr., preparing a salmon barbeque; and posing for
 a picture during fall mushroom hunt, photographed by Ray
 Collins.
Betty Bowen, University of Washington Libraries, Special
 Collections, Mary Randlett, photographer, UW38024.

Chapter 8

Guy Anderson, Moonrise and *Skagit Storm* oil on heavy paper, 46.75" x 55.25", Gallery Dei Gratia, Deryl Walls.

Portrait of Morris Graves, photograph by Art Hupy.

Fishtown, photographer unknown.

Charles Krafft, untitled, geese flying, from Bo and Jo Miller collection, with permission.

Richard Gilkey, *Evening Slough* oil on canvas, 18" x 24", from the collection of Tim and Gail Bruce, with permission from Janet Huston.

Philip McCracken, *Dream of a Dying Owl* 1963, print, pencil and ink on paper, 24" x 17.75", from the collection of Tim and Gail Bruce.

Charles Krafft, untitled, ink on paper, 17" x 11.5", with permission.

Charles Krafft, *Famous Poet Robert Sund* with permission.

Bo Miller *Cedar Nude,* inspired by a small bronze nude by Matisse, marsh cedar, with permission.

Chapter 9

Boardwalk to Fishtown, photographer unknown.

Bo Miller, *Lady Moon* expressing upset at man's moon landing, cedar shake bolt form salt water marsh, with permission.

Charlie Krafft at house, photo by David King and Heidi Obzina.

Collaborative Fishtown piece, *Shack Work,* including Robert Sund and Charles Krafft poetry, with permission from Bo Miller.

Bo Miller Chevy, *Ying Yang Mandala* Pen and Ink, with permission.

Ralph Aeschliman, *Coots* with permission, Bo and Jo Miller collection.

Bo Miller poetry, Steve Herold calligraphy.

Michael Clough, *Winter Light Cessation, Spring Light Prelude, Summer Light Zenith, Autumnal Light Subsistence;* acrylic and gouache on muslin, 24" x 18".

Fishtown on the Skagit River, February, 1969. From left: Charlie Krafft, Hans Nelson, Allen Benditt. Art Jorgenson, Tom Skinner (sitting), Erik Nelson, Robert Sund and Fred Decker. University of Washington Libraries, Special Collections, Mary Randlett, photographer, UW38028.

Chapter 10

Bill Slater in La Conner, circa 1968, with permission.

Bill Slater with Japhy in La Conner, with permission.

Bill Slater, untitled. This painting included collaboration from Tom Robbins who added the word "PLUM" and several outlining blue lines. From the collection of Tom and Alexa Robbins, with permission.

Larry Heald, *Alpine Dancing* acrylic on canvas, 30" x 24", from collection of Bo and Jo Miller.

Larry Heald for Paul Heald, painted after Paul Heald's death, two cups of tea, acrylic on canvas, 30" x 40", with permission.

Gertrude Pacific with her art in Conway bank home, with permission.

Larry Beck

Ed Kamuda untitled painting of cove, with permission, ie Gallery and Margy Lavelle.

Ruth Bakke hosting Rita Hupy at Nordic Inn, circa 1970 photo by Art Hupy

Barbara Silverman Summers, *NW Woman,* 24" x 36", acrylic on canvas, with permission.

Betty Miles portrait, with permission.

Betty Miles, *Japanese Woman,* with permission.

Maggie Wilder, *When Dusk Had Meaning* oil on canvas, 11.5" x 12", with permission.

Lea McMillan Diacos, with permission.

Guy Anderson, 1972, oil on paper on board, 62 ½" x 41". MoNA, Anonymous gift, 1995.037.002.

Max Benjamin, untitled, oil on canvas, 48" x 36", with permission.

Chapter 11

Art Hupy and camera self-portrait, circa 1950's with permission.

Interior of Hupy home in Canada, by Art Hupy.

Gaches Fire, photographer unknown, with permission from Northwest Textile Museum.

Kay and Glen Bartlett, photo by Art Hupy, with permission from Bartlett family.

Connie Bartlett Funk wearing "wearable art" from Chez la Zoom's Kelly Matlock for a Gaches Mansion event.

Museum interior, circa 1970s, photo by Art Hupy.

Paint La Conner art program, photo by Art Hupy.

Art's School with Bill Cumming, photo by Art Hupy.

First Arts Alive Poster, with Kelly Matlock, photo by Art Hupy.

Guy Anderson, *Birth of Prometheus* 1984-85, oil on paper, 96" x 72". MoNA, Gift of the Paul I. Gingrich, Jr., Collection, 2012.315.164.

Guy Anderson painting at home, La Conner, University of Washington Libraries, Special Collections, Mary Randlett, photographer, UW38021.

Richard Gilkey, *Lunation* 1976, oil on linen, 31 ¾" x 32 ¾". MoNA, Gift of Simon and Carol Ottenberg, 2006.039.038.

Chapter 12

Quilt Museum exterior, circa 1990's photo by Ruth Newell.

Miwako Kimura at the Quilt Museum, circa 1990's photo by Ruth Newell.

Joan Colvin, photo by Amy Pattee Colvin, with permission.

Joan Colvin, *Dungeness Crabs* 44" x 43", fabric and beads, with permission.

Joan Colvin, *Tree Bark 2,* 69" x 43", fabric, Tyvek and paint, with permission.

Anita Mayer and her wearable art, photo by ACME Creative, with permission.

Penny Peters, *Roadside Attraction II* for Gail Harker School, with permission

Gwen Lowery, *Corona I* for Gail Harker School, with permission.

Chapter 13

Kevin Paul *Heron,* with permission, Kevin Paul.

Kevin Paul, *Skagit Valley College Totem,* with permission.

Kevin Paul with carving, with permission.

Tracy Powell, public installation, *Maiden of Deception Pass,* photo by Maralyne Powell.

Tracy Powell, *Embrace,* granite, Photograph by Maralyne Powell.

Tracy Powell, *Ska-atl the Otter,* granite, on Fidalgo Bay by Tommy Thompson Trail, photograph by Maralyne Powell.

Philip McCracken, *Piping Rabbit,* bronze, from Tim and Gail Bruce

collection.

Philip McCracken, *Pika Mountain Sentinel* Cedar and onyx, 21.5", with permission from Tim and Gail Bruce collection.

Leo Osborne, *Gathering of Owls,* burlwood, 23" x 17" x 12", with permission.

Chapter 14

Richard Gilkey being arrested, circa 1988, Skagit Valley Herald, photographer unknown

Lavone Newell Reim with paintings.

John Simon, *Deer,* incised oil panel 20" x 26" with permission from Maggie Wilder (Studio?)

Barn Show 1990, photograph by Cathy Stevens.

John Simon, untitled, at Boulder Creek, 31.5" x 41.5", with permission from Maggie Wilder

Anne Martin McCool, *Magic Valley,* acrylic on canvas, 18"x 36", with permission.

Morris Graves, photograph by Art Hupy

Richard Gilkey, *Tibetan Spheres,* 1997, oil on canvas, need dimensions. MoNA, 2012.315.189.

Guy Anderson, *Angels Frolicking over McGlinn Island,* 1970s, woodcut on paper, 6 7/8" x 7 3/8". MoNA, Gift of Ulrich Fritzsche, 1981.002.006

Bill Slater, untitled, oil on canvas, with permission, Tom and Alexa Robbins.

Bill Slater, untitled, oil on canvas 48 x 48 inches, with permission, from Bo and Jo Miller collection.

Theodora Jonsson, *Skagit Ludovica: Ecstasy with the land,* oil on canvas, 60" x 48".

Chapter 15

Ed Kamuda and Guy Anderson, circa 1990's photographer unknown

Guy Anderson, *Falling Fragments,* 1984 oil on heavy paper, 72" x 96", with permission Gallery Dei Gratia, Deryl Walls.

Guy Anderson poses with his work, circa 1990's, photo by Art Hupy

Joel Brock, *Flowers IV: Mr Anderson,* acrylic and mixed media on

canvas, courtesy of Harris Harvey Gallery

Joel Brock, *House,* 2008, acrylic, charcoal and gesso on rag board, 11" x 11", courtesy of Harris Harvey Gallery

Joel Brock outside Edison studio, 2008, photo by Peter de Lory with permission

Jack Gunter "with" Guy Anderson 2011. This enhanced image puts two artists from two eras together. "Although Jack Gunter denies meeting Guy Anderson, certain photographs on the Internet have surfaced that suggest otherwise."

Jack Gunter, *Garden of Surgical Delights,* Egg Tempura, with permission.

Allen Moe, untitled, herring, deerskin, clay pot, 10" height, with permission.

Allen Moe, *North Fork Skagit River Delta,* cast with modified cement, 18" x 18", with permission.

Philip McCracken, *Earth Rhythms* 1983, colored pencil on paper, 36" x 24.5", from collection of Tim and Gail Bruce

Ed Kamuda, *Red Seed* oil on wood, 8" x 12" from the collection of Tim and Gail Bruce.

Chapter 16

Thomas Wood, *Looking South from River Shack,* 2011, oil on linen, 16" x 20", courtesy of the Harris Harvey Gallery

Thomas Wood, *Ika Island from Beaver Slough,* 2011, oil on panel, 12" x 15", courtesy of Harris Harvey Gallery.

John Cole, *Skagit Drift,* 1990, oil on linen, 20" x 24", courtesy of the John D. Cole Estate and Harris Harvey Gallery

Guy Anderson, untitled, 1978, oil on roof paper mounted on Masonite, 97 x 74 inches. MoNA, Gift of Marshall and Helen Hatch, 1999.027.004

Ed Kamuda, *Skagit Morning,* oil with wax varnish, 12" x 20.5", courtesy of Harris Harvey GalleryFig 124 – b Dederick Ward, Beginning to Clear with permission Scott-Milo Gallery.

Ed Kamuda, *Bow Hill Spring,* 2007, oil with wax varnish, 14" x 15", courtesy of Harris Harvey Gallery.

John Simon *Chuckanut Mountain Range,* 2009, oil on canvas, 48 x 60 inches. MoNA, Gift of Smith & Vallee Gallery and Friends of the artist, 2009.221.036

Clayton James looks skyward, photo by Dederick Ward.

Clayton James, *Clayton in a Mustard Field,* 30" x 24", oil on wood panel, with permission from David Rothrock collection, photo by Chris Petrich.

Clayton James *Snow King* 2000, oil on canvas, 21" x 25". MoNA, Gift of Chris and Allen Elliott Collection, 2011.275.026.

Paul Havas, untitled Gouache on paper, 20" x 22", with Permission Margaret Miller.

Guy Anderson, photo by Art Hupy

Betty Bowen and Tom Robbins in La Conner, University of Washington Libraries, Special Collections, Mary Randlett, photographer, UW38033

Cover

Richard Gilkey untitled, oil on canvas, from the collection of Guy Hupy, with permission from Janet Huston.

CHAPTER NOTES

Chapter One: Seattle Artists
1 Guy Anderson interview, "Approaching 90," KCTS, Seattle, Washington, 1995.
2 Deloris Tarzan Ament, *Iridescent Light: The Emergence of Northwest Art* (University of Washington Press, 2002).
3 KCTS interview.
4 Ibid.
5 Oral History Interview with Guy Anderson, Smithsonian, 1983.

Chapter Two: A Farming and Fishing Village
1 Paul Dorpat, "Ivar Haglund (1905-1985)," *HistoryLink*, June 20, 2000. Accessed January 29, 2010.

Chapter Three: Morris Graves and Guy Anderson Move In
1 *The Seattle Times*, July 4, 1977.
2 Oral History interview with Jan Thompson, Sept. 6–Nov 16, 1983, Archives of American Art, Smithsonian Institution, p.31.
3 *The Weekly*, John S. Robinson. Dec. 15, 1987.
4 William Cumming, *Sketchbook: A Memoir of the Thirties and the Northwest School* (University of Washington Press, 1984).
5 *The Weekly*, John S. Robinson, p.31, Dec. 15, 1987.

Chapter Four: WPA and World War II
1 Georgia Johnson, Just Past Dew Point (Flying Trout Press, 2016), part iii of three parts.
2 Frederick S. Wight, John I.H. Baur and Duncan Phillips, Morris Graves (University of California Press, 1956), p.22.
3 Doris Tarzan Ament, Iridescent Light, University of Washington Press, p 114.
4 Vicki Halper and Lawrence Fong, Morris Graves: Selected Letters (University of Washington Press, 2013).
5 Vicki Halper and Lawrence Fong, Morris Graves Selected Letters, p.19.
6 The Anacortes American, Sept. 18, 1991, "Richard Gilkey: Coming Into His Own," Nancy Walbeck.

7 Steve McQuiddy, Here on the Edge: How a Small Group of WWII Conscientious Objectors Took Art and Peace from the Margins to the Mainstream (Oregon State University Press, 2013), p.137.

8 Bruce Guenther, Guy Anderson, (University of Washington Press, 1986), p.98.

Chapter Five: Objectors Find Community

1 Bob Rose, "Sullivan Slough," *A Flutter of Birds Passing Through Heaven: A Tribute to Robert Sund* (Good Deed Rain, Edited by Allen Frost & Paul Piper, 2016).

2 Ament, *Iridescent Light*, Letter to Elizabeth Willis, p.125.

3 Ibid, p.127.

4 Halper and Fong, *Morris Graves: Selected Letters.*

5 Wesley Wehr Oral History Interview, conducted by Martha Kingsbury in Seattle, 1983 for the Smithsonian Archives of American Art.

6 *Anacortes American*, Sept 18, 1991 p.B4.

7 Ament, *Iridescent Light*, p.163.

8 Ken Levine, *Northwest Visionaries* (Iris Films, 1979).

9 *The Seattle Times*, Jan. 21, 1990, "His art's in the Northwest," Deloris Tarzan Ament.

10 Ament, *Iridescent Light*, p.98.

11 Ulrich Fritzsche, *Helmi Dagmar Juvonen, Her Life and Work; a Chronicle* (Self-published, 2001), p.42.

12 *Skagit Valley Herald*, page 15, "Fine Art" March 3, 1988.

13 Wesley Wehr, Smithsonian Interview.

14 Jan Thompson Oral History Interview, Sue Ann Kendall.

Chapter Six: Arts meet Crafts at Quaker Cove

1 Tony Curtis, *Approximately in the Key of C* (Arc Publications, 2017).

2 *The Seattle Post Intelligencer*, Feb. 17, 1977 Emmett Watson, Sect. B1.

3 Ament, *Iridescent Light*, p.276.

4 http://docs.google.com/viewer?a=v&q=cache:2IcGeBMdlRgJ: www.theevergreengallery.com/artists_index/njm/NJM_FullStory. pdf+nan+mckinnell+pennington&hl=en&gl=us&pid=bl&s

rcid=ADGEESggZl7iHElWY-IiU9RSSCicCZeSQjq
95pa-ga684_cADhWZpfB3Nci-54p1HgjMjJbcDeIs
bqeJI5RU_PQtX6yOZXAJb87LeJaP0HAiV4iECc5f
XSBtc24fJQsySC6a3RctszGO&sig
=AHIEtbQ3E4SFtg5xIG6uQN0cvf2DFsOdaw

5 Smithsonian Archives of American Art, Oral History Interview, Nan McKinnell, 2005, June 12-13.

Chapter Seven: Blend of Arts and Farming

1 Wesley Wehr, Oral History Interview conducted by Martha Kingsbury for the Smithsonian Archives of American Art, 1983.

2 Ament, *Iridescent Light*, p.104.

3 Halper and Fong, *Morris Graves Selected Letters*, p.78.

Chapter Nine: Life at Fishtown

1 Later, while living in La Conner, Sund would purchase an autoharp which he named "Pyrrah" after the Greek myth of Pyrrah and Deucalion.

2 Steve Herold, *Where the River Ends: Art & Poetry of the Lower Skagit* (Books A to Z, Incorporated, 2008), p.40.

3 Ibid., p.47.

4 Fred Owens, *Frog Hospital* "A Bit of Fishtown History," Jan. 19, 2010 http://froghospital911.blogspot.com/2010/01/bit-of-fishtown-history.html

Chapter Ten: Influx of Painters

1 Martha Kingsbury, Smithsonian interview 1983.

Chapter Eleven: Gaches Mansion and the Museum of Northwest Art.

1 *The Highline Times*, Weds. Dec 8, 1976, C-6, "Hupy offers a special kind of dignity."

2 *Skagit Valley Herald*, Saturday, April 26, 1980.

3 *La Conner Weekly* News, Feb. 18 and 25 series by Janna Gage.

4 *Skagit Valley Herald*, Arts & Entertainment, Thursday August 16, 1984.

5 *Skagit Valley Herald*, "New museum would keep art in valley," Sec. 3, p.15, March 3, 1985.

6 *Skagit Valley Herald*, Sect 2, p.19, Thursday, June 27, 1985.

7 *Skagit Valley Herald*, "Hupy fired as curator of Valley Museum," Thursday, Feb. 8, 1990.

Chapter Twelve: Quilt Museum and Fabric Arts

1 Pat Morse, *Needle Arts*, "The Nature of Joan Colvin's Design," Sept. 2000.

2 *Tri City Herald*, March 30, 2000.

Chapter Thirteen: The Vision of Carvers

1 Deloris Tarzan Ament, *600 Moons, Fifty Years of Philip McCracken's Art* (University of Washington Press, 2004).

Chapter Fourteen: Beyond River-life

1 *Channel Town Press*, Column written by Smith, publication date unknown.

2 *The Seattle Post-Intelligencer*, Interview, "What's Happening," Dec. 9, 1983.

3 *The Seattle Times*, Applause, Dec 14-20, 1990.

4 Ament, *Iridescent Light*, pp.271-272.

Chapter Fifteen: Passing of the Northwest Masters

1 http://library.humboldt.edu/art/Artists/Graves_Morris/ AboutGraves.htm

2 *The Seattle Times*, "Graves famed studio burns to the ground," by Sheila Farr, Saturday, Sunday, May 13, 2001.

3 Brock had just sold a painting for $38,000 when he was interviewed for this book.

4 Robert Sund died in 2001 after living in a shack he resurrected in the Flounder Bay Boatyard in Anacortes where he had created a garden and living-work space in his final years.

Chapter Sixteen: The future of an arts community

1 Wirth is husband of coauthor Claire Swedberg.

CONTRIBUTORS

Bob Abrams
Ruth Bakke
Christopher Barnes
Glen Bartlett
Max Benjamin
Carly Brock
Joel Brock
Larry Campbell
William Cumming
Alfred Currier
Pat Doran
Phyllis Dunlap
Harriet Eaton
Pien Ellis
Richard Fallis
Rebecca Fletcher
Jack Gunter
Theodora Jonsson
Jim Kohn
Paul Hansen
Robert Hart
Ramone Hayes
Larry Heald
David Hedlin
Steve Herold
Pamela Hom
Barbara Straker James
Clayton James
Robert Allen Jensen
Sybil Jenson
Miwako Kimura
Sheila Klein

Charles Krafft
Margy Lavelle
Janna Gage
Paul Gingrich
Jack Gunter
Lisa Harris
Janet Huston
Edward Kamuda
Joseph Kinnebrew
Phillip Levine
Anne Martin McCool
Philip McCracken
Robert McLaughlin
Carol Merrick
Lea McMillan
Betty Miles
Bo Miller
Bill Mitchell
Allen Moe
Kathleen Moles
Ben Munsey
Roberta Nelson
Terry Nelson
Peregrine O'Gormley
Joann Ossewarde
Fred Owens
Gertrude Pacific
Kevin Paul
Mark Pederson
Tracy Powell
Tom Robbins
Greg Robinson

Betty Bowen and Tom Robbins

Tom Robinson	Doris Thomas Robbins
Dana Rust	Kevin Tighe
Christopher Shainin	Jacqueline Trevillion
Barbara Silverman Summers	Glen Turner
John Simon	Bruce Wyman
Japhy Slater	Keith Wyman
Jim Smith	Deryl Walls
Peter Strong	Dederick Ward
Charles Stavig	Maggie Wilder
Austin Swanson	Michael Wirth
Tamara Swanson-Toyama	Thomas Wood
Elizabeth Tapper	Wesley Wehr
Charles Talman	Robert Yarber

GOOD DEED RAIN

Saint Lemonade, Allen Frost, 2014. Two novels illustrated by the author in the manner of the old Big Little Books.

Playground, Allen Frost, 2014. Poems collected from seven years of chapbooks.

Roosevelt, Allen Frost, 2015. A Pacific Northwest novel set in July, 1942, when a boy and a girl search for a missing elephant. Illustrated by Fred Sodt.

5 Novels, Allen Frost, 2015. Novels written over five years, featuring circus giants, clockwork animals, detectives and time travelers.

The Sylvan Moore Show, Allen Frost, 2015. A short story omnibus of 193 stories written over 30 years.

Town in a Cloud, Allen Frost, 2015. A three-part book of poetry, written during the Bellingham rainy seasons of fall, winter, and spring.

A Flutter of Birds Passing Through Heaven: A Tribute to Robert Sund. 2016. Edited by Allen Frost and Paul Piper.

At the Edge of America, Allen Frost, 2016. Two novels in one book blend time travel in a mythical poetic America.

Lake Erie Submarine, Allen Frost, 2016. A two week vacation in Ohio inspired these poems, illustrated by the author.

and Light, Paul Piper, 2016. Poetry written over three years. Illustrated with watercolors by Penny Piper.

The Book of Ticks, Allen Frost, 2017. A giant collection of 8 mysterious adventures featuring Phil Ticks. Illustrated by Aaron Gunderson.

I Can Only Imagine, Allen Frost, 2017. Five adventures of love and heartbreak dreamed in an imaginary world. Color illustrations by Annabelle Barrett.

The Orphanage of Abandoned Teenagers, Allen Frost, 2017. A fictional guide for teens and their parents. Illustrated by the author.

CPSIA information can be obtained
at www.ICGtesting.com
Printed in the USA
LVHW02s0922170118
563046LV00006B/22/P